2/99

Life in the Vatican

JOHN PAUL II

99 00 02

4/99

GAYLORD MG

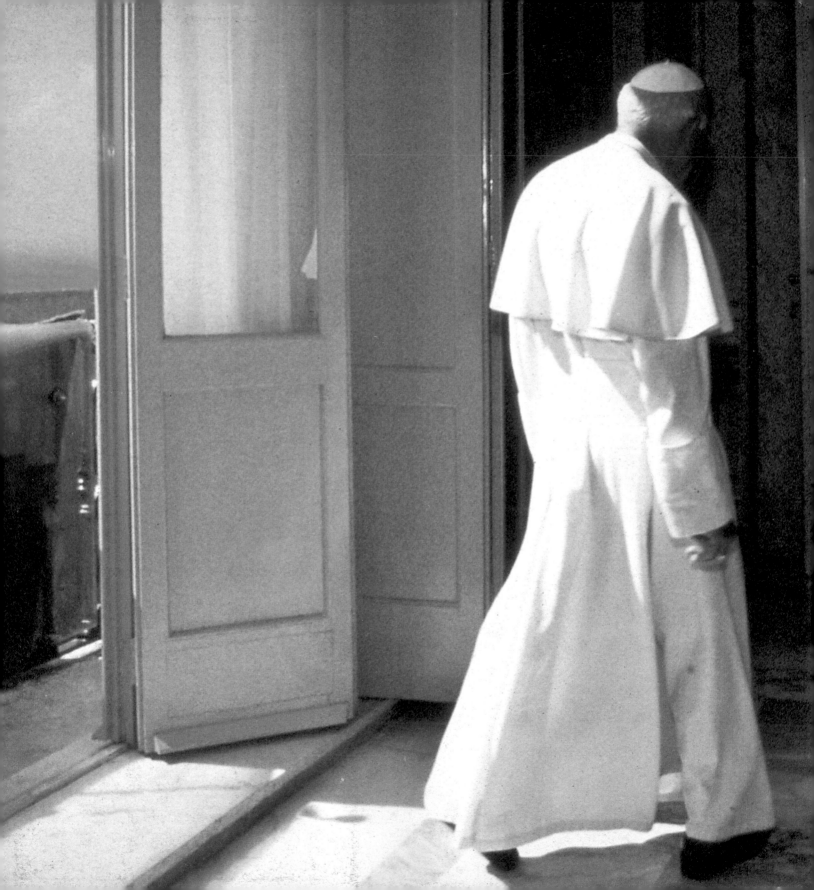

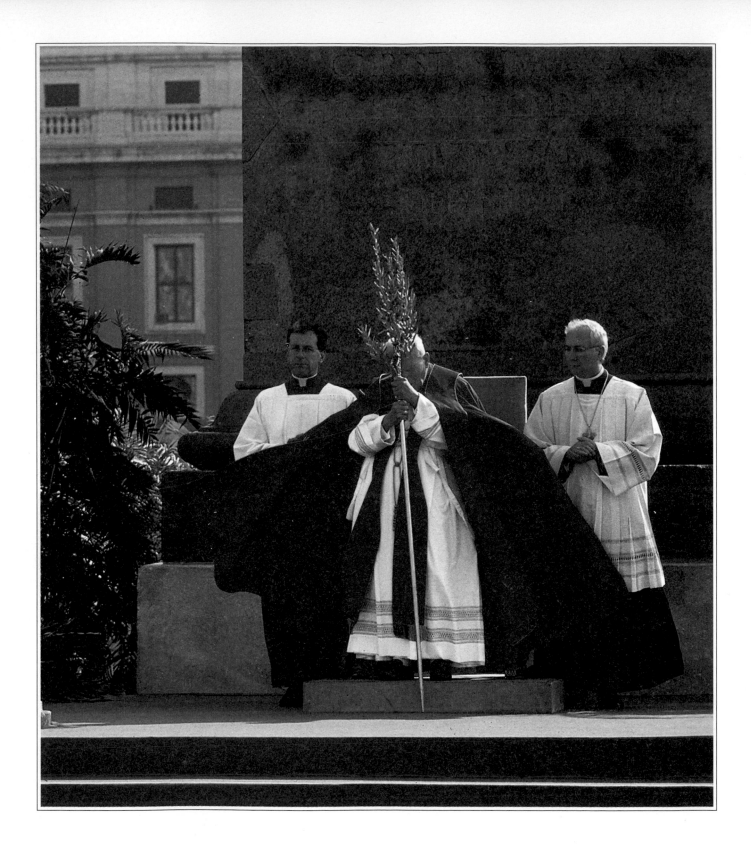

LUIGI ACCATTOLI

Life in the Vatican with
JOHN PAUL II

photography by
GRZEGORZ GALAZKA

foreword by
Joaquín Navarro-Valls

Universe

Luigi Accattoli
Life in the Vatican with John Paul II

Photography by
Grzegorz Galazka

First published in the United States of America in 1998
by UNIVERSE PUBLISHING
A Division of Rizzoli International Publications, Inc.
300 Park Avenue South
New York, NY 10010

Translation by Marguerite Shore

English Translation © 1998 Universe Publishing

© 1998 Arsenale Editrice

98 99 00 01 02/ 10 9 8 7 6 5 4 3 2 1

Printed in Italy

Library of Congress Catalog Number: 98-61383

The authors and publisher would like to thank
the Offices of the Holy See and the Vatican City
which, with their authorizations and suggestions,
helped make this possible.
In particular, we would like to thank the
Papal Council of Corporate Communications
(and Ms. Marjorie Weeke at that office), as well
as the Governatorato, the territorial government
office.
Special thanks go to the director of the Holy
See Press Office, Joaquín Navarro-Valls, who
agreed to read this book and write an
introduction, and to the Papal Private Secretary,
S.E. Stanislaw Dziwisz.

Contents

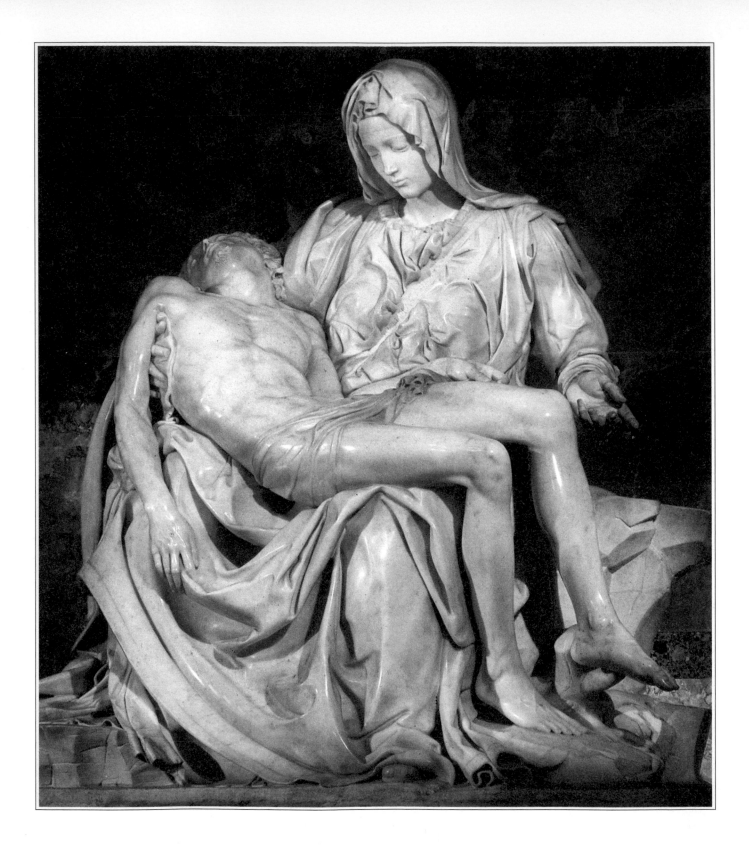

FOREWORD

Another trip through the Vatican! And a rediscovery—in words and images—of this small world, ancient and new, which never ceases to amaze those who come upon it. We have many requests for presentations such as these, about the City of the Pope, and these will probably increase with the approach of the Grand Jubilee. Each year there are greater numbers of pilgrims and visitors, and the demand for books is increasing, both as a tool of knowledge, in view of an impending visit, and as a souvenir of a visit already completed.

I would advise reading this beautiful book in its entirety, both the photos and the text, for they have been compiled by two professionals who are independent experts. For years they have followed the pope on his travels, in the Vatican, and at Castel Gandolfo. They know the history and the current status of the world they are describing, but their familiarity has not robbed them of the freedom that comes from being a guest and outside observer in the Vatican. Those who are part of the Vatican—or to put it more correctly, those who work in an office of the Holy See—cannot help but appreciate the balance of respect and freedom that photographer Grzegorz Galazka and journalist Luigi Accattoli have achieved with this book which will serve as a guide for visitors.

The book dwells at length, and justly so, on the daily life of the pontiff and his activities.

For it is the pope, obviously, who justifies the existence of this unique Vatican world, and it is he who attracts both global and personal interest as no city museum or garden could ever do. Indeed, what would the Vatican be without the pope? As one would expect, photographer and journalist roam about the gardens, courtyards and rooftops, but they never lose sight of the fact that the Vatican City is the pope's home. They conscientiously show John Paul visiting and using the various environments of the city, or they present these spaces in terms of the role they play in his service.

For this is the reality: the Vatican City provides the successor to St. Peter with that "minimum body to contain the maximum spirit," as Pius XI defined it when the City's sovereignty was recognized in 1929 by the Italian State. And if this home of the pope contains living signs of so much past history and so much of the present world, this is because its foundation is grounded in the centuries and today's pope is surrounded by a truly worldwide spiritual communion.

The two authors never forget these origins and this purpose for all things in the Vatican, whether splendid or modest. And you, welcome visitors, should also keep them in mind!

Joaquín Navarro-Valls

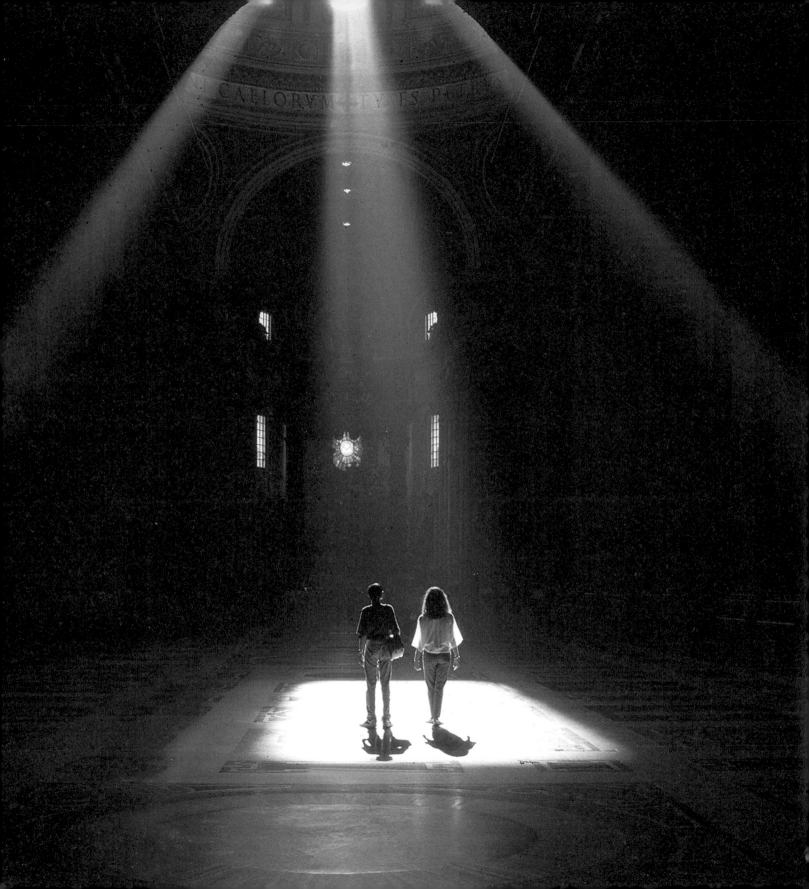

DAILY LIFE
IN THE CITY
OF THE POPE

The Vatican thrives on its visitors, with pilgrims and tourists as its primary and true resource. And yet, a large portion of this "city" is off-limits to visitors, or admits them only upon presentation of special credentials. We will now take the tour that is open to all, visiting those places where we are allowed to go. We will begin, naturally, with the pope. Without the pope, the Vatican would be a museum, and it is thanks to the pope that it is both a place of great history and a living, vibrant presence on the world stage.

We will look at a typical day of the pontiff and at his rapidly evolving image. Today's pope is animated and imaginative; he travels the world, plays sports, visits hospitals, reaches out to the common people. To understand the novelty of this approach, we must remember how constrained the pontiff has traditionally been, even in recent times.

We will observe the pope in his two apartments, the private quarters from which he makes an appearance on Sundays, and the public rooms where he receives bishops and heads of state. But we will also look at the pope in the sanctioned sites of his public activity: St. Peter's Square and the Vatican basilica, beginning with the tomb of St. Peter, at the center of the basilica, beneath Bernini's baldachin and Michelangelo's dome.

When we have passed through the square and visited the basilica, when we have climbed up to the dome and descended into the grottoes, we will have seen as much as the average visitor. We will also take a look at the museums, and our travels there will take us to the Raphael Rooms and the Borgia apartment, the Sistine Chapel and the Vatican Library. In the meantime, we will have participated in a general papal audience, finishing off the list of places that can be visited by the public. But at this point, our itinerary will be only half complete.

Using images that present a heretofore unseen view, and information that comes from long familiarity, we will lead you through the two papal apartments where one enters by invitation only, into museums that are not open to the public. We will also venture into the Vatican gardens and the excavations beneath the basilica, both of which are usually restricted to guided tours, to the library and archives, which require special authorizations, to the Vatican pharmacy and supermarket, which is reserved for employees, and to offices open only to duly accredited diplomats and journalists.

We want to present a living image of the pope's city, in its everyday moments as well as its pomp-filled splendor. Our descriptions and images will touch upon things that are too vast to be described in their entirety, as well as things that are, or seem, modest in scale. The coexistence of these two registers—in every visit we pay to the Vatican—is a sign of life, and something we feel should be left to speak for itself.

Thus, in every space we visit, we will turn our attention to both great and small, and we will attempt to understand the present along with the shadow of the past, for the Vatican universe is witnessing the advent of many innovations that are leaving their mark on ancient places and customs.

In earlier times, the popes celebrated mass and ate alone, but today's pope always has worshipers at his mass and guests at his table. The basilica of St. Peter is full of images of popes receiving kings and emperors who kneel in obedience. It is in that same setting that Pope Paul VI knelt down, in 1975, before the envoy of the patriarch of Constantinople. The Royal Hall contains a depiction of the St. Bartholomew's Night Massacre, presented as a defense of the Catholic faith, an event that the current pontiff has recognized as "an act that the Gospel condemns." And while the majority of pilgrims who descend into the Vatican grottoes are women, in centuries past, women who entered this site were threatened with excommunication.

As we come across them, we will show the changes that are being felt, now more than ever, in this city at the threshold of the millennium. For we will show the entire millennium that is coming to a close, dark chapters and all, which the church of Pope Wojtyla has chosen to acknowledge. Perhaps in no other place on earth does the past have greater presence than in this city of the pope, and no place else does today's world present a struggle as it does here. This struggle enlivens the present and guarantees that the city will endure in the millennium to come.

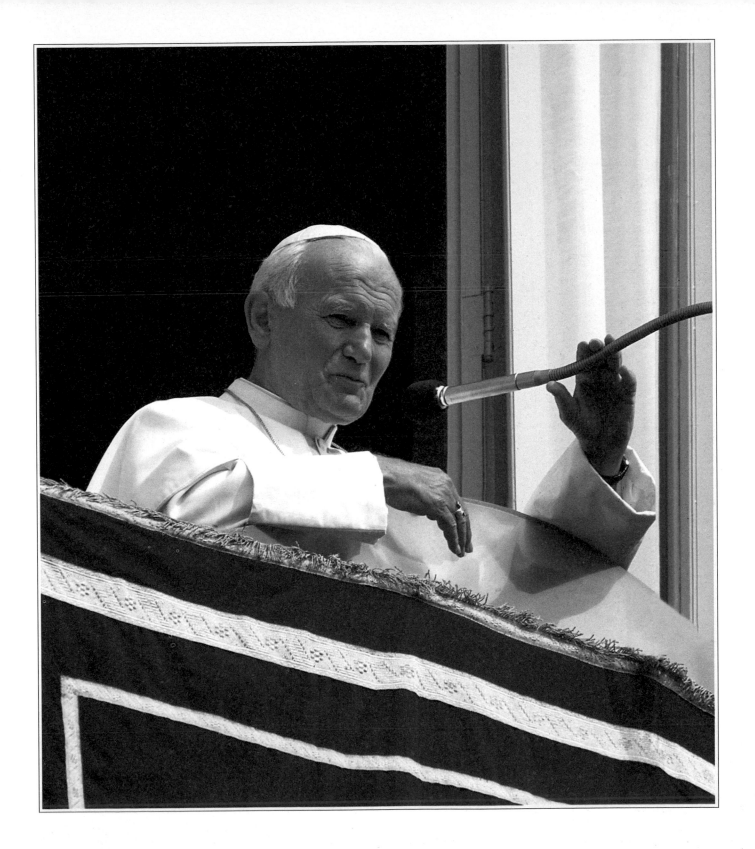

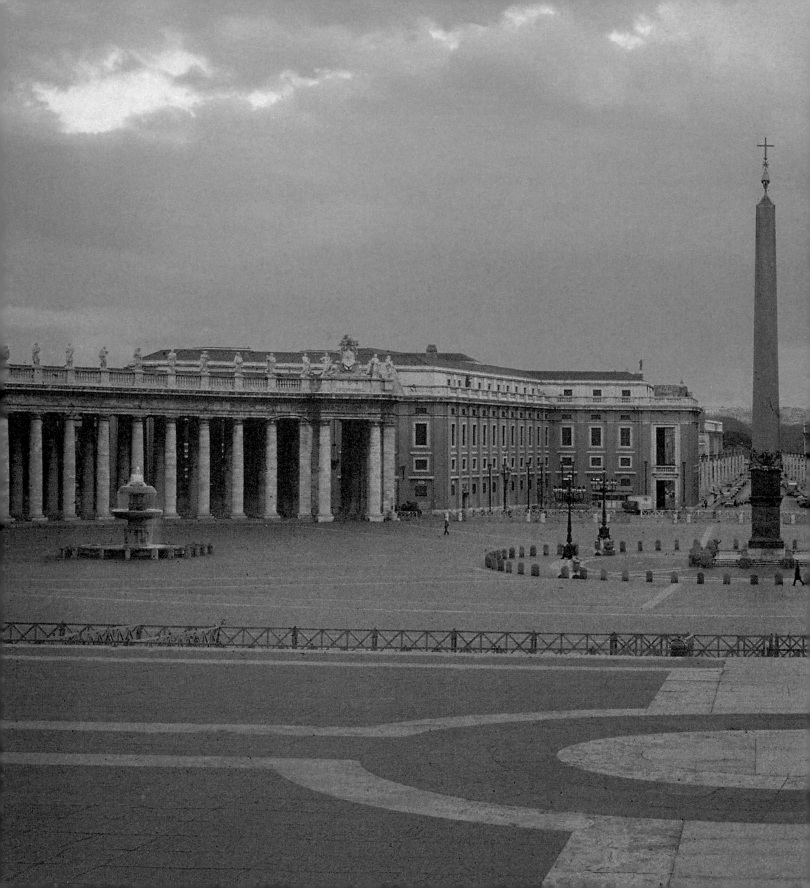

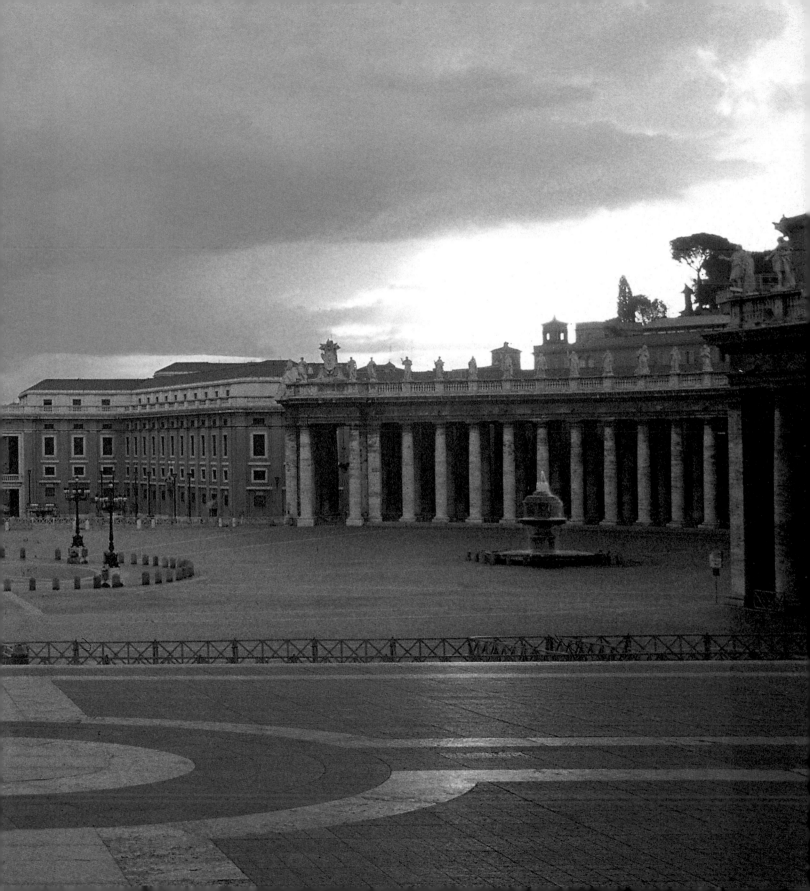

Legend

1 St. Peter's Basilica
2 Villa of Pius II
3 Ethiopian School
4 Belvedere Courtyard
5 Cortile della Pigna
6 Cortile di San Damaso
7 Heliport
8 Galea Spring
9 Lourdes Grotto
10 Belvedere Palace
11 Government Office Building
12 Piazza del Sant'Uffizio
13 Piazza della Zecca
14 St. Peter's Square
15 Piazza Santa Marta
16 Radio
17 Sala Nervi
18 Sant'Anna
19 Station
20 Printing Office

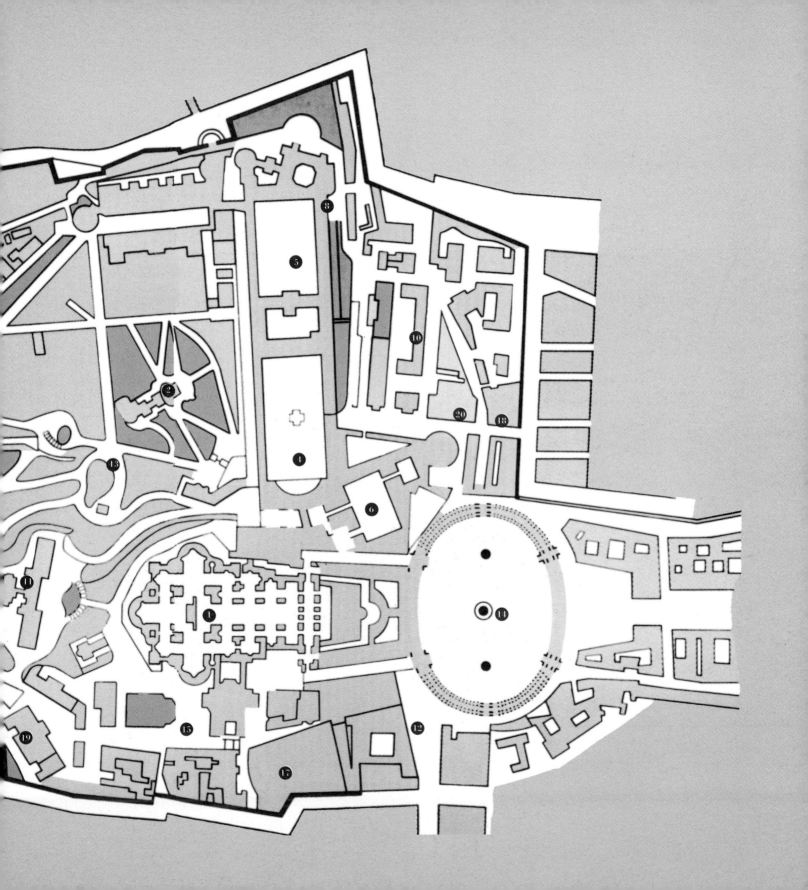

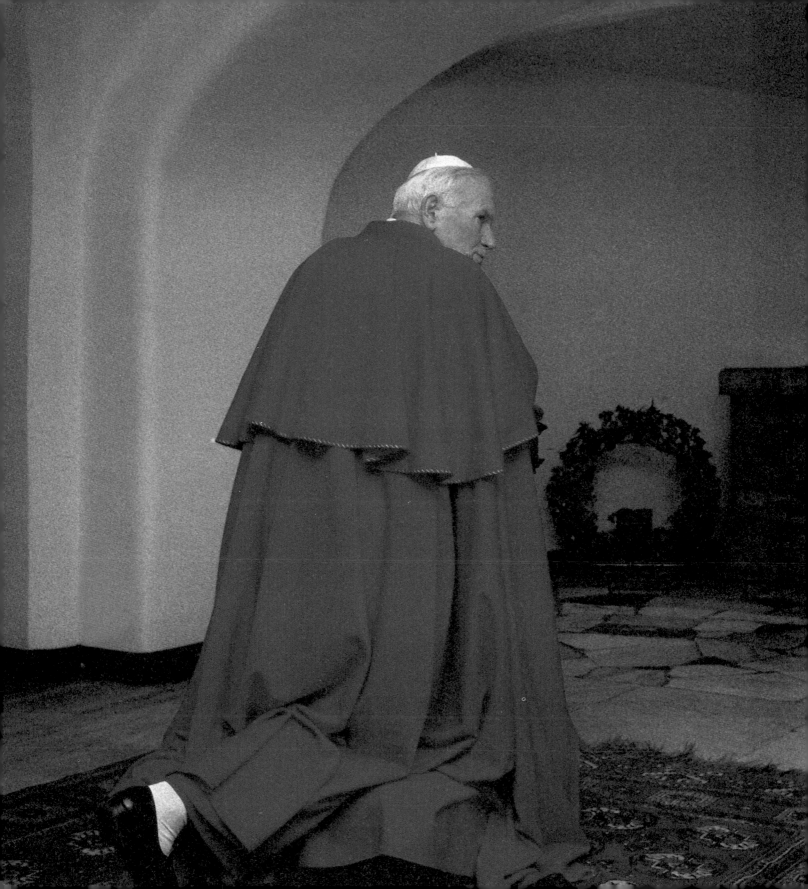

THE POPE'S DAY

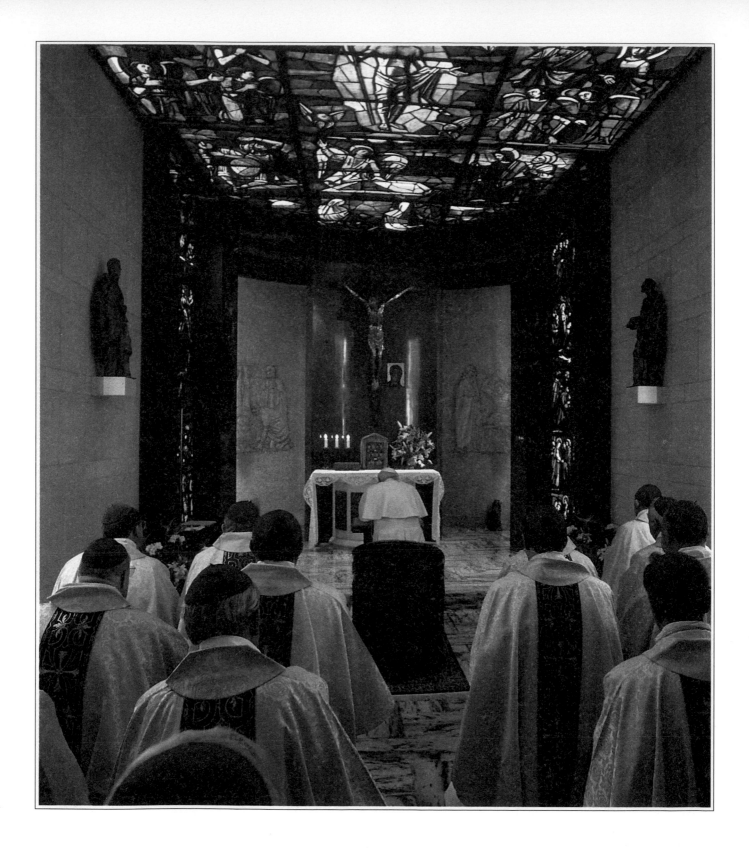

The pope's day begins with mass, at seven in the morning. It lasts one hour and does not include a homily but has long pauses, particularly after the readings and after Communion. For the entire hour, the pope maintains his concentration to a degree that amazes those present.

Yes, there are others present, for his morning mass is no longer private, that is, closed to the public. It has been the pope's wish that morning mass become a full-fledged papal expression, and with the help of his gracious Polish secretary, Father Stanislaw, the pope's desire has been fulfilled. This innovation has already met with great approval from his now wide public, which seems to prefer this sort of public appearance to private audiences.

Just as there have always been both private and public papal audiences, there have also been private and public papal masses. The criterion for distinguishing the two has remained the same. Anyone who so desires may attend the Wednesday public audiences, as well as public mass in St. Peter's. But a summons from the pope or an official request to receive an invitation is required in order to be admitted to a private audience or to mass in the private chapel. Today, no one could say that mass in the private chapel is less important than a private audience; as papal acts, both are significant elements of his ministry.

I once attended mass in the private chapel. The pope seemed to neither see nor hear what was happening around him, but he was clearly alert. I was there with my family, and Matilde, who was two years old, fell asleep for a bit and then awoke and called out for her mother. After the mass, the pope greeted us and praised the little girl: "You were a good girl the entire time, but you made yourself heard for a moment!" So he had noticed, but without breaking his concentration, which would have been unimaginable in a man of action.

Divo Barsotti has celebrated mass with the pope on numerous occasions and describes his "spirit of oration": "During the Liturgy of the Word, he turns toward the faithful, but during the

The celebration of the mass in the private chapel with the Polish bishops as guests.

Liturgy of the Sacrifice, he removes himself from the assembly and enters into the mystery of Christ's presence. At that moment, it seems as if the world is incapable of entering his spirit, of distracting him from God."

The chapel is crowded during mass, for the days when the pontiff celebrated mass and ate alone are long gone. Once there was a clear separation between the private and public apartments in the papal palace; no one was supposed to know about the pontiff's private life, and the public stage was governed by protocol and was in Latin.

John XXIII and Paul VI introduced some innovations, but it is John Paul II who has broken the public/private barrier; he wants guests in his chapel and in his dining room, and he also admits journalists and photographers. He has personalized the public stage and has made his private life a tool of his reign. With him, the papacy has once again become well-rounded, after centuries of pontiffs who were either ascetics or diplomats.

At mass, in addition to six Polish nuns and two secretaries, there are always invited guests: friends passing through, bishops making *ad limina* visits, superiors of the religious orders that have general chapters in Rome, traveling groups, individuals with families. The chapel seats about forty, with the seats arranged in rows of four behind the pope's chair, as seen in these photos.

Invitations to morning mass are granted personally by Father Stanislaw Dziwisz. He telephones those he wishes to invite, and if the party responding doesn't know who Father Stanislaw is, he explains, "I am the pontiff's secretary. The Holy Father would like to invite you to attend mass in his private chapel tomorrow morning. Please come to the bronze doors at 6:30 in the morning."

Those who are expecting the invitation respond promptly. But those who don't expect it sometimes remain astonished and disconcerted. Some have no idea just where the bronze doors are; women ask how they should be dressed; couples want to know if they may bring their small children. And no one seems to feel comfortable calling back the pontiff's secretary, to request a postponement so there might at least be time to buy appropriate

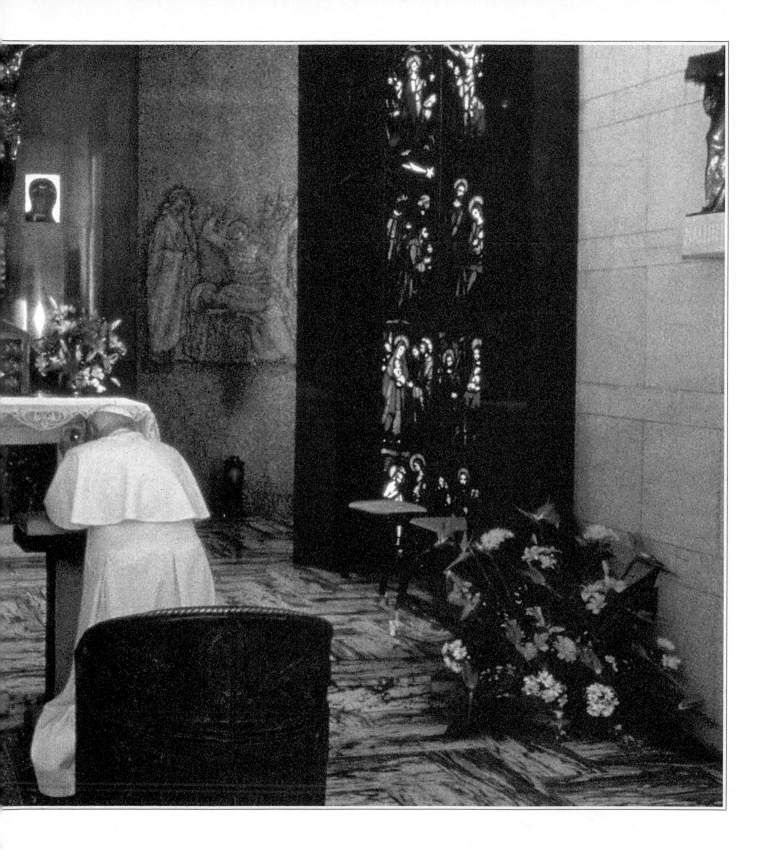

outfits for adolescent children who have only denim jackets. But Father Stanislaw is always available; he grants postponements and calls back a month later.

Anxiety brings families early to the bronze doors, which are still closed. At the agreed upon hour, one Swiss guard looks them over through half-closed eyes, while another checks the names of the guests on Father Stanislaw's list. Then he accompanies them up the grand staircase to the St. Damasus Courtyard elevator, which takes them to the fourth floor. There are people who have spent their entire lives working in the Vatican, even in important positions, without ever reaching the mythical fourth floor. On the other hand, some poor soul who has no idea how he was chosen might end up there, and the reason may simply be that the pope had heard that the invitee's young daughter was ill.

The guests find the pope in meditation, seated on a gilded bronze chair in front of a prie-dieu, at the center of the chapel. The chair is the work of Mario Rudelli, a sculptor who was inspired by the medieval bishops' thrones, but he designed this private throne of the bishop of Rome to face the altar rather than the people, and thus be seen from the back and not from the front.

The chapel, which Pope Paul VI commissioned during the second half of the 1960s is by the same artists who were entrusted with the renovation of the public apartments on the third floor of the papal palace, and is "a magnificent space for prayer, but small and enclosed within a compact architectural mass" (Jean Chélini). And it is perhaps the most successfully designed or renovated space in the Vatican, following John XXIII's and Paul VI's decisions to "update" the Holy See and to keep step with the times.

The overall design of the chapel is the work of architect Dandolo Bellini. The entire space and every element of the furnishings refer to the figure of Christ. This concentration on Jesus was the wish of Pope Montini, in keeping with his own directives, and following the Ecumenical Council which called for the reform of the liturgy and the construction of new churches. The crucifix that dominates the room is by Enrico Manfrini, as is the bronze door of the chapel depicting "spiritual and corporal works of mercy," which are shown as carried out by Christ, who, for example, gives fish to the hungry, or by those destined to serve him, as in the "deposition from the cross." The Christ Resurrected, portrayed in the stained glass of the ceiling, is by Luigi Filocamo. The words of the Lord's Prayer are written in Latin on the back of the chair. On the wall to the right, sixteen panels and one bronze plate, the work of Lello Scorzelli, depict the Passion and the Last Supper. The audience at mass is too intent on observing the pope to look around at the chapel, but it deserves attention.

If there are more than forty people at mass, the

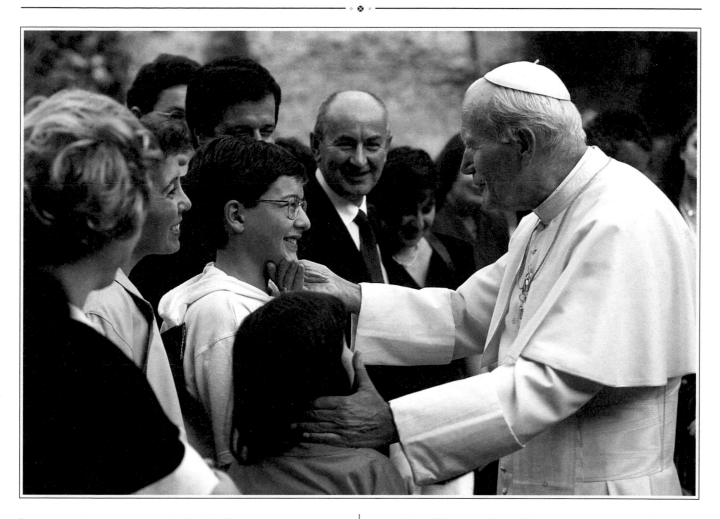

last to arrive must stay in the hallway, as at a large family gathering. When more than fifty guests attend the pope's mass (this might happen, for example, when there are pilgrimages from Poland), the celebration is held in one of the chapels of the papal palace, most frequently in the Redemptoris Mater Chapel (which used to be called the Matilde Chapel) or in the Pauline Chapel.

When mass is over, the secretary invites those present to go into the library and line up along the walls there, where he will then accompany the pope, to whom he introduces individuals and groups. "This is the journalist who was on the airplane," says Father Stanislaw. And the pope

replies, "I remember. You wrote an entire book about me, and you succeeded in dismissing many myths. I'm grateful for the effort you made to understand me."

Father Stanislaw now guides the pope toward another group, takes a young woman by the arm and suggests, "This young mother needs your blessing." John Paul makes the sign of the cross on the woman's forehead and embraces her as a father would a daughter.

When children are present, Father Stanislaw prepares a small table of chocolates or a little panettone. The ever present photographer, Arturo Mari, immortalizes the meeting, and the photographs are available within a day—at minimal

cost—at the photography office of *Osservatore Romano*, the Vatican newspaper.

Those present might include a friend from Poland or one or two people the pope would like to meet, and a second invitation will go out: to stop by for breakfast, which might last from half past eight until nine in the morning. However, guests are seen more frequently at lunch and dinner. Breakfast can also be an occasion for important private meetings, perhaps with leaders from the Italian government—Andreotti or, more recently, Prodi—who are about to leave for Poland.

At the dining table, John Paul is more spontaneous than one might imagine; he eats well, pours his own wine—when his hands were steadier, he used to pour for his guests—and he might propose a toast to those present. Wine, milk, honey, fruit, and vegetables come from the farms in Castel Gandolfo and from the Vatican gardens. The nuns in the kitchen are Polish, and the dishes served are often typical of the pope's native land.

Angelo Gugel acts as waiter. A courteous and impeccable Venetian, he has become a familiar sight to television viewers, for he is always at the pope's side when the pontiff travels, handing him his cape or holding his umbrella. Gugel's title is assistant of the bedchamber, and he is the only one who remains from the once numerous employees of the ancient "laic family" attached to "His Holiness of Our Lord," as the pope was called until the time of John XXIII. At the beginning of his papacy, Paul VI drastically reduced the official entourage, which pertained more to the age of heraldry than to current reality. At that time, the Papal Annual List still included the cupbearer (he who "holds the wine for the Supreme Pontiff," according to a "historical note" in the annual list), the guardian of the wardrobe, the pope's sacristan, the paymaster, the "riding master of His Holiness" (the person responsible for the "Palace Stables," which ceased to exist under Pius X), the "Bearer of the Golden Rose" (if the pope had needed to send one to a Catholic queen), privy cloak-and-dagger servants, servants of honor in purple costume, and the privy steward (who presided over the pontiff's table).

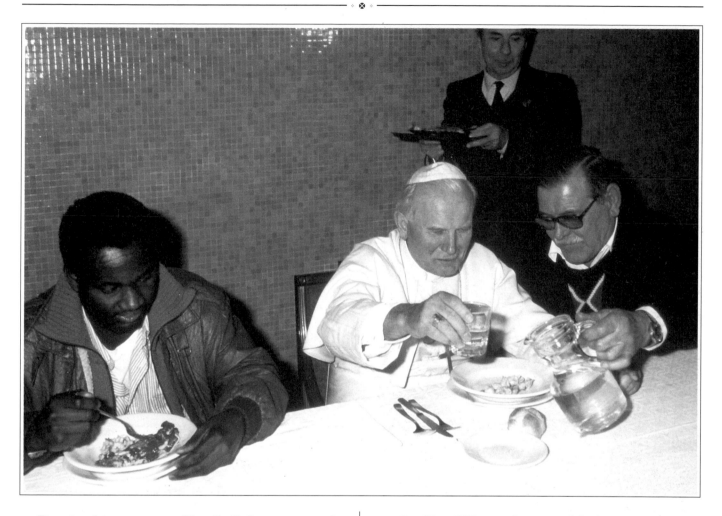

Despite this numerous "family," the popes used to eat alone, although it is difficult to understand why. A sign of distinction, sacred respect, and perhaps other unknown reasons forced the popes of the Counter-Reformation into this unnatural isolation at meal times, which should have been "convivial" social occasions. To fully understand the revolution brought about by Pope Wojtyla, who might be found sharing a meal with whomever—the homeless charges of Mother Teresa, a group of Adriatic fishermen, workers on the floor of the factories he visits every March—we must stop and think about the model he inherited from his predecessors. The model of the monastic, even hermitic meal, which reached its severest form

under Pius XII, was later modified, but not entirely overturned, by Popes John and Paul.

For example, during the centuries of the Counter-Reformation, even if the popes' meals were public occasions on certain feast days or for visits from the emperor, the pontiff's table would be kept apart and placed at a higher level than the others, and women could not be seated there. As at a mass, silence was demanded, and passages from the New Testament were read. All in attendance would kneel when the pope was offered his chalice by the cupbearer, who went through the same ritual gestures he might use if he were at the altar, serving the celebrant. Bishops and cardinals did not kneel but removed their skull caps and

bowed their heads. "Eating with the pope is an ideal honor and a bodily effort," exclaimed a Venetian ambassador who had the experience of sitting at Sixtus V's table.

This form of ceremony is tenacious; Pius VII, the second of the popes imprisoned by Napoléon, still ate at a square table surmounted by a canopy. His privy chaplain (really his personal secretary), Gregorio Speroni, wrote in his journal of his chagrin at the liberties taken by this affable pope, who invited people to be present at—not to participate in! —his meals, where some of these "witnesses" did not know the proper code of behavior. But then Speroni does mention one guest who did exhibit suitable conduct, and the demanding

chaplain mentioned that guest with praise: Cardinal Braschi, who remained seated (or, rather more formally put, "situated") on a simple stool and stood up and removed his skull cap each time that the pope touched his glass to his lips.

Perhaps in order to avoid these sorts of complications, or perhaps as a reflection of the sadness of the times, the popes of the nineteenth century and the first half of the twentieth century indulged in fewer public meals, or meals open to the public, and the rule rapidly developed that the pope would eat in solitude. It was a rule that doubtless inflicted suffering on some pontiffs, and some would say that its reversal required greater effort than these blessed men had had to put forth

during the Enlightenment, the revolution, Napoléon, or the *risorgimento*. Indeed, while the "Roman question," that is, the problem of the popes' secular sovereignty after the conquest of Rome by the Italian crown in 1870, was partially resolved with the 1929 Lateran Treaty between Italy and the Holy See, this requirement that the Holy Father eat alone remained intact until the papacy of Pius XII (1939–58).

The first to rebel against this ritual of isolation was Pius X. He was God-fearing and respectful of the rules inherited from his predecessors, but he was accustomed to the sociable ways of his parish in the Veneto and felt restricted by these rules. He wanted the two secretaries he had brought with him from Venice to join him at his table. But he was joined only once at his table, by his two sisters and a nephew, for a surprise organized by his secretaries for one of the last Christmases of his life. While the pope was pleased, he "prohibited this event from being repeated" (Silvio Negro).

Benedict XV and Pius XI, both of whom were more modern in every way than Pius X, nonetheless returned to the old rule. History rarely proceeds in direct fashion, and the official Vatican background of these two pontiffs prepared them for the burden of solitude that Pius X had found so oppressive. Sometimes the Countess Persico, sister of Benedict XV, was present at his table, but Pius XI admitted no one to his private apartment other than his personal staff. Occasionally a porter, private cleaning person, barber, or doctor was called in. Even the closest relatives were received in the public apartment, on the third floor. During his meals, one of his two secretaries read the newspapers, remaining standing until the pope motioned to the secretary to sit—a modernized vestige of the rule of silence and of interpretations of monastic repasts.

It seems impossible that a pope would want to isolate himself in this way, and yet Pius XII did so, combining the God-fearing instincts of Pius X with the Vatican background of his two successors. Pius XII outdid the other twentieth-century popes and went so far as to keep the two secretaries away from his private quarters, to which he admitted only three Bavarian nuns. He always

dined in absolute solitude, with the company of a caged canary, almost a mirror image of his own prisonlike domain.

Pius XII left the Vatican some twenty times, but he was succeeded by Pope John XXIII who left more than forty times in a single year. And he always had people at his table. Then came Paul VI, who traveled throughout the world and was the first to invite people to dine with him. And we know, of course, about John Paul II.

When Pius XII died, Karol Wojtyla was thirty-eight years old and had just been named bishop, one of Pius's last appointments. Only twenty years later, Wojtyla was elected pope, but the intervening period had been marked by the papacies of

John XXII and Paul VI, the most innovative pontiffs in at least four centuries. Taking their two names—John and Paul—Wojtyla promised to continue along their path. And at least in terms of the image of the pope, he has fully continued the innovations that those two predecessors had outlined.

Karol Wojtyla was on a river excursion with a group of students when he received the call to the episcopacy. He accepted but warned that he intended to complete his vacation, which for him was as important as the rest of his activities: it represented his relationship with nature, which is essential for all men, and his relationship with young people, which is decisive for a priest. He

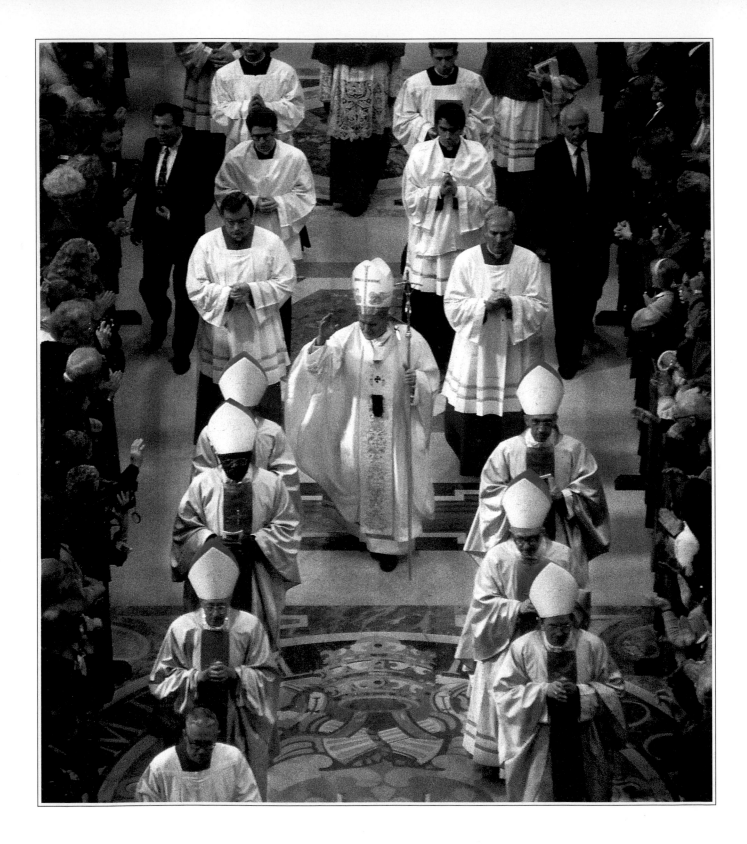

Audience in the Hall of Paul VI for the young people attending the eleventh World Youth Day.

became pope, but he kept that conviction.

The pope has had a swimming pool built at Castel Gandolfo and, for the first two and one-half years of his papacy, until the attempt on his life, it is said that he used to jog in the early morning in an isolated area of the Vatican gardens and in the park of the papal villa in Castel Gandolfo. As long as he was able, he went to the mountains of Lazio and the Abruzzi to ski; and when he had to stop skiing, following his fall in the Clementine Hall in November 1993, which resulted in a dislocated right shoulder, he continued to go to the mountains, taking walks in summer and enjoying the snow-scented air in winter. He has initiated Alpine vacations. He always wants people at his table. He tries, as much as possible, to

remain the man who received the call to the episcopacy as he was traveling with young people. And he would still like to keep those young people, and their children, in his presence.

After breakfast, between nine and eleven in the morning, the pope is in his study where he reads and writes but does not receive people. Father Stanislaw presents the pope with the day's schedule and then leaves him alone so he can devote himself to the documents, the discussions, and the issues that are demanding his attention.

The morning routine allows only two weekly exceptions: on Tuesday and Sunday. On Sunday, he celebrates mass in the basilica, or in St. Peter's Square, and he visits the various parishes in Rome. On Tuesday, he frees himself from all commitments and devotes his time to preparations for the general audience held on Wednesday.

Otherwise, at eleven in the morning, he begins

his audiences. Wednesday is the general audience, in the Hall of Paul VI or in St. Peter's Square. On other days, he holds private audiences in what is called, appropriately, the Apartment for Audiences, on the third floor of the papal palace.

Private audiences have always constituted the popes' most traditional activity and have been a habitual tool for the government of the Curia and a privileged form of contact between the popes and their bishops, government leaders, and other members of society. Even when times were utterly different—when popes did not travel, hold general audiences, recite the Angelus from the window, visit parish churches of Rome, or give speeches other than formal orations—they did hold private

audiences, exactly as John Paul II does today. And there are some popes who have governed the church exclusively through such sessions.

There are various types of audiences, and the adjective "private" is hardly descriptive, in that it simply distinguishes the meeting from a formal "state" audience (reserved for heads of state) and from *ad limina* audiences (obligatory visits with bishops, at the basilicas of the apostles Peter and Paul). Private audiences take place in the pope's private library, at the back of the Apartment for Audiences, but when there are groups rather than individuals, particularly large groups, the pope might receive them in another of the rooms that make up that apartment.

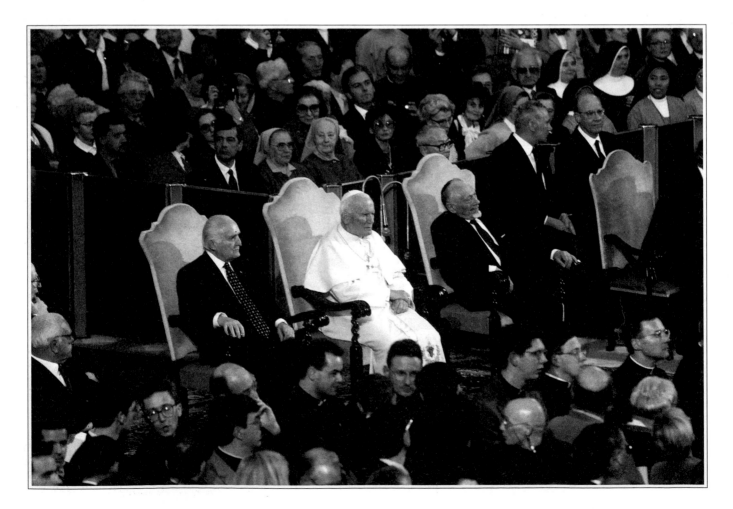

Finally, if there are a great many groups all of the same nature, then the official audience apartment is used, with the groups arranged throughout the various rooms that, under ordinary circumstances, are traversed by visitors making their way to the library. At such times, the pope will visit the rooms in sequence, until he has met with all the groups.

Recently, on January 7, 1998, there was a festive occasion of this type when the apartment was bustling for an entire morning. The pope received audiences from—or rather, more actively, visited—the nine bishops he had consecrated the day before, on the Feast of the Epiphany, and the bishops were accompanied by their families. The pope proceeded through the apartment in the following order, visiting the Polish bishop of Tarnow, Wiktor Skworc, in the Clementine Hall; the Italian bishop of Ischia, Filippo Strofaldi, in the Concistorial Hall; the Italian prelate of the Curia, Francesco Saverio Salerno, in the Hall of St. Ambrose; the Italian missionary to Brazil, Franco dalla Valle, in the Corner Hall; the Chilean auxiliary bishop of Concepcion, Tomislav Koljatic Maroevic, in the Hall of the Popes; the Philippine Apostolic Vicar of Jolo, Angelito R. Lampon, in the Hall of the Chapel of Urban VIII; the Italian prelate of the Curia, Mario Francesco Pompedda, in the Hall of the Throne; the African bishop of Broaso (Ghana), Peter Kwaku Atuahene, in the Hall of the Ambassadors; and the Italian Papal Nuncio, Marco Dino Brogi, in the Hall of the Small Throne.

The innovations introduced by John Paul to the extremely traditional papal activity of holding audiences have been minimal and quite marginal. The biggest change has been that he receives more people, as many as five hundred a year for private audiences. He only holds two receptions for the presentation of credentials from ambassadors; after the attempt on his life, he streamlined this procedure, preserving the meeting format but eliminating the reading of speeches, which are now exchanged in writing. After the 1994 operation on his femur, he introduced group audiences, where he jointly receives ambassadors from a group of nations. However, with *ad limina* visits from bishops, he has reinstated private meetings, which Paul VI had reserved for exceptional cases, choosing instead to receive together all the bishops from one country or region.

Left: the pope with Italian president, Oscar Luigi Scalfaro, and Rabbi Elio Toaff.

Right: Orthodox patriarch Bartholomew I's visit to the pope (June 27, 1995).

Following pages: ordination of bishops in the basilica of St. Peter's.

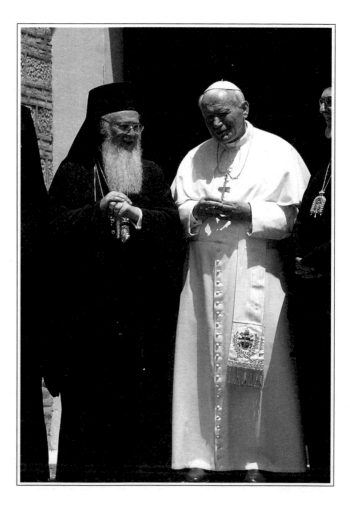

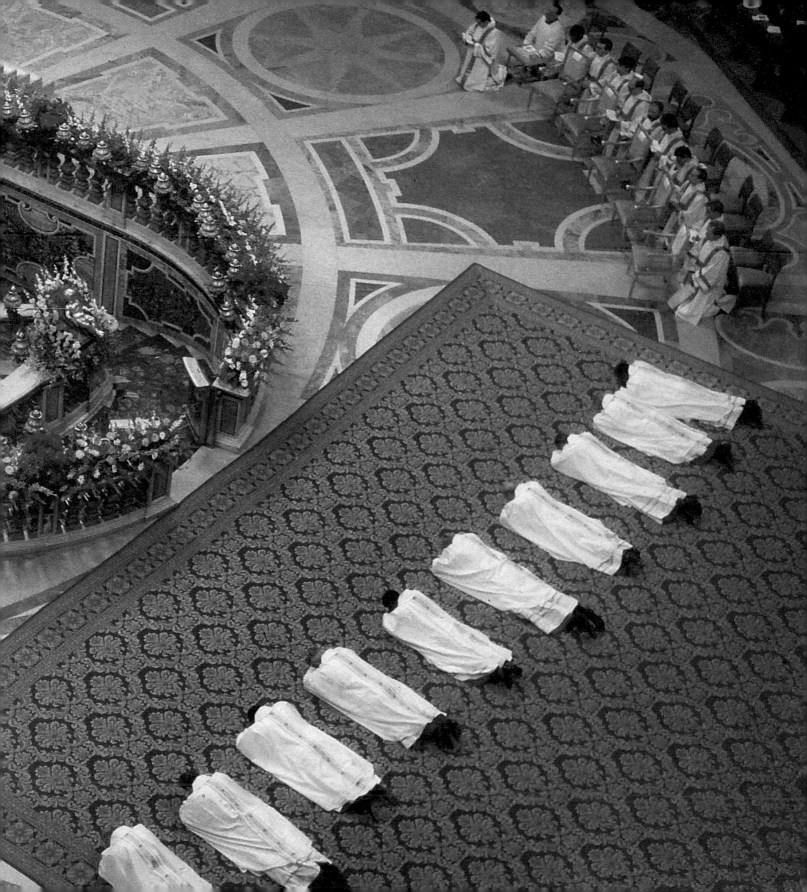

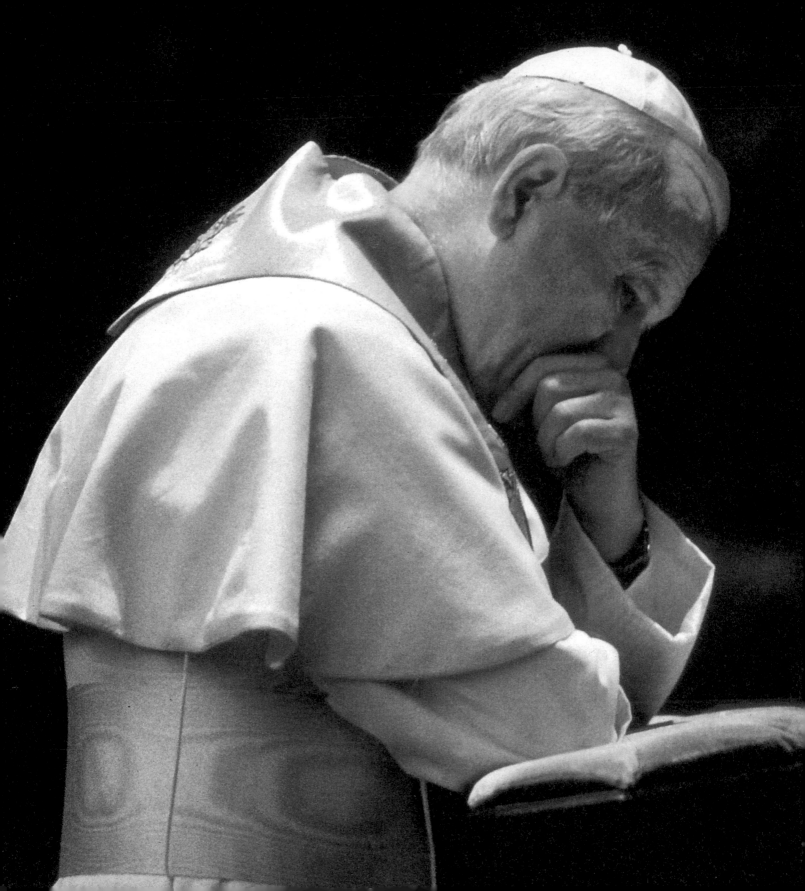

THE IMPORTANCE
OF THE PRIVATE
APARTMENT

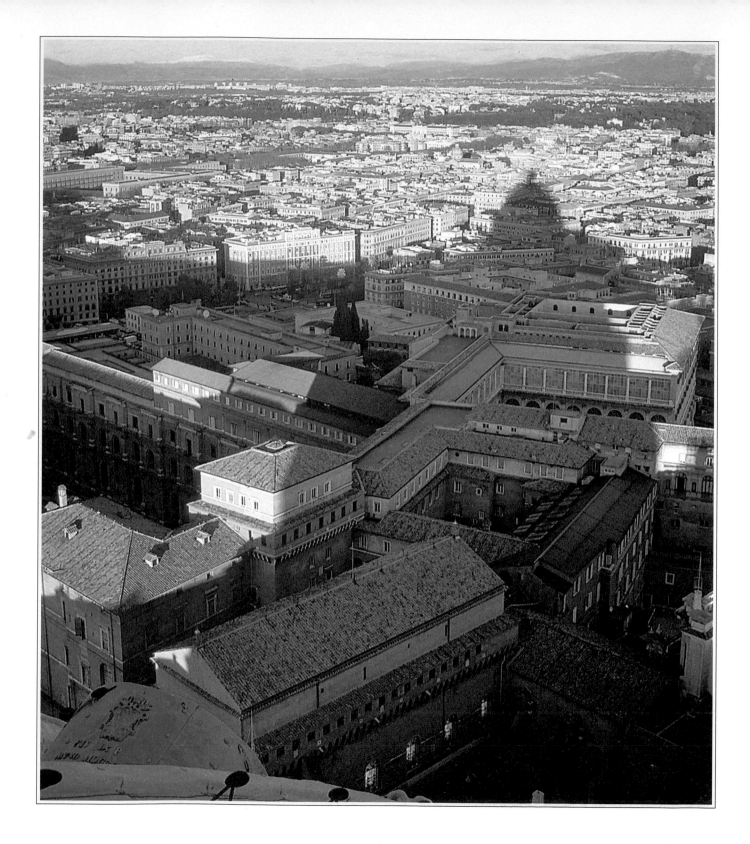

The true novelty of John Paul's private audiences is the continual flow of visitors between meetings on the third and fourth floors of the papal palace. Until the reign of Paul VI, there was a clear separation, as we have seen, between the two apartments, and only the pope and his secretary went from one floor to the other. Today however, the pope, moving from his private to public apartment and back again, frequently brings guests along with him, extending their time together. In this way, he confers the dignity of papal activity to the hospitality of his private apartment, which his predecessors had kept minimal, almost hidden. And his public meetings are likewise enriched with a convivial warmth.

Thus it might happen that the Ukrainian bishops, with whom he had celebrated early morning mass in the private chapel on the fourth floor, would meet with him at noon for an audience in the third-floor library, and they then might accompany him to lunch back on the fourth floor. Something similar happens with his visits to the parish churches of Rome, which have occurred 266 times as of this writing: on a Thursday he might have a late-morning audience with Cardinal Vicario, the auxiliary bishop of the region, and with the parish priest of the church he will visit the following Sunday. The pope invites them both to lunch, and as has now become customary, the two visitors escort each other there and inform the pope about the people and the setting he will encounter three days later.

The movement between the two apartments, so obvious to an outside observer, created astonishment and disapproval during the pontiff's early years at the palace, but he has gradually won people over. The "master" of the fourth-floor audiences, Father Stanislaw, has been accepted by the Curia in a way that was not possible for the secretaries of Paul VI (Father Pasquale Macchi, then an archbishop) and John XXIII (Father Loris Capovilla, who also became an archbishop), and the flow between the two apartments has finally become official. The Curia ratified this practice

The papal apartments in the shadow of the dome.

with the naming of Father Stanislaw to the rank of archbishop and "assistant prefect of the prefecture of the papal house" on February 7, 1998. United States Archbishop James Michael Harvey officially manages the third-floor audiences, while Archbishop Stanislaw Dziwisz manages those on the fourth floor. They work together to organize the audiences that flow between the two realms. When spokesman Navarro-Valls announced Father Stanislaw's appointment as archbishop and assistant prefect, he said he was "formalizing a function and duty that had been already in place for some time."

Having taken leave of his lunch guests, the pope rests for a half hour to an hour and then goes to the roof garden, above the apartment and overlooking the rooftops of Rome, for a breath of air. This garden, created during the time of Paul VI, has potted trees and a fountain, complete with fish. Every morning a gardener tends the plants, and the nuns periodically call upon the elevator operators to clean the fish-tank. The Vatican still does not have exclusively defined job descriptions!

Wojtyla—traveler and skier—loves to walk, even if only back and forth on the terrace. When he was stronger, he did this often, but he still continues to do so a bit each day. Speaking to a group of young people in Rome on April 7, 1995, he said: "The young are privileged because they have good legs; they can walk vigorously. But I try not to give in, and I, too, keep walking."

At the end of his walk, the length of which varies, the pope returns to his study where he remains, working in solitude, until half past six. At this time, every day, he is visited by colleagues of his secretary of state and, occasionally, other leading figures in charge of the Curia, such as the Bavarian cardinal Joseph Ratzinger, prefect of the Congregation for the Doctrine of the Faith.

Even if none of Wojtyla's innovations should survive him, his time on the throne of St. Peter has made an indelible impression. He has changed the papal image, moving closer to today's world and taking the papacy outside the Vatican, amid the conflicts of the world.

Fate has granted this spirited pope the support of two extremely prudent Italian cardinals,

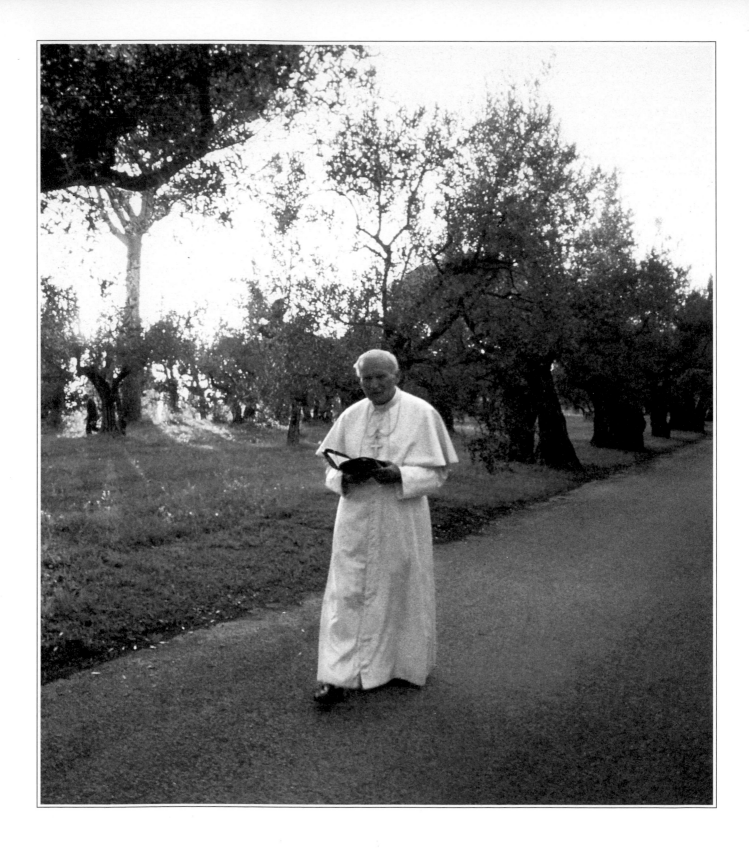

Casaroli and Sodano, as secretaries of state. Agostino Casaroli was with him for eleven years, from 1979 to 1990, and Angelo Sodano has been with him since then. In midafternoon, once a week, the secretary of state goes to the pope with a dossier on current events. The cardinal does not sit in the armchair in front of the pontiff's desk, as heads of state do in the private library, but instead sits to the side of the table, for he is a staff member, not a guest or on an equal footing. But the pope does not remain seated at his desk like someone of higher rank, instead he turns with a familiar gesture toward his secretary of state. Casaroli was six years older than the pope. Sodano is seven years younger, but the relationship is equally familiar and respectful.

Every day, the secretary of state, or Archbishops Giovanni Battista Re and Jean-Louis Tauran, his immediate coworkers, bring the pope meticulous and voluminous files. And it seems that John Paul II looks upon these papers with a certain suspicion. They say that John Paul I feared the documents from the Curia. John Paul II is afraid of nothing, but he tries not to spend too much time on paper work. He listens at length to his colleagues and questions them about various aspects of the issues they are presenting. He listens without taking notes. If he needs to write something down, the cardinal or archbishop has paper ready and waiting.

The pope has dinner at about eight o'clock. There are often guests, but less frequently than at lunch. At breakfast and at lunch, guests are generally from outside the Vatican. At dinner it is more likely that his companions at the table will be from the Curia. The Vatican spokesman, Navarro-Valls, is among those who regularly dine with the pope; he consults with the pope about the pope's activities, both in and outside Rome. He is perhaps the only layperson to play this role on an ongoing basis. The pope's advisors still do not include a woman.

If he has no guests, the pope watches the TV news during dinner. He might also watch part of a soccer match or a film that has been recommended to him.

"Your Holiness, will you be watching the Poland-Italy match tomorrow?" he was asked during a flight from Buenos Aires to Rome, on June 14, 1982. His response: "I don't know if I'll be able to, but the important thing will be to know the outcome."

He is a pope who watches and reads news about his own health. Once, during a flight from Rome to Havana, on January 21, 1998, Wojtyla responded thus to a question about his health: "If I want to know something about my own health, especially about my operations, I have to read the papers!"

After dinner, the pope returns to his study. Shortly before eleven, he makes his last visit to

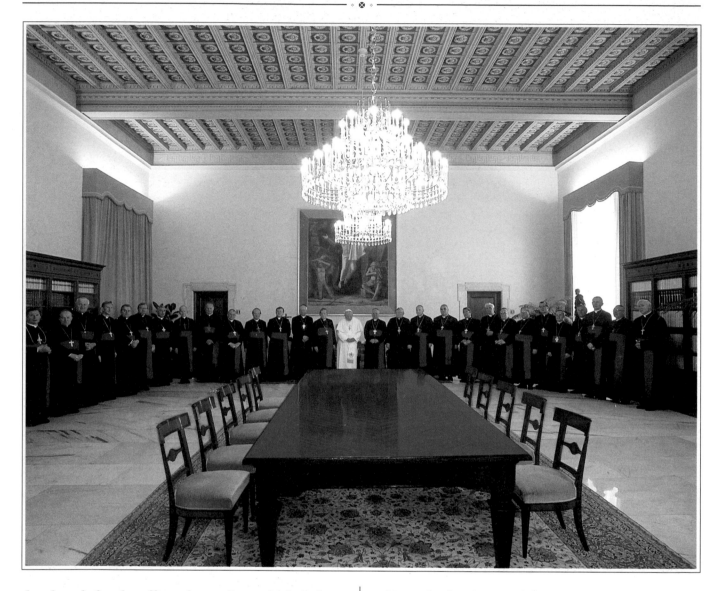

the chapel, for the office of compline, which is the nighttime prayer that concludes the Liturgy of the Hours, which it is said, he never misses.

But between morning mass and nighttime prayers, the pope often returns to the chapel. He goes there to take a break from his work in his study, as if to discuss current events with God, or when he learns of some dramatic news, or when he has heard about someone he wishes to place in his prayers. Then his attention is focused on the prie-

dieu, which, along with his chair, was designed by the sculptor Rudelli. Speaking in the Hall of Paul VI on October 27, 1995, the pope specified the

Above: audience with the Polish bishops in the private apartment of the pope.

Right: the recitation of the rosary at the microphone of the Vatican Radio.

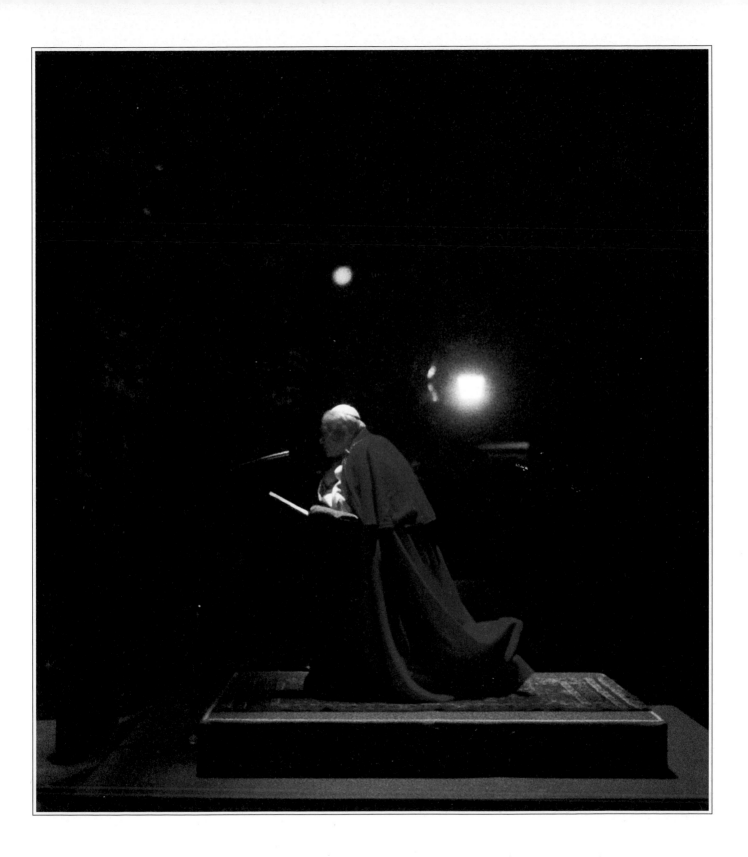

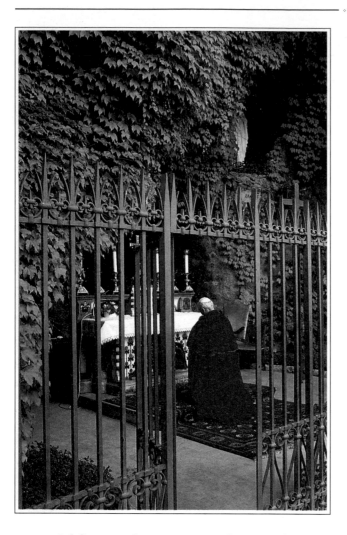

Left: at the grotto of the Madonna of Lourdes in the Vatican Gardens.

Right: the procession with candles for the festival of the Madonna.

With the exception of his travels and his visits to the parish churches of Rome, there are few weekly, monthly, yearly, or extraordinary commitments that alter the pope's day. He can leave his apartment to visit a cardinal who is ill or his friend, the Polish cardinal Andrej Deskur, who is confined to a wheelchair. Indeed, it was to pay a visit to Deskur in the hospital that Wojtyla first left the Vatican, the day after his election, October 17, 1978, immediately giving the impression that he would be a pope "on the move."

His best-known monthly commitment is the recitation of the rosary over the Vatican Radio, the evening of the first Saturday of the month. Usually, he does this from his apartment or from the St. Damasus Courtyard (and in the summer, from the courtyard of the Castel Gandolfo villa); on extraordinary occasions (to pray for peace during the Gulf War or during the war in the former Yugoslavia), he will speak from the Hall of Benedictions or from the Grotto of the Madonna of Lourdes, in the Vatican gardens.

At the Lourdes grotto, there is also a rosary with torchlight procession every May 31, in the evening, at the conclusion of the "Marian Mass." The candlelight procession begins at the church of St. Stephen of the Abyssinians, located behind the apse of St. Peter's, and moves through the gardens up to the hilltop grotto, at the beginning of the second section of the Leonine Wall, to the left.

The general Wednesday audience and the Sunday prayer from the window of his private study are the weekly appointments that put him in touch with the world. After the celebrations of mass in St. Peter's or in St. Peter's Square, the Sunday appearance at the window is the pope's activity that is most often followed by the media.

John Paul enjoys this dialogue with the crowd from his palace window; the custom began by chance with Pope John, and Paul VI seemed to

memorial function he entrusts to this prie-dieu: "I make note of the needs directed to me from people throughout the world, and I preserve them in my chapel, as I kneel down, for they are present at every moment in my mind, even when they cannot be literally repeated every day."

At around eleven at night, the pope retires. He doesn't stay up later, as did Pius XII and Paul VI; he eats well and sleeps well. When he was young, one could see his positive approach to life in his face. Even now, it is still apparent, and people continually ask the pope where he finds the energy for all his activities, despite the years, the shooting, the falls, and the tumor.

continue it more out of a sense of duty than spontaneous conviction. The distance from the crowd, which embarrassed the intellectual Montini, gives a surreal tone to the scene, as if the pope were a muezzin on a minaret. Once he joked about that distance, taking his cue from a sign raised above the crowd: "I read on the poster that the Gospel should be preached from the rooftops. Here it is not quite a roof, but the Gospel is being preached from the window, near the roof!"

The image of the pope looking out from this window, the most photographed and filmed image in the world, and his announcement that he will be going into the hospital have become part of our collective memory. "I would like to confide in you now; I will be going this evening to the Policlinico Gemelli, to undergo certain diagnostic tests." It was July 12, 1992; they found a tumor in his colon.

Even more vivid was the impression made by the illness that struck him at that same window, on Christmas day of 1995, during his message, *Urbi et Orbi* (To the City of Rome and to the World): "Excuse me, I must stop now. Benedicat vos Omnipotens Deus. Pater et Filius et Spiritus Sanctus."

The pope's resistance to illness has garnered him more sympathy than did his earlier image as a swimmer and skier. Even the Audience Chamber

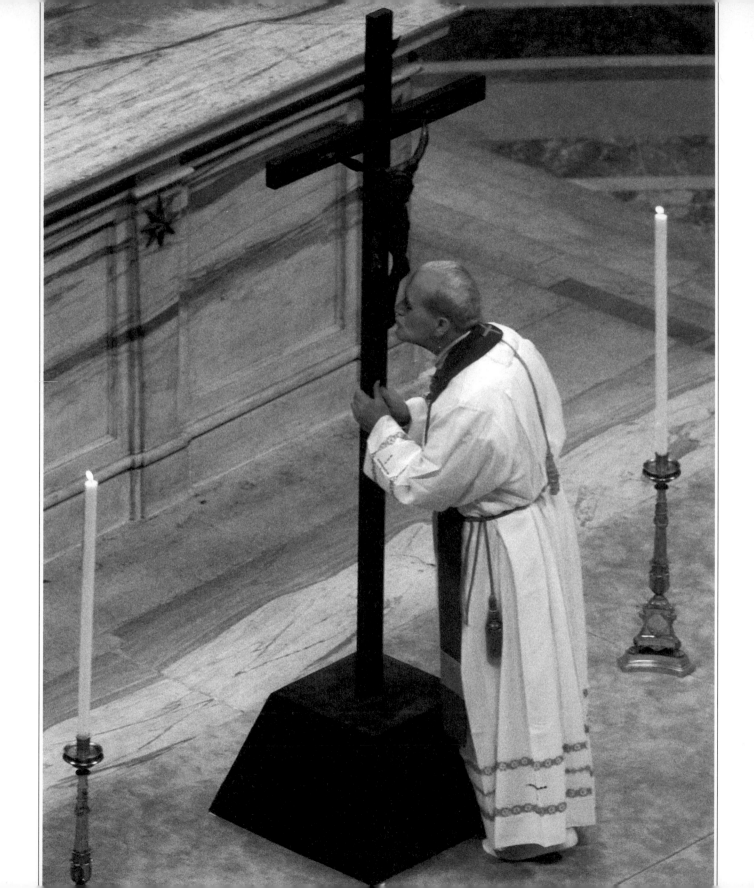

has often become a theater for this ability to communicate through suffering. More often, Wojtyla will be playful upon this stage, spinning his cane like Charlie Chaplin or raising it in a playfully threatening gesture. And it was from that room that he once said to a group of Poles: "You have done well to come to see how this pope looks. They say he is getting old and that he can't walk without a cane. And yet, somehow, still, still, still! His voice still holds up, and things aren't going so badly with his head either!"

A direct line from the papal apartment to the Audience Chamber is no more than 240 meters but to travel that distance without leaving the Vatican, the pope must take a circuitous route: he takes the elevator at the back of the apartment down to the courtyard of Sixtus V, and from there goes by car, through the St. Damasus Courtyard, the Courtyard of the Parrots, the Borgia Courtyard and the Sentinel's Courtyard, then travels along the road that winds behind the apse of St. Peter's Basilica, before finally descending toward the Hospice of Saint Martha.

General audiences follow the format established by Paul VI. They open with a Liturgy of the Word, followed by the pope's catechesis. Then some prelates of the secretary of state announce, in their various languages, the national groups that are present in the chamber, and the pope greets them, each in its own tongue. He is the first pope in this century who is a true polyglot. In addition to Polish and Italian, he speaks correct French and German, improvises imaginatively in Spanish and English, and manages to say something in Portuguese and the principal Slavic languages. He exhibits great linguistic virtuosity during his *Urbi et Orbi* messages at Christmas and Easter. On December 25, 1997, he wished people "Merry Christmas" in fifty-six languages, including Mongolian, Romany (the language spoken by gypsies), Turkish, Malay, Korean, and Esperanto!

We have described a typical day in the life of Pope John Paul II. But it is known that no pope of the modern era has passed so many days and nights outside his official residences. His trips, within Italy and abroad, have taken him far from home for over 715 days in twenty years.

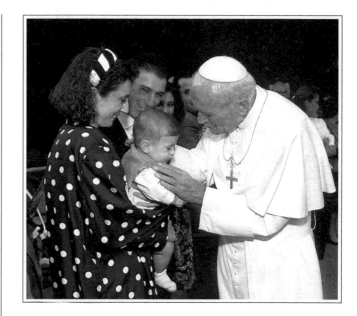

All popes have always needed to leave the Vatican and go to Castel Gandolfo, and they have done so as often as possible, but Wojtyla is the first who has needed to leave even Castel Gandolfo; indeed, in 1987, he came up with the idea of the papal Alpine vacation.

At first, he took a two-day trip to the Adamello Massif in July 1984 with his "friend", Italian president, Sandro Pertini. Photos were taken of the pope with his skis, and the news was out in Adamello before it reached the Vatican. New things are more easily said than done, and photographs of the pope skiing reached the newspapers before the *Osservatore Romano* found the courage to write, "The pope has gone skiing." Within the symbolic universe of the Vatican, ancient instinct dictates that images prevail over words.

During 1985 and 1986, the pope took quick trips, each lasting only a day, to the Abruzzi, once to Gran Sasso, again with his skis, and once to Majella, for a hike. The photos taken on this second occasion showed Wojtyla eating a bag lunch and sleeping beneath a tree, covered by a blanket.

These clandestine outings, about which no official notice was given, multiplied; it is estimated that he took more than twenty such trips over ten years, to the mountains of Lazio and the Abruzzi.

He began vacationing in the Alps in July 1987, spending fifteen days in Lorenzago di Cadore in the Veneto, where he returned again for two weeks in 1988, 1992, 1993, and 1996. Other years—1989, 1990, 1991, 1994, 1995, 1997—he has gone to Introd (in Aosta, near Mont Blanc).

Wojtyla's vacations outside Castel Gandolfo resemble his trips, or are interwoven with them, as when he has taken half-day vacations in the Tatra Mountains of his native Poland, or in the nature preserves of Canada, Kenya, Spain, and the United States. The human aspect of the pope's travels must not be underestimated—his desire to move about, be out-of-doors, see the world and its people.

Pope Wojtyla's boldest new gestures have been toward women: when he receives ten thousand nuns in the Nervi reception hall and spends a quarter of an hour between two walls of hands, all trying to touch him; when he leans over the terrace of the papal envoy's palace in San Jose in Costa Rica, clasping the hand of a female guitar player, who jumps up in the air to touch him; when he joins hands with an entire stadium of young people, as he did in Sydney, holding hands with two girls and singing along with them; when, at the sports arena in Genoa, he holds between his hands the face of a girl who has greeted him in the name of the thirteen thousand youths who are there and kisses her on the forehead, and then the girl approaches Cardinal Siri, a few steps away and down from the pontiff, and the severe octogenarian archbishop raises his hand and offers the twenty-year-old his ring to kiss.

John Paul kisses girls on the forehead, or hugs them to his chest, or takes some dance steps, holding the girls by the hands. He swims, skis, and goes on excursions, like a sports-minded grandfather. There is no doubt about it: Wojtyla has eradicated the papal image set in bronze, marble, and Latin communicated by his predecessors, and he has audaciously brought it closer to the everyday life of our era.

But we still don't have an entirely clear picture of what a day in the life of the pope is like: it is both active and constrained, isolated and full of contact; it is a compromise between the life of the "prisoner" popes and the relatively free life of the popes of past centuries.

Until the time of Pius IX, the life of the pope was active, and this active pace returned with John Paul II. But in the intervening period, throughout the reign of eight pontiffs, life was isolated more than ever, and for four of them—during the fifty-five years between the election of Pius X, in 1903, and the death of Pius XII, in 1958—it was totally frozen in time. One needs to resort to images of monks and vestal virgins of bygone times, or to Chinese emperors and Indian ascetics, to find human beings forced into isolation similar to that of Benedict XV and Pius XII, who ate every meal of their papacies alone and who passed entire days at their desks, forced into, but also adapted to, their isolation, which in the end became a tool of government.

It was not only the contentiousness with Italy that forced the popes into isolation. The "Roman question," as that dispute was called, turned the popes into "prisoners of the Vatican"; during that period, they didn't even venture out to the Lateran to take possession of their cathedral, nor did they go to Castel Gandolfo during the summer. Pius IX was also such a "prisoner" during the last stage of his papacy (which lasted some eight years), and Leo XIII was as well for his entire papacy, which lasted a quarter century (1878–1903), but neither of these two men adapted to the idea of a prison, and each devised ways of keeping his days as full as possible. The prisonlike conditions ceased midway through the papacy of Pius XI (1929), but both he and his successor, while they did resume leaving Rome to vacation at Castel Gandolfo, maintained the severe and isolated lifestyle that Pius X had endured and that Benedict XV had enjoyed.

Until Pius IX, that is, as long as "temporal powers" prevailed, the popes not only went to Castel Gandolfo in the summer, but also had a second Roman residence at the Quirinal Palace (which is now the residence of the president of the Italian Republic), celebrated mass periodically in the great basilicas throughout the city, made excursions and pilgrimages to the surroundings outside Rome, and, in Rome, received visits from

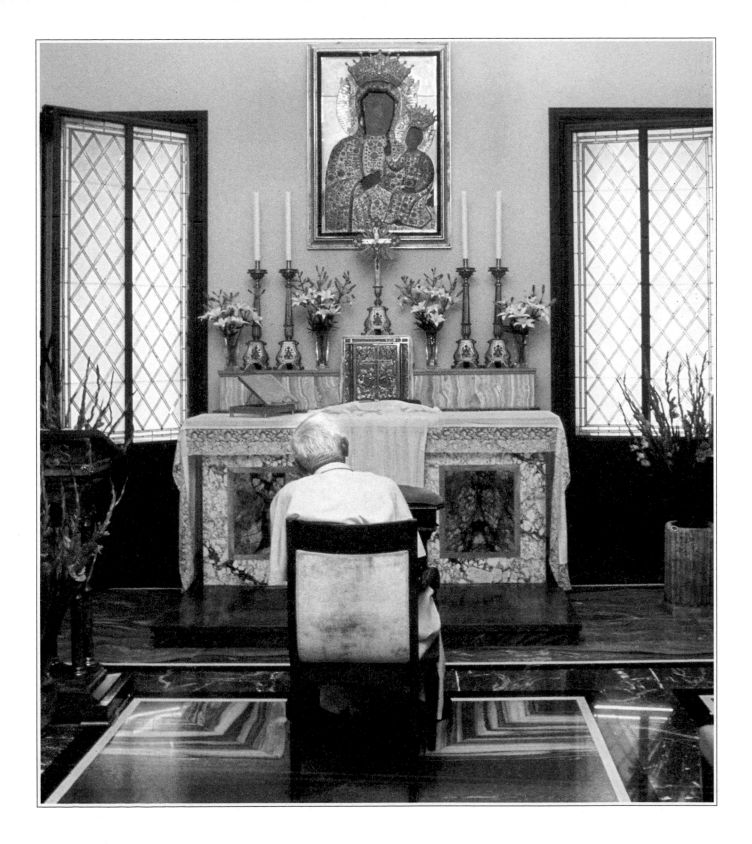

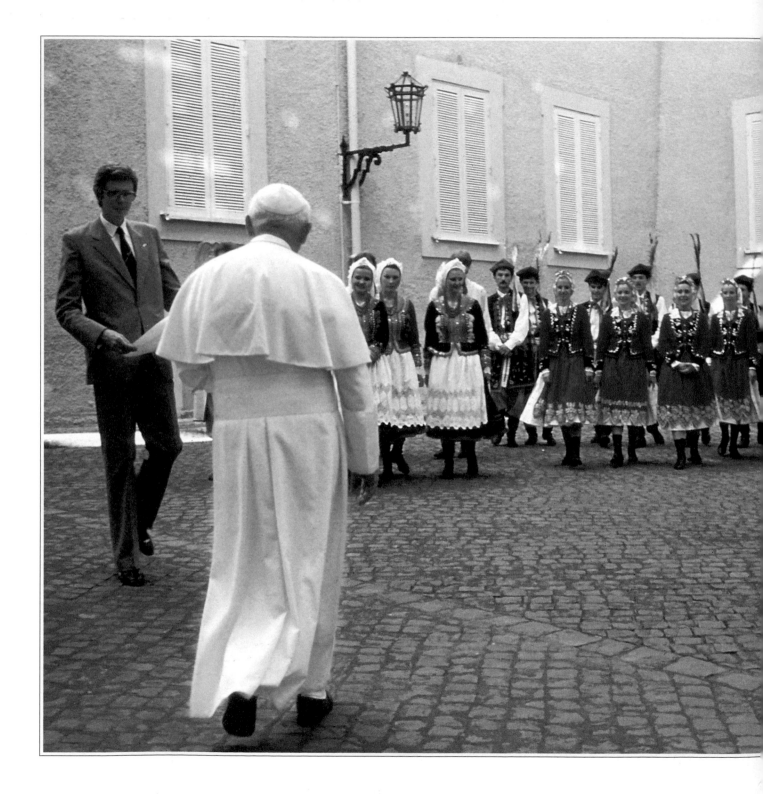

prelates and great families. For those who enjoyed it, and Pius IX was among them, there was also the tradition of taking carriage rides on the Pincio and going for walks through the streets.

These possibilities for movement ceased with their being closed off in the Vatican. But it is one thing to live permanently in an apartment, as Pius X and Benedict XV were forced to do, and it is quite another to make generous use of the various Vatican settings and gardens, which is how Leo XII mitigated the cloistered state that he found unacceptable.

A passionate hunter accustomed to returning often, even when he was a cardinal, to his native Carpineto (a town in the Ciociaria region, eighty kilometers south of Rome), Pope Pecci did not resign himself to the life of a recluse and took advantage of his large garden as much as possible. Leo XIII rode his carriage in the gardens, took walks, hunted (that is, he observed the hunt with nets held by a "pope's hunter"), and even "vacationed" there. The tower, now the headquarters of Vatican Radio, was outfitted as a holiday residence and Leo stayed there, day and night, for months at a time.

While there have been tremendous changes with respect to the past, the pope's ordinary day still remains closed off in two apartments in a palace high above the world, and in a garden, even higher up, that overlooks the rooftops of the city. On July 11, 1997, while on vacation in Lorenzago di Cadore, Pope Wojtyla made the following pithy observation, comparing the closed world of the Vatican with the open horizons of the mountains: "You have to know that prison in order to appreciate this freedom!"

Today's popes escape more often from their walled city, but they leave their palace less often. They used to go outside to walk in the gardens, an activity that was particularly enjoyed by Pius XII. John was the last pope to do this. The custom of keeping everyone at a distance from the papal path embarrassed Paul VI, who preferred the rooftop gardens.

Folk dancers from Cracow in a performance for the pope.

There have always been vague tales about the pope's unexpected or incognito excursions. The latest one was told by Lino Marzioni, a sort of "water bearer" of our own era, who drives his van into the Vatican once a week, distributing cases of mineral water to his customers, one of whom is the pontiff.

He unloads his cases in front of a small door in the turret of Nicholas V (near the Porta Sant'Anna), and a nun comes down to get them. He has been doing this since 1973.

One day when he was waiting there, leaning against the wall, Marzioni saw the elevator open up and he thought he glimpsed the nun's white robe; he raised his eyes and saw the pope. Not knowing what to do, he stood at attention; the pope smiled at him and gave him a pat on the shoulder.

Lino Marzioni swears he saw the pope exit and walk around alone, along one of the Vatican's narrow lanes, toward the house of a bishop who was recovering from an operation. Marzioni can't say if this was before or after the attempt on the pontiff's life, but he is sure that the pope was alone.

Once the Vatican had its own water bearer and its own vegetable bearer. The former delivered little bottles of drinking water, brought in on a donkey, to the Vatican residences; the latter went around every day, to all the apartments, laden down with baskets of greens gathered from the Vatican kitchen gardens, and he would distribute these according to people's tastes and depending on availability.

The Vatican has always been a place of great thrift. During wartime, salad was grown in the courtyards, and even today, the nuns and sisters of prelates try to sell back to Lino Marzioni the bottles of wine that they cannot bring themselves to dispose of as throwaways.

It is a place of thrift and also a place where life is unexpectedly simple, inhabited by people we are accustomed to seeing only in official ceremonies. When he resided there, the American archbishop Paul Marcinkus used to go in person to fetch his cases of mineral water from Marzioni's van.

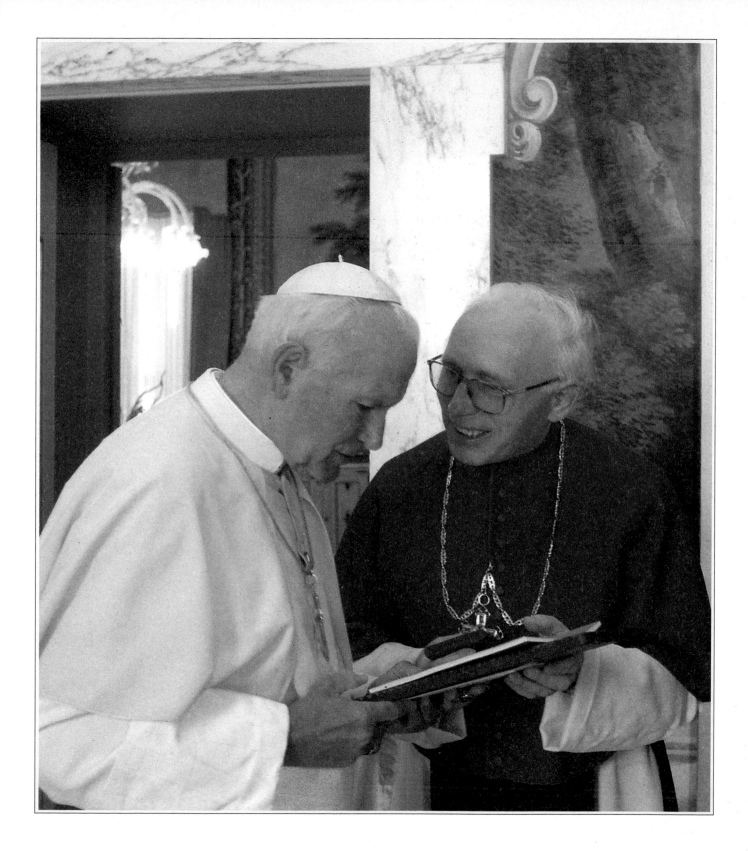

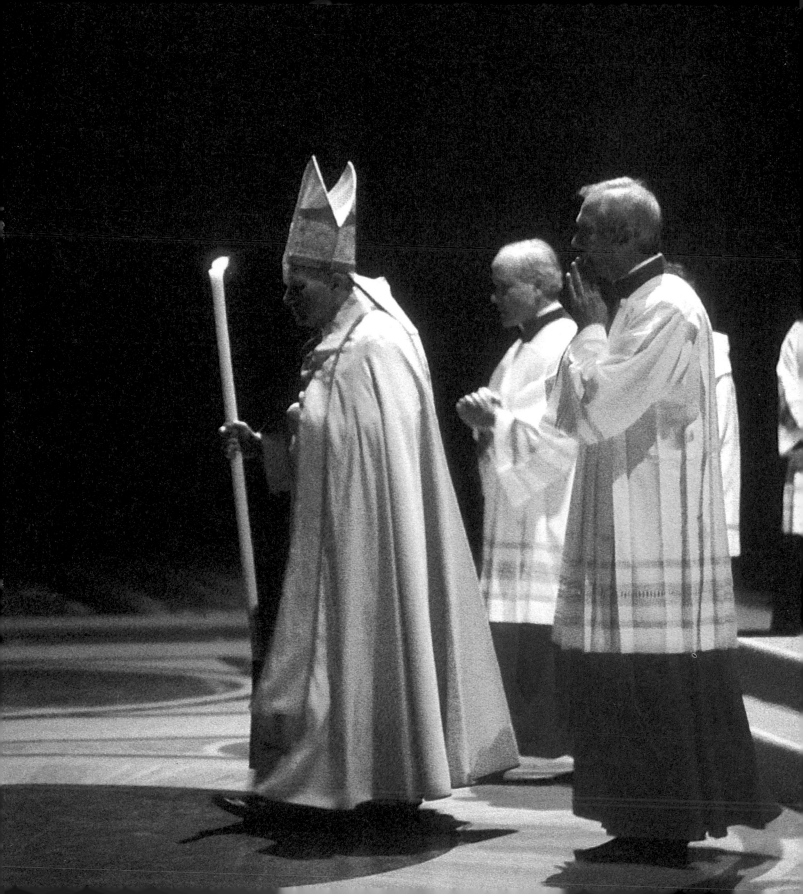

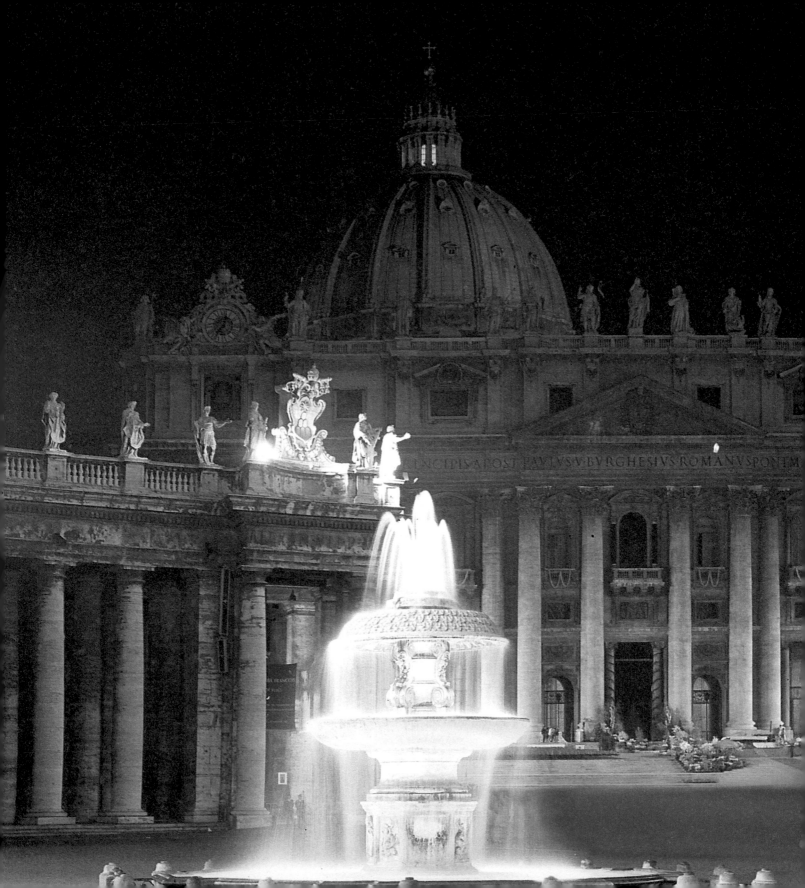

FROM THE COURTYARD OF ST. DAMASUS TO THE POPE'S LIBRARY

Pilgrims go to the Vatican to see the tomb of St. Peter and to see the pope. Guests of state go there to meet with the supreme pontiff. Tourists go there for a variety of reasons, above all for the museums.

The average pilgrim sees the pope at audiences and celebrations of mass, in St. Peter's Square or the basilica. But guests meet with him in the Apartment for Audiences, on the third floor of the papal palace. Heads of state and governments are received there, as are ambassadors who present their credentials and bishops on *ad limina* visits, but so are ecumenical guests, cultural figures, stage personalities, and groups that request and obtain a particular audience: from the board of directors of a company in which the Vatican holds a group of shares to a soccer team to performers from a circus. This chapter describes the experience of such guests of honor.

Whether they arrive on foot, through the bronze doors, or by car, through the Arch of the Bells, every guest of honor's first Vatican appointment takes place at the courtyard of St. Damasus, in the drawing room of honor of the papal residence, where all state visits begin. One hopes for good weather because the famous Roman light is particularly enchanting as one looks up to the stained-glass windows that enclose that magical cubic space on three sides; the fourth side faces the sun. I know of only one other architectural space that can transport you in this way: the cloister of the upper basilica in Assisi, a world of stone detached from earth.

As the chosen locale of the ceremonial papacy, this room of glass tolerates no intruders. On December 23, 1967, the windows of the third and highest loggia were shattered by the powerful blades of a helicopter of United States President Lyndon B. Johnson. His visit had been greeted by anti-American demonstrations against the war in Vietnam, and in order to avoid this in the Vatican, it was decided that his helicopter should land in St. Peter's Square. It would be another ten years before the Vatican would have a heliport, at the top of the gardens.

The Vatican strictly adheres to diplomatic formalities, which isn't surprising, given its own emphasis on ritual. But its ambassadors are called nuncios and wear cassocks, and they don't kiss women's hands but offer their own to be kissed; these are differences that serve to delineate a distance from worldly affairs, without diminishing their attention to diplomatic relations.

The "solemn audience" with which the pope receives new ambassadors who come to present him with their credentials is the visiting card of papal diplomacy. The protocol is as follows: "His Excellency, the Ambassador" is "called for at his residence by an Attendant and by two of His Holiness's Chamberlains"; he is thus accompanied to the courtyard of St. Damasus, where "a unit of the Swiss Guard pays their respects. At the elevator landing, His Excellency the Ambassador is received by a Chamberlain of His Holiness and, immediately thereafter, ascends to the second Loggia, where he is met by the Attendants and the Chair-bearers. From the second Loggia, the procession is directed to the Clementine Hall, where the Ambassador is received by the Prefect of the Papal Residence, who accompanies him to the private Library. The Prefect presents the new ambassador to the Holy Father, and "after an exchange of speeches," there is a "private meeting"; the ambassador then visits the secretary of state before "descending into the Vatican basilica" to visit the Chapel of the Sacrament and the tomb of St. Peter. Finally, before leaving the basilica, the ambassador goes to the Door of Prayer, where he takes leave of the dignitaries who have accompanied him and returns to his residence.

"Door of Prayer" is another extremely beautiful name for the Door of St. Martha, which goes from the basilica to the Piazza Santa Marta. The ambassador arrives here, stunned by the splendor of the St. Damasus Courtyard, the Clementine Hall, the ten rooms he has passed through, and, obviously, St. Peter's. After that reception, His Excellency, who might even have accepted the ambassadorship to the Holy See as a sinecure, thereupon promises himself that he will take every word said to him in those halls and on those staircases with the greatest seriousness.

An official visit from a head of state is similar,

The courtyard of St. Damasus seen from the third Loggia.

but obviously more solemn. Protocol requires that the descent into the basilica proceed as follows: "A procession is formed that, having passed through the Royal Palace Hall, descends the Royal Palace Staircase as far as the equestrian statue of Constantine and enters the atrium of St. Peter's Basilica."

The halls of the papal palace are many in number and are chosen for various audiences on the basis of the number of people to be accommodated, or with an appropriate symbolic intention related to the name of that space, or the furnishings, or its traditional use.

For example, a meeting between the pope and "the most eminent cardinals, the papal family, the Curia, and the Roman Prelature, for the presentation of the Christmas greetings" takes place in the Clementine Hall. This is the hall for grand occasions, and it is reached directly from the large staircase of the Sistine Palace. In this hall, popes used to receive the aristocracy and Roman nobility for New Year's greetings. They were received there for the last time by Paul VI, on January 15, 1964, when the pontiff urged them to acknowledge that times had changed: "As you well know, we are no longer the secular sovereign around whom, in centuries past, the social ambiance to which you belong used to gather." Here the pope now receives ambassadors for "group presentations" of their credentials; on December 18, 1997, for example, the ambassadors from Togo, Eritrea, Norway, Sri Lanka, and Benin were there to be presented.

At times the public seems unsuitable to this

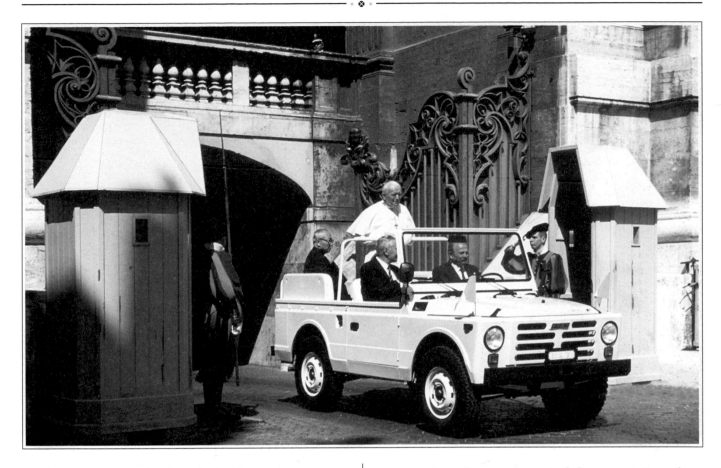

space, and it might be that the hall was chosen out of convenience, to avoid having the pope move very far, or to utilize a hall already arranged with chairs. And so "a representative of Azione Cattolica Ragazzi" or "the managers and athletes of the Atalanta soccer team" might be received in the Concistory Hall, which is as ancient as the Clementine Hall, adjacent to it and only slightly smaller, its name indicating its assignment for meetings of the pope with cardinals. But official assemblies, or concistories, are obviously also held in the Concistory Hall.

Special guests might be accompanied to see places in the Vatican that are usually off-limits. One such visit took place on December 4, 1997, with "His Excellency Raul Castro, first vice president of the State Council of Cuba" and brother of Fidel Castro. This took place during an extremely delicate moment of the negotiations for the pope's visit to Cuba in late January 1998, but it was said that the visit was "private" and due to Raul Castro's "desire" to "see some of the Vatican sites." No one believed this, and the Vatican spokesman then made an official announcement: "Tomorrow afternoon a visit is scheduled to the excavations and to the Vatican basilica. Therefore, passing through the courtyard of St. Damasus, His Excellency Raul Castro will visit the Royal Palace Hall, the Ducal Hall, the Pauline Chapel, and the Sistine Chapel."

Within these spaces of such great solemnity and ritual, John Paul is capable of incredible freedom of gesture. News accounts refer to the generosity with which he accompanied his "friend" as far as the courtyard of St. Damasus, something, it would seem, that no pope has ever done with any guest.

But something even more unusual happened with Lech Walesa, during his visit of April 21, 1989, when the pope repeatedly embraced the Polish leader for the benefit of journalists, photographers, and cameramen. As Walesa entered the pope's private library at 12:45 P.M., and knelt before him, Wojtyla had him rise and brought him outside in front of the photographers, saying, "We need to show them how Mr. Walesa greets me and how I welcome him!" At these words, Walesa fell to his knees once again, and the pope had him rise once more, and embraced him yet again.

Just think that at one time visitors had to kiss the pope's feet and were not allowed to speak to him! Here is an ironic account of that ritual, told by Michel Eyquem de Montaigne in *Italian Voyage*, referring to the day of December 29, 1580, when he paid a visit to Gregory XIII: "Having taken a step or two into the room, in a corner of which the Pope is seated, those who enter—whoever they might be—touch a knee to the ground and wait for the pontiff to give them a blessing, which, in fact, he does; then they rise back up and advance toward the middle of the room. . . . They kneel down again and receive the second blessing; this accomplished, they move toward him, in a line, as far as a plush carpet extending out for seven or eight feet before him, and they stop to kneel down at the edge of this carpet. At this point the ambassador being presented bent down and lifted up the Pope's garment from his right foot, which was clad in a red slipper adorned with a white cross. Those kneeling stayed in that position as they approached, in turn, the Pope's foot, then bent down to kiss it. Mr. Montaigne related that he had slightly lifted the end of His Holiness's foot."

Montaigne had a secular spirit, but there were even saints who found the prohibition against speaking to the pope to be extremely odd. This is how Theresa of Lisieux rebelled against this rule when she visited Rome (1887), as described in her autobiography: "Leo XIII was seated on a large armchair. . . . Around him stood cardinals, archbishops and bishops; as we passed before him in a line, each pilgrim kneeled down in turn, kissed Leo XIII's foot and hand and received his blessing; two noble guards then touched the pilgrim, according to custom, thereby indicating that it was time to rise. I turned toward my dear Celina, to see what he thought: 'Speak! he told me.' A moment later I was at the feet of the Holy Father; I kissed his slipper, he offered his hand, but instead of kissing it, I clasped it in my own and turned my tear-bathed eyes upward toward his face, exclaiming: 'Most Holy Father, I have a great favor to ask of you!' The Holy Father's goodness encouraging me, I wanted to speak further, but the two noble guards touched me politely, having me rise; seeing that that wasn't enough, they took me by the arms and forcefully brought me away from his feet."

Under Paul VI the Apartment for Audiences, which used to be called the Noble Apartment

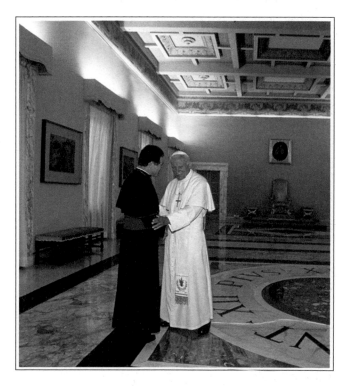

Left: the statue of Charlemagne.

Above: the pope in an audience with a bishop in the Hall of the Swiss Guard.

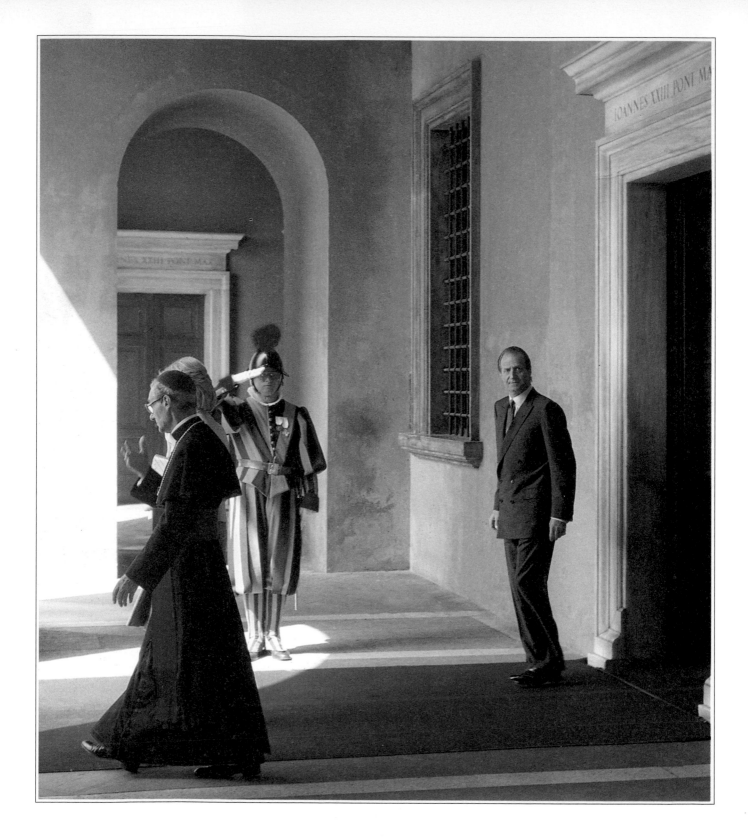

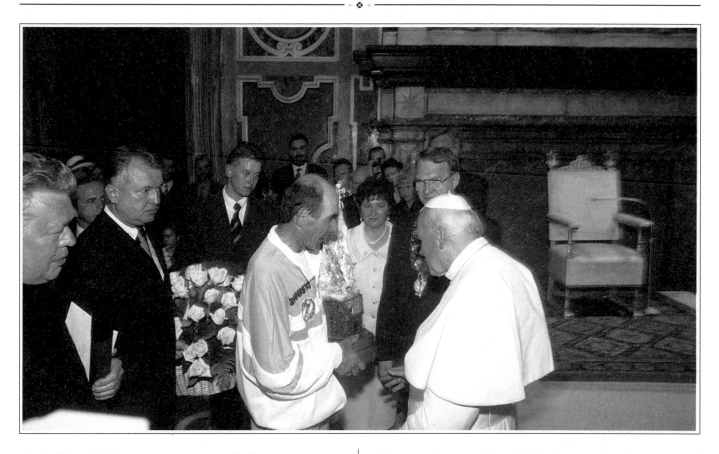

of the Papal Palace, was renovated. Its rooms, which the visitor passes through like a horseshoe-shaped corridor that leads up to the pope, have had a change in decor and in name. These restorations have updated the ambiance, in an attempt to adapt it to the image of the church after Vatican II. The anachronistic pomp has been removed and statues and paintings, both ancient and contemporary, have been added, conveying a more direct message.

During the years when Pope Montini had the apartment renovated and abolished the court and the armed papal troops, a faithful but intractable theologian, Hans Urs von Balthasar, who was

Left: the visit of the King of Spain, Juan Carlos I.

Above: the pope's birthday.

later made a cardinal by John Paul II but died (in June 1988) before receiving his red cap, formulated a more radical proposal: "Actually, it would perhaps be logical if the pope were to transform the Vatican into a museum and if he were to move outside the gates, into Rome. This could be a sign, one of many already given by Paolo VI" (*Punti Fermi*, 1971).

I believe that Paul VI's response to this objection led him to give numerous "signs," including the renovation of the apartment. What is "important," Balthasar had further written, is not the sumptuous or spare surroundings of the papal residence, but that the "apparent grandeur of its structures seems to stay within their true limits." And certainly things are better today than they used to be. We have gone from popes and papal courts who believed in all the pomp to popes and courts who feigned such belief to the

modern popes—popes of conciliatory reforms, John, Paul, and John Paul—who don't believe in the anachronistic trappings, who say so and who have adapted to living amid that apparent grandeur as a sort of obedience to tradition.

And so there are signs of reform that can be seen, such as the abolition of cardinals' trains (which even Pius XII had reduced from twelve to three meters in length), the giving up of the papal tiara and the coronation, the prohibition against having the *Osservatore Romano* refer to him as "the Holiness of Our Lord," and the suspension of the fans and drawn sabers that used to accompany the pope during the liturgy.

The Clementine Hall no longer has the monumental chandelier that used to be a source of pride, and the removal of which saddened many admirers. It has been described as "that vast chandelier that hangs down at the center, from the allegorical scenes on the ceiling" (Silvio Negro).

The Hall of the Chair Bearers has become the Antechamber: here, the chair bearers, that is, the men who used to carry the pope on their shoulders as he sat in his gestatorial chair, used to welcome visitors and pass them on to the

Below: the Royal Hall.

Right: the Cortile della Pigna with Arnaldo Pomodoro's sphere in the foreground.

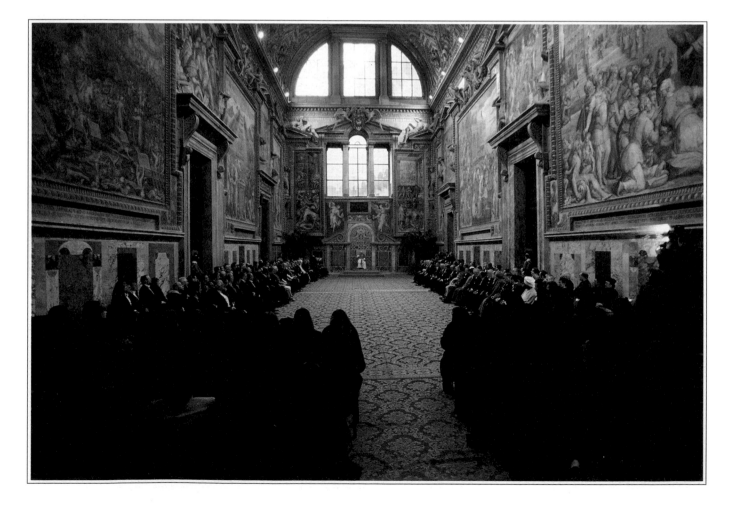

bussolanti, the litter bearers (from *bussola*, the wooden main door that led into the "palatine halls," in other words, into the rooms of the palace), who would accompany them for the rest of the way. Now there is no *bussola* and there are no *bussolanti*. The chair bearers have remained, but, since John Paul II has done away with the use of the "gestatorial chair," they are limited to welcoming guests.

The Hall of the Gendarme has become the Hall of St. Ambrose, and a Swiss guard stands there, day and night, with his halberd. The old name referred to the gendarmes in full dress uniform, with their bearskin helmets and high boots, who used to welcome visitors here during audience

hours. The new name comes from a fifteenth-century wooden statue of St. Ambrose, archbishop of Milan. The choice of name is a sign of Pope Montini's background, since he was archbishop of Milan before being elected pope.

The Corner Hall has become the Hall of Sculptors; its previous name came from its configuration, with windows facing out on two sides, and its present name refers to the presence of works by Francesco Nagni, Francesco Messina, Lello Scorselli, Giuseppe Pirrone and Enrico Manfrini, all twentieth-century Italian sculptors. "For the first time, after a great many years, the decoration of the official rooms has incorporated the work of contemporary artists" (Romeo

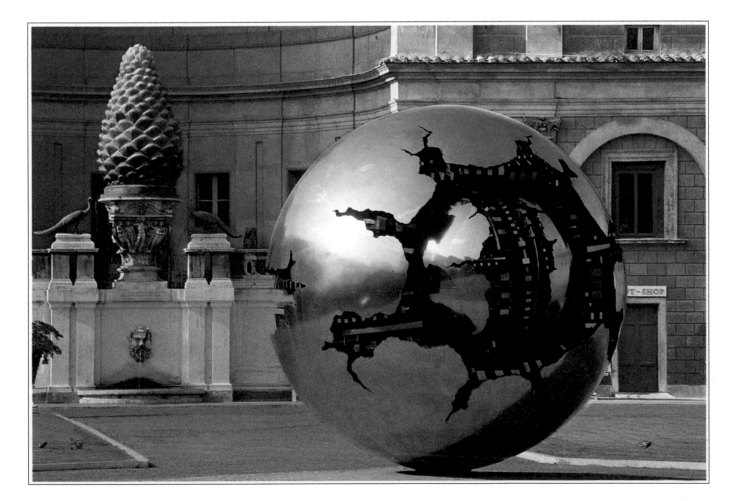

Panciroli), and this is also true for the corresponding Hall of Painters.

The decision to open the Vatican to contemporary art was preceded by an official announcement by Paul VI in the Sistine Chapel on Ascension Day, 1964. At this time, the renovation of the Apartment for Audiences had already been entrusted to Dandolo Bellini, an architect and decorator from Milan. "We need you," Pope Montini said to the artists on that occasion. "Our ministry needs your collaboration, for as you know, our ministry is to preach and to make the world of the spirit—the invisible, ineffable world of God—accessible and comprehensible."

With this pronouncement and with the simultaneous decision to bring risky, contemporary art into the Vatican, Paul VI was going back to the great pontifical tradition that

had been abandoned during the last two centuries, during which it seemed as if the church could no longer understand the language of its time.

The "Hall of Tapestries" has become the "Hall of the Popes" and contains a superb sculpture of Boniface VIII by Arnolfo da Cambio, which had been in the old St. Peter's basilica and afterwards in the Grottoes. Before Pope Montini's reforms, this hall was occupied by on duty officers from the Swiss and Palatine Guards. The following hall, instead, was reserved for the troops of the Noble Guard.

The "Hall of the Noble Guard" became the "Hall of Painters"; Silvio Cosadori, Floriano Bodini and Luigi Filocamo were the artists chosen by Paul VI's advisors, among whom the Milanese

Below and right: the reception of the ambassadors.

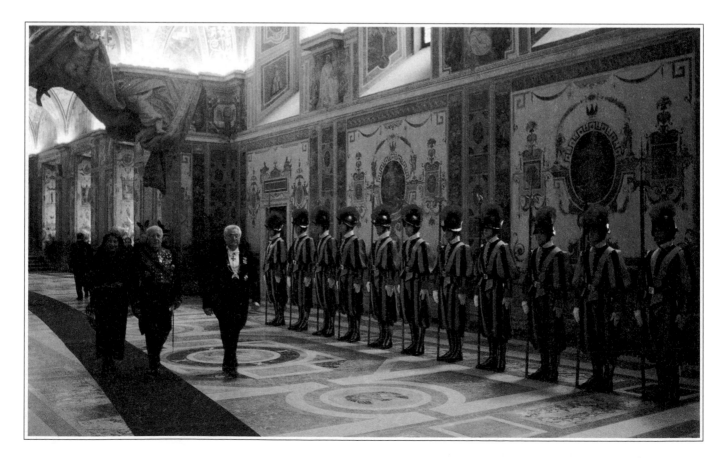

secretary, Don Pasquale Macchi (later prelate Archbishop of Loreto) played a decisive role.

The renovation of the Apartment for Audiences suggests a visual itinerary through the Vatican, one with a contemporary art slant. It might begin with the doors of St. Peter's basilica, four of which are by contemporary artists, then continue with new works of art in the basilica and the Grottoes: the monument to Pius XII by Francesco Messina and the monument to John XXIII by Emilio Giaroli in front of the statue of Saint Peter.

The tour would continue in the Hall of Audiences by Pierluigi Nervi and the sculpture *Christ Resurrected* by Pericle Fazzini, which enlivens the space. "For me, this sculpture was a great prayer," the artist said when the piece was inaugurated. A contemporary art tour of the Vatican would also include the Pope's Chapel, on the fourth floor of the Papal Palace (described in the chapter on the pope's day), the halls of sculptors and painters in the Apartment for Audiences, which were previously mentioned, and the renovation, under John Paul, of the Matilde Chapel on the third floor. The chapel has been renamed the "Redemptoris Mater Chapel" and contains sculptures by Fazzini and stained-glass windows by the Hungarian artist Hajnal, who also signed the windows in the Hall of Audiences. Our itinerary would then lead to the "Collection of Modern Religious Art," which is part of the Vatican Museum and to Arnaldo Pomodoro's *Sphere within Sphere*, located in the Cortile della Pigna.

The "Hall of the Throne" is now the "Hall of the Evangelists." The gilded papal throne has been replaced with one more sober, which echoes

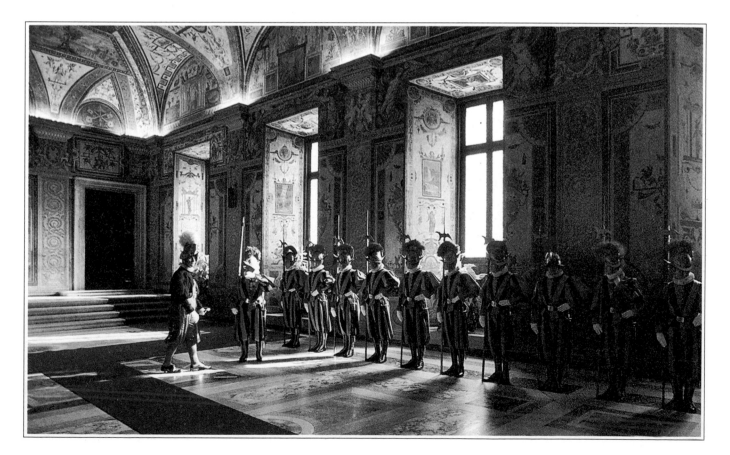

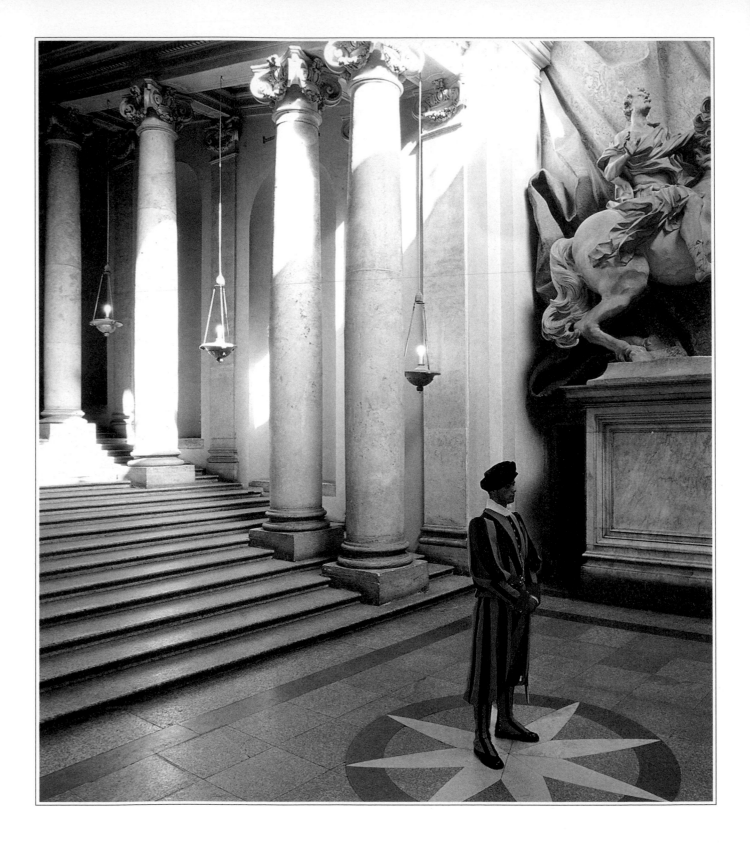

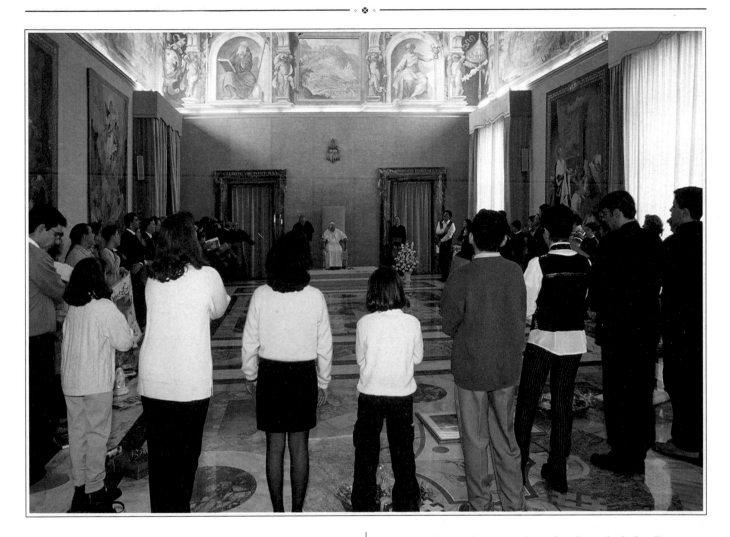

Left: the Royal Hall.

Above: The Hall of the Concistory.

the shape of ancient thrones and is flanked by two large corbels, from the grottoes and the ancient basilica, which represent the apostles Peter and Paul. The new name of the hall is derived from the statues of the four Evangelists, located along the walls to the side of the throne. These statues also come from the ancient basilica. In front of the throne is a stone table resting upon a Romanesque pelican. On the table is a fifteenth-century Bible. The strong symbolism is obvious: Bible and Evangelists, the apostles who founded the Roman See and the throne. Unlike the previous arrangement of the hall, the throne is not dominant and unique, but one element within a harmonious unity that encompasses and supports it. The symbolic whole is then witnessed by statues, stones, and a Bible that are more ancient than the baroque throne that used to dominate the space alone, and that gave its name to the hall prior to Montini's reforms. This look backward also has significance and refers to a tradition that is more ancient than the one it immediately replaced.

The "Privy Antechamber" has become the

"Hall of the Redeemer." At the threshold of the privy (meaning "private") antechamber, during audience hours—that is, when the pope was in the Library—there used to be a member of the Noble Guard with a bloodied saber. It was obvious that his presence was no longer desired by a pope who had come to question even the propriety of his own pontifical garments: "Wouldn't a poor fisherman's or pilgrim's mantle," Paul VI once asked, "perhaps give a more faithful and accurate image of Peter than the one evoked by the Pontifical mantle donned by his successors?"

The "Hall of the Popes" has become the "Hall of the Madonna," and the "Hall of Saint John" has been re-baptized the "Hall of Saint Catherine," which is the office of the prefect of the Pontifical House, the prelate in charge of audiences. It was in this hall that Leo XIII "slept and took his meals" (Silvio Negro) before, under Pius X, the private apartment was set up on the fourth floor, which has been ever since inhabited by all the popes of this century.

The "Hall of the Small Throne" has been renamed the "Hall of Saints Peter and Paul" and here too, as in the Hall of the Evangelists, at the threshold of the papal library, the significance of the new name and new furnishings is obvious.

Right and below: the Hall of General Audiences designed by Pierluigi Nervi; the bronze Christ is by Pericle Fazzini.

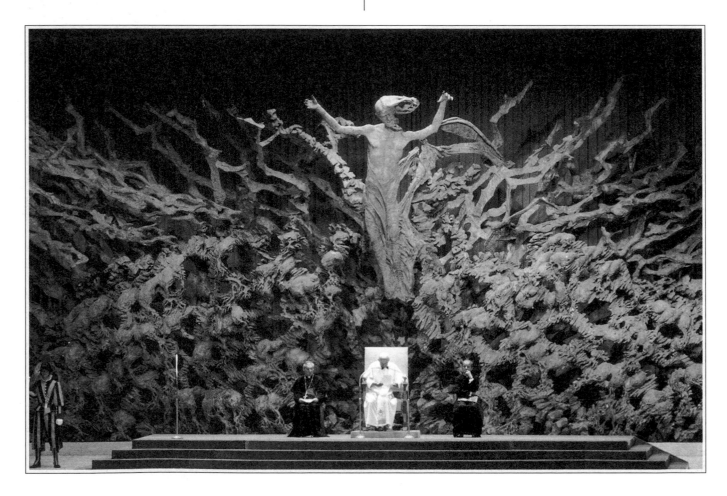

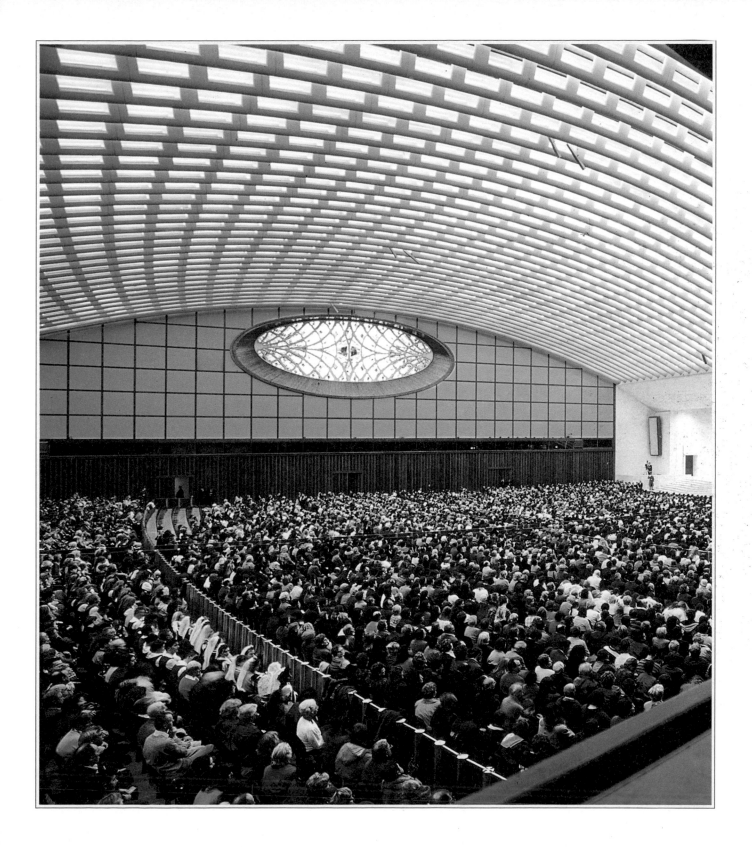

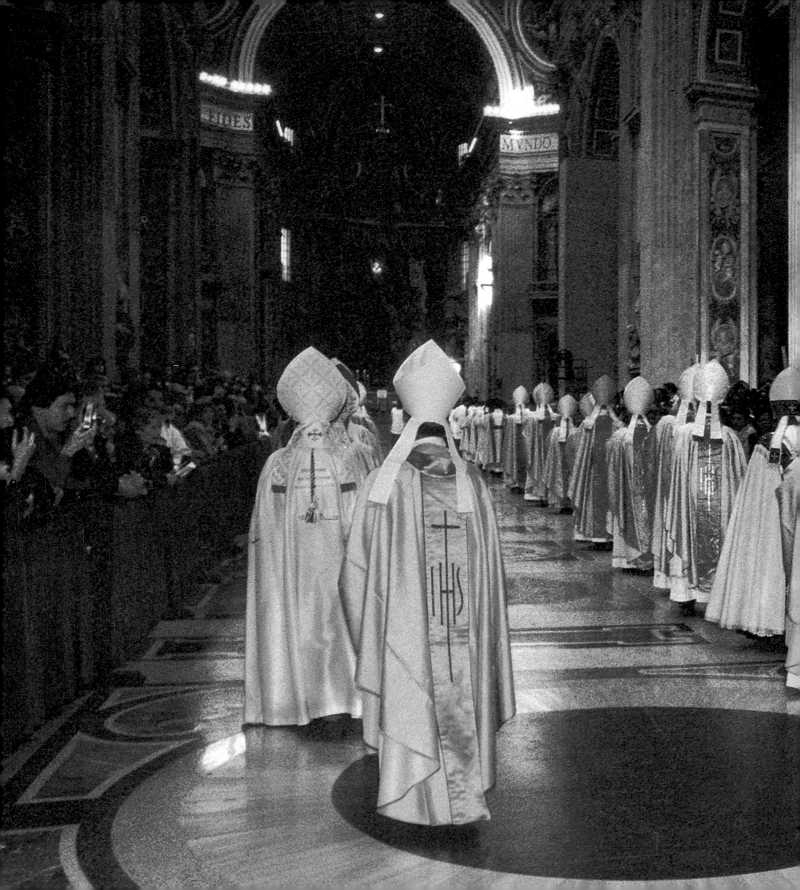

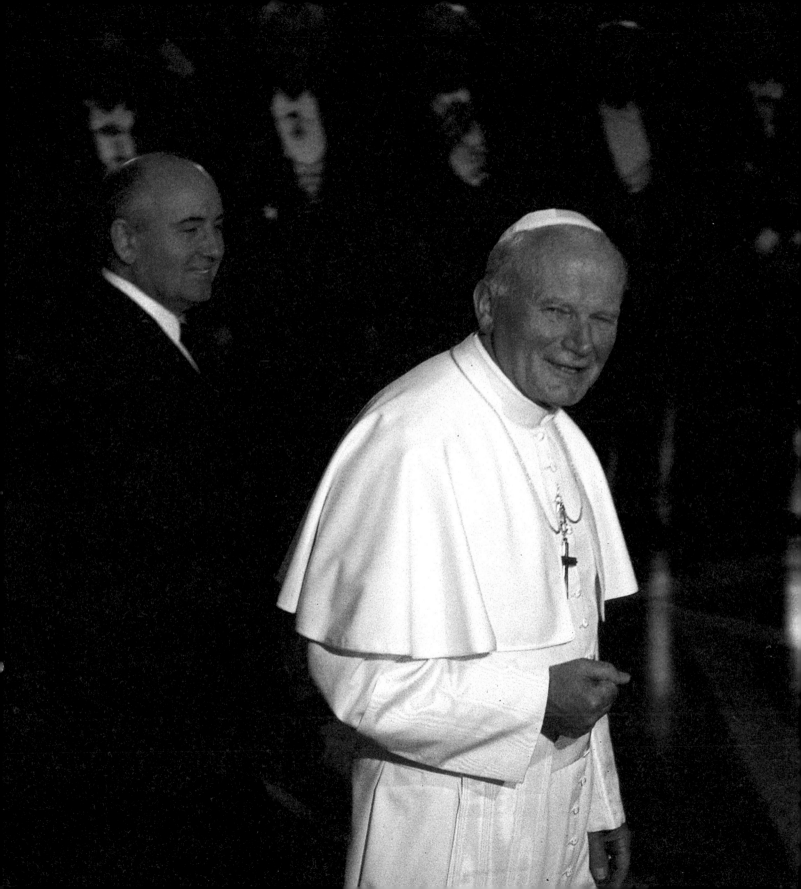

TEMPORAL POWER AND THE FREEDOM OF THE CHURCH

We finally arrive at the pope's library, known to television audiences throughout the world because it is the space where the pontiff receives guests for private meetings. Here John Paul II has received Gorbachev and Mandela, Fidel Castro and Yeltsin, Carter and Reagan, Bush and Clinton, Queen Elizabeth and Princess Grace, Solzhenitsyn and the Dalai Lama, Rabin and Arafat, Jaruzelski and Walesa.

The library has three windows that look out over St. Peter's Square, and its furnishings are simple, more typical of a working study than a grand drawing room. The wall facing the entrance holds a large painting by Perugino, the *Resurrection of Christ*; behind the pope's desk is a panel by Antoniazzo Romano, depicting the Madonna; an illuminated Bible from the fifteenth century sits on a small sixteenth-century table. The large sixteenth-century bookshelves that line two of the four walls contain a collection of Bibles from various centuries and in many languages, the complete collection of the church fathers, the encyclicals of the popes, and some works on the history of the church. As in the other rooms we have seen, these choices send a message: papal teaching is based on Scripture, on the church fathers, and on ecclesiastical tradition.

And if a guest is a smoker? If someone wants to smoke here, in the pope's library? Flexible Vatican diplomacy will find a way to deal with this weakness, which was conspicuous in someone like Nikolai V. Podgorny, president of the Supreme Soviet of the U.S.S.R., who was received by Paul VI on January 30, 1967. "The president cannot last an hour without smoking," his colleagues warned. And Archbishop Agostino Casaroli (then cardinal and secretary of state) discussed this with Paul VI, who quickly offered his guest cigarettes and ashtrays as a prelude to their meeting, which was expected to be difficult and didn't need to be marred by additional nervousness.

With regard to smoking, the situation can be more creative if the guest is American. On September 28, 1970, President Richard Nixon entered the pope's library, accompanied by his secretary of defense, Melvin Laird, who in turn was inseparable from his Cuban cigar. "Get rid of that cigar!" ordered Secretary of State Henry Kissinger, and the hapless Laird attempted to put it out on a book of matches and place it in his pocket. But the flame smoldered beneath the ashes, and the cigar burst into flame midway into the pope's discourse, causing the unfortunate secretary to try to extinguish it with his hand, resulting in inappropriate applause all around.

The Royal Staircase, leading out from the Ducal Hall and the Royal Hall, is not open to most visitors but is an important stop on our tour if we are to gain a deeper understanding of the Vatican.

Here the papacy is celebrated as a political power. More precisely, in these spaces already designed for passage (the Royal Staircase) and gatherings of dukes (the Ducal Hall) and kings (the Royal Hall), the superiority of the pope over any emperor, principality, or power is affirmed through the clarity of the architectural and pictorial language.

The French cardinal Jacques Martin spent more than half a century in the Vatican and was prefect of the papal residence from 1969 to 1986. Writing about the decoration of these spaces, he said, "It is a question of evoking some of the most glorious pages of papal history and thereby taking the opportunity to remind the illustrious personages received there of the superiority of spiritual over temporal power."

This claim of superiority of papacy over empire and over all principalities, which has endured beyond the demise of the empire, was in large part responsible for the dispute of the Church of Rome with modern life, its difficulty in accepting the secular states that emerged from the French revolution, and for its refusal, which lasted until 1929, to recognize its irreversible loss of temporal power.

The Lateran Treaties, which were established between Italy and the Holy See in 1929, began the phase of reclaiming reciprocal independence and autonomy between the spiritual and temporal powers, which were placed on an equal footing.

The pope receives the Polish president, Lech Walesa, in the private library.

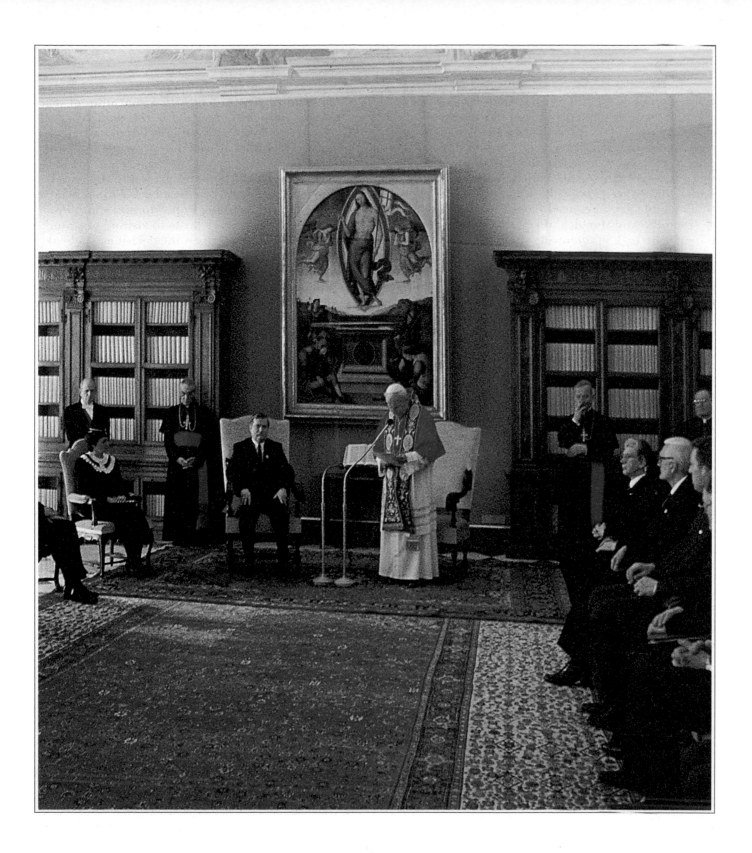

In item number 26 of the treaty between Italy and the Holy See, this equality is stated with utter clarity: "The Holy See recognizes the Kingdom of Italy under the dynasty of the House of Savoy, with Rome as the capital of the Italian State. In its turn, Italy recognizes the Vatican City State, under the sovereignty of the Roman Pontiff."

Thus the claim changed from superiority to one of equality. And the idea of equality resulted in the delicate task of endowing the Vatican State its own flag and currency, its own stamps, railway station, radio station, and license plate. Visiting the city, we shall see that with the passage of time, there are glimpses of signs of a new form of this claim for independence and autonomy: a form that rests less on the establishment of symbolic parity and that is content with a guarantee of true autonomy, which shows itself in the claim by Christians to freedom from interference by all powers, which was affirmed in principle by Vatican II.

When he was bishop and prefect of the papal residence, for nearly two decades Cardinal Martin had the task of fulfilling Pope Montini's and Pope Wojtyla's obligations as hosts to visitors of state. These were the years when the decisions made at Vatican II regarding Vatican autonomy bore fruit and a new attitude began to be delineated regarding the freedom to criticize and make proposals to governments, maintaining complete formal respect for them as well as a clear distance from their political policies. Through Cardinal Martin's writ-

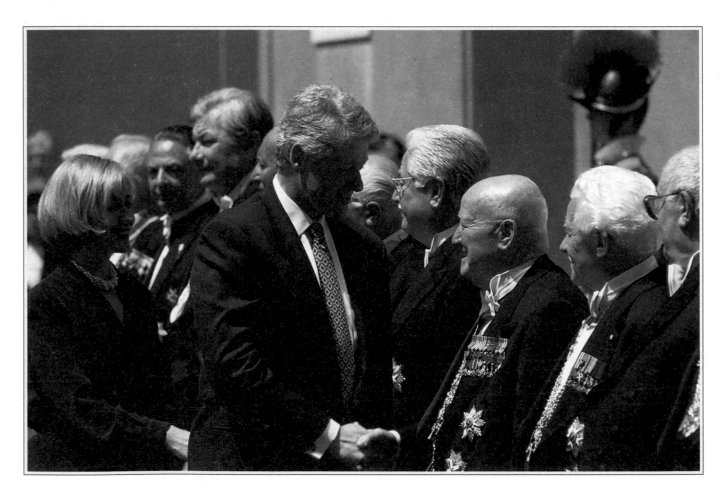

ings, he remains an ideal guide for our visit to this realm.

Let us enter the Royal Hall and look at the walls for the stories of the popes who proclaimed their superiority over temporal powers, a claim that was never peacefully accepted. To the right of the entrance to the Pauline Chapel, Federico Zuccari's fresco depicts Emperor Henry IV as a penitent, begging and receiving a pardon from Gregory VII in the castle of Countess Matilde in February 1077.

Next to the entrance to the Ducal Hall, which forms an L with the Royal Hall, is another illustration representing the church's primacy over the empire. Here a fresco by Francesco Salviati shows the so-called *Peace of Venice* of 1177, with Emperor Frederick Barbarossa prostrate before Alexander II, who places his foot right on the emperor's shoulder. That foot is a false historical note; in fact, the two men exchanged only "a kiss of peace," but the papal court cultivated the legend according to its own conviction.

The front wall of the Royal Hall has two large frescoes by Giorgio Vasari, celebrating the Christian victory in the Battle of Lepanto (October 7, 1571); the north wall has three paintings by the same artist, celebrating the St. Bartholomew's Night Massacre (August 23–24, 1572). The two events are treated as two triumphs of faith, over the Turks and over heretics!

The foreground of the battle scene has three women with intertwined arms, symbolizing the three powers of the league against the Turks: the papacy, Spain, and the Venetian Republic. The woman in the center, the personification of the papacy, wears the papal tiara atop her blonde curls, the papal cross to her right, the keys to St. Peter's to her left. This had been the only woman to represent the Holy See until, in 1995, John Paul appointed Mary Ann Glendon from the United States to head the Vatican delegation at the United Nations Conference on Women, held in Peking.

The three frescoes dedicated to the St.

Left and right: the president of the United States, Bill Clinton, and the first lady on an official visit.

Bartholomew's Night Massacre (*Admiral Coligny Wounded, The Massacre, Charles IX of France Sanctions the Massacre and Thanks God*) were painted only a few months after the massacre of the Huguenots, who were assaulted in a surprise attack by the Catholic and loyalist faction headed by Catherine de' Medici. The paintings were the subject of much discussion over the centuries, and not only on the part of Protestants: "In Europe there is a place where the massacre is publicly honored!" wrote the French writer Stendhal in the *Passeggiate Romane* of March 7, 1828.

Above: Aleksander Solzhenitsyn with his wife in St. Peter's Square.

The frescoes in the Royal Hall were not the only celebration of the massacre ordered by Gregory XIII. He also had a *Te Deum* (the liturgical hymn of thanksgiving) sung at Santa Maria Maggiore and at San Luigi dei Francesi, and he had commemorative medals struck, one of which bore the phrase *Pietas excitavit justitiam* (piety—that is religious zeal—reawakens justice) and another of which depicted the angel of death with the words *Hugonotorum strages* (the massacre of the Huguenots).

In August 1997, John Paul visited Paris, where he presided over a vigil with a million young people, precisely on St. Bartholomew's Night. He evoked those past events in the context of the jubilee year of repentance and ecumenical reconciliation: "On the eve of the 24th of August, we cannot forget the sorrowful St. Bartholomew's Night Massacre, with unfathomable motivations in France's political and religious history. There are Christians who have carried out actions that the Gospel condemns."

John Paul's mea culpa refers to more than those events in France; it also refers to the celebration of the massacre by Pope Gregory. Those facts had "unfathomable motivations in France's political and religious history," and so today's pope has nothing to say about the objective and subjective responsibility that determined them, but they imply "actions that the Gospel condemns" and thus should not be celebrated as a victory of faith. Obviously, one pope never contradicts another, and so John Paul did not mention by name Gregory XIII or the frescoes in the Royal Hall, but in reality, his pronouncement in Paris was a disavowal of his predecessor's celebration of the massacre, and it altered the impact of those frescoes.

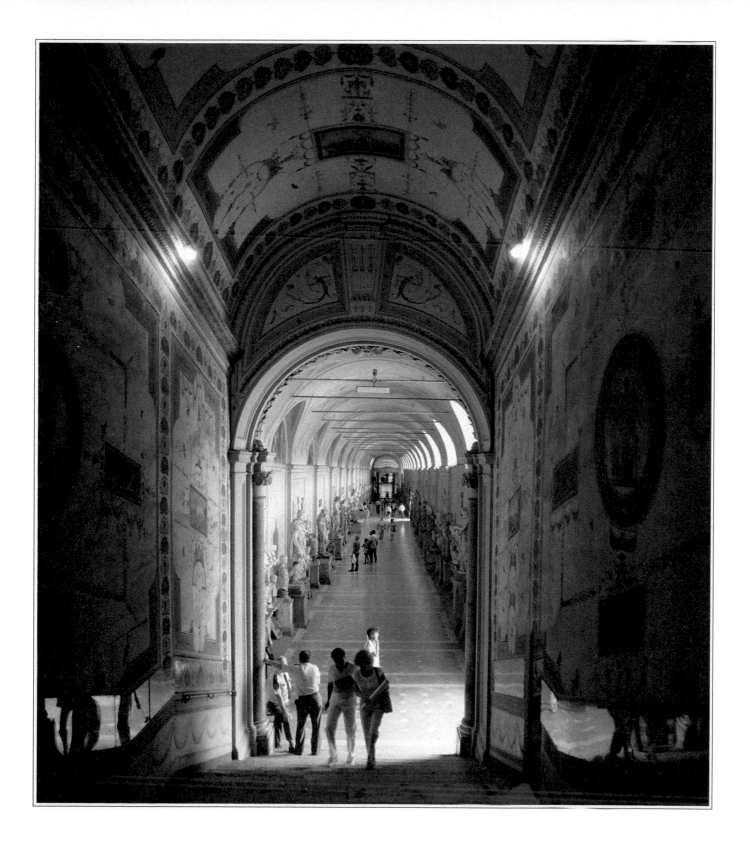

One could trace a Vatican itinerary that places in sequence the triumphalist sites of other times that have already undergone revision by the innovative popes of the second half of the twentieth century. This itinerary, perhaps the most stimulating one that exists at the turn of the millennium, could begin at the central doorway of St. Peter's Basilica, where Filarete sculpted Pope Eugene IV receiving obedience from the emperors of the East and the West. Like Vasari in his painting of the Huguenots, Filarete had a direct understanding of the events.

The Vatican is full of images of enthroned popes receiving homage from rulers—images that are sculpted, painted, illuminated, and coined. But the strongest of these is Filarete's sculpture because, and in this it is perhaps unique in the Vatican, it affirms, in two juxtaposed panels, the superiority of the pope over both empires. The homage of the emperor of the East, John VIII Paleogolus, was received by Pope Eugene IV during the Council of Union between the Church of Rome and the Orthodox Churches, held in Ferrara and Florence in 1438–39. On the occasion of that council, Eugene IV had the patri-

Tourists in the Raphael Rooms in the Vatican.

arch of Constantinople, Joseph II, kiss his foot.

If we enter the basilica from the central doorway, it will be easy to recall Paul VI's gesture of reparation to the patriarchate of Constantinople, in the central nave, as a correction for that gesture of submission imposed by his predecessor, Eugene IV. On December 14, 1975 (on the tenth anniversary of the abolition of reciprocal excommunications between the two churches), Pope Montini, dressed in liturgical robes, knelt down and kissed the feet of Metropolitan Melitone, who had been sent by the patriarch of Constantinople.

The basilica of St. Peter's always brings to mind another gesture of reparation, this one made by Paul VI when he renounced the papal tiara. It was November 13, 1964, and the pope, in council, had an announcement made that "he was offering his tiara to the poor and to the needy" (in pauperes et egenos), and he descended from the throne, bearing in his own two hands the tiara that had been given him by the people of Milan for his coronation, and placed it on the altar. That gesture, too, had the significance of a self-criticism, this time with regard to Roman pomp. And it had consequences, because from that day on the pope no longer wore the tiara and his successors also repudiated it. The "coronation" ceremony was replaced with a "celebration of the beginning

of the universal pastor's ministry." With this gesture, Paul VI changed a symbol that had endured for twelve centuries.

The entrance to the grottoes is no longer marked by the tombstone of Sixtus V, who once, under the column of St. Andrew, threatened to excommunicate all women who dared to go there. This change, too, was greatly anticipated by some of the most important women in history, including Theresa of Lisieux, who, relating her visit to the Vatican, noted in her autobiography: "Every time we take a step forward, we are told: do not enter here, do not enter there, you will be excommunicated!"

In the papal palace, in addition to the Royal Hall, another possible stop on this itinerary of innovative popes is one of the Raphael Rooms called the Room of Heliodorus, where *The Expulsion of Heliodorus from the Temple* (an episode taken from Maccabees 3:25–27) is depicted as if it were taking place in the presence of Julius II, the pope who commissioned the fresco. Heliodorus had attempted to plunder the treasury of the Temple of Jerusalem for Seleucus IV, king of Syria, and so his expulsion—from a temple where the features allude to the new St. Peter's and in the presence of a pope who enters the temple in a gestatorial chair—proclaims the inviolability of the legacy of the church and the papacy.

In the Room of Heliodorus, *The Meeting of Pope Leo and Attila* is also depicted. Here the topicality of the celebration is emphasized by the fact that in the clothing of Pope Leo the Great there is a portrait of Leo X, the Medici pope who, in the meantime, had succeeded Julius II.

There are two other images in the Raphael Rooms that might provide ideas for the "end of millennium examination" proposed by John Paul in consideration of the grand jubilee: the *Battle of Ostia* in the Room of the Fire and the *Offering of Constantine* in the Room of Constantine.

The fresco of the *Battle of Ostia* celebrates the victory of Leo IV (pope of the Leonine Wall) over the Saracens, but here, too, the ancient pope is portrayed as Leo X, and the entire representation alludes to that pope's plans to resume the Crusade against the Turks. In his visits to Africa and the Arab countries, John Paul has frequently been held accountable as the party responsible for the Crusades, and he has clarified in exacting fashion that the Crusades, while justified by the logic of their times, were not a means of defending the Christian faith that was "in keeping with the Gospel."

The fresco of the *Offering of Constantine* is located between the two windows of the Room of Constantine that look out onto the Belvedere Courtyard. It was painted, in the early sixteenth century, by Giulio Romano and Francesco Penni. The offering, as we know, was a medieval falsehood, which the popes used for at least five centuries to support their claims *in temporalibus* (over secular matters). When the Room of Constantine was painted, the "offering" had already been recognized as false by prominent humanists and ecclesiastical figures, such as Lorenzo Valla and Cardinal Niccolò Cusano, but in the papal court, "the legend of the Offering was still fully believed and accepted" (Martin) and continued to be so for the entire sixteenth century, until the time of Cardinal Cesare Baronio. The portrait of Pope Clement VII in the clothing of Pope Sylvester I attests to the fresco's topicality.

The itinerary of jubilee year reevaluation of the history of the church might end with a passage through the library and a visit to the palace of the Holy Office, which was the headquarters of the "Roman and universal Inquisition," known to be a central theme in the millennial mea culpa proposed by John Paul.

In the library, at the back of the Sistine Hall, there is a fresco depicting the *Crusade against the Albigensians*. It shows St. Dominick burning the books of heretics and offering instructions to the combatants with words below reading "Convinced by St. Dominick, Count Simone di Monfort began the battle." This, too, was a terrible massacre, in the year 1213.

Based on tradition, the Church of Rome cannot detach itself from the past, as the entire Vatican demonstrates. And so for forty years, this church, which has arrived at a millennial turning point, has conducted a laborious reevaluation of its own history, and it has judged itself and has asked to be forgiven.

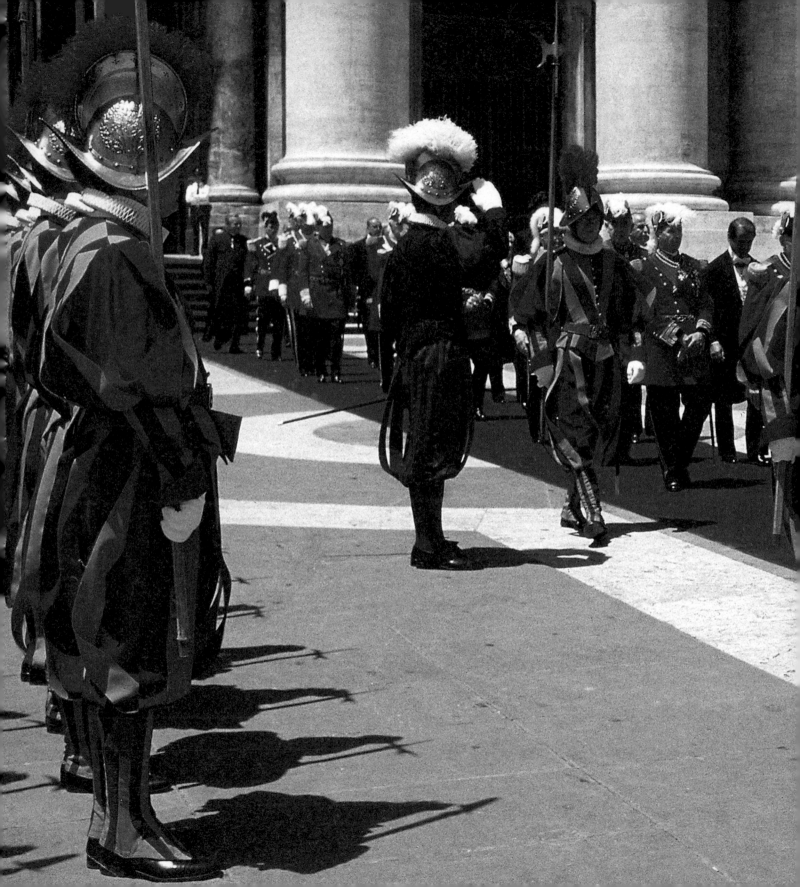

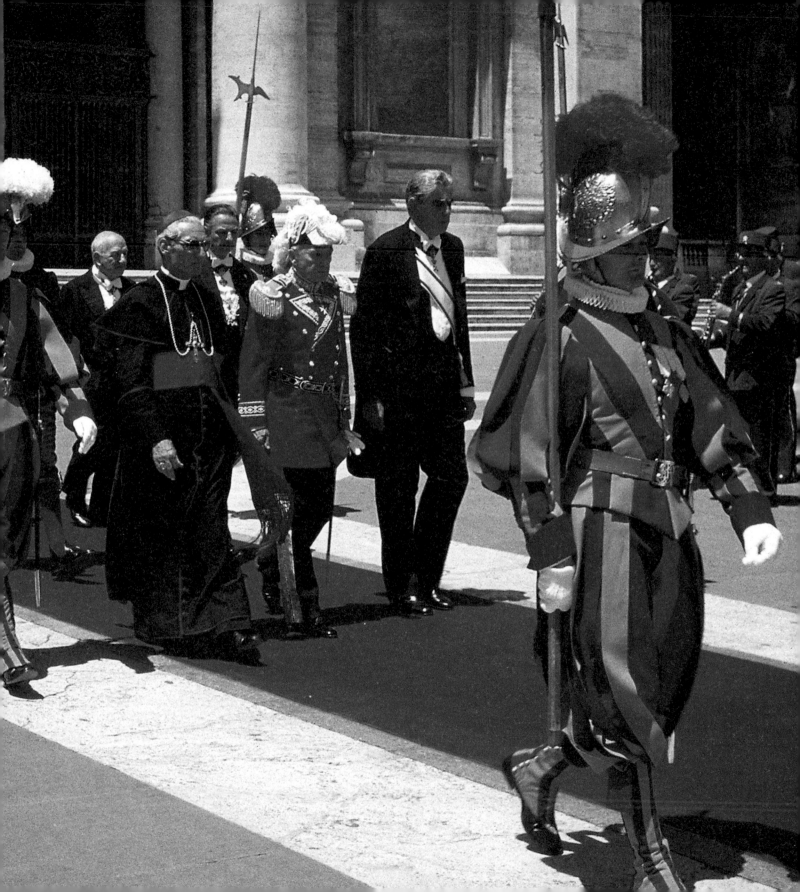

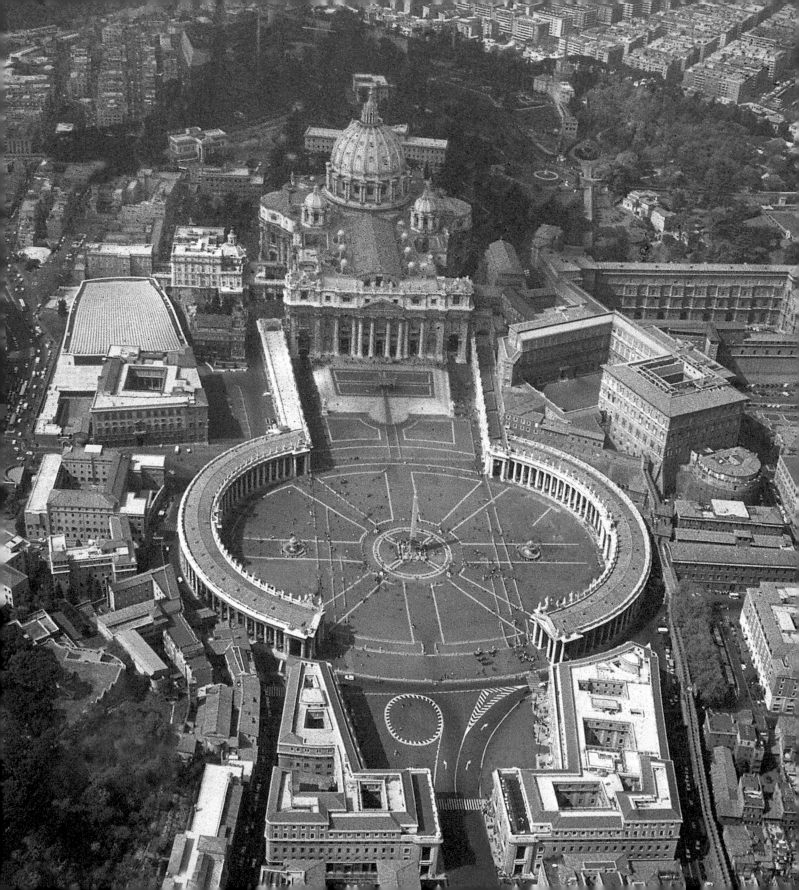

A WALK THROUGH ST. PETER'S SQUARE

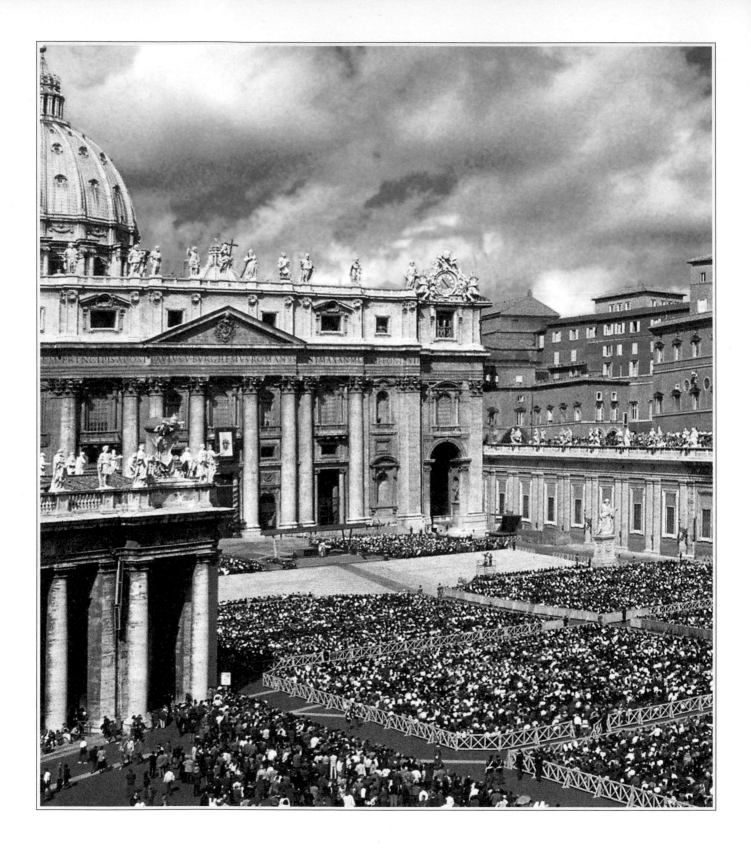

During the year 2000, there will be perhaps triple the usual ten million visitors who enter the Vatican each year. Every visit begins from St. Peter's Square, and even virtual visits, experienced through television, use this spot as a point of departure. Indeed, most visitors, having already seen the piazza on television, feel that they have already been there before when they finally arrive in person for the first time. This feeling of déjà vu gives way to amazement only after the new arrival has traversed the entire length of the square (268 meters from the colonnade to the basilica), realizing the time it takes to do so and the extraordinary size the facade assumes when he arrives in front, at the top of the steps.

Designed in 1656–67 by Gian Lorenzo Bernini, a genius of the baroque period who spent his lifetime working for the popes, St. Peter's Square is a grand theatrical spectacle that is best appreciated on the move. After crossing its depth or length, the visitor then needs to experience its width in order to arrive at the points where two stone disks in the pavement indicate the two focal points of the ellipse bordered by the colonnade. Climbing onto those disks and turning toward the closest colonnade, the viewer will see a semicircle of thirty-six columns. In reality there are four times that many, but from that focal point, the columns line up perfectly, four deep. And above the colonnade, there is a statue for each visible column. Once the visitor has understood some of the elements of the spectacle set forth by Bernini, it is impossible not to get completely caught up in it, for example, when walking through the central corridor of the two arms of the colonnade and looking out from there at the piazza and the city.

Designed to amaze, St. Peter's Square and Basilica more than fulfill Bernini's intention. "St. Peter's is a church of spectacle and of triumph," Silvio Negro has written in *Vaticano Minore*. And naturally, those who don't appreciate or understand that triumph may not fully admire the church.

To understand it, at least a bit, it can be useful to read the classical text attributed to the humanist pope, Nicholas V, who planned the renovation of the "Leonine city" and the restoration of the ancient St. Peter's: "The extremely grand, total authority of the Roman church can be understood only by those who have understood its origins and developments through studies of its literature. But most of the populace is ignorant of literary things and completely without culture; and if they often enough hear scholars and sages affirm that the authority of the Church is very great and they have faith in these assertions, believing them to be true and incontestable, they still need to be struck by grandiose spectacles, for otherwise their conviction, resting as it does on a weak and unstable foundation, would end with the passage of time, and would be reduced to nothing. However the grandeur of the buildings, the seemingly perfect monuments, which seem to bear witness that they are almost works of God Himself, can reinforce and confirm the very popular conviction that has its basis in the statements of scholars, so that it is propagated among the living and passed down through the ages to all those who have had the opportunity to admire those marvelous constructions. . . . And so these are the reasons, and not because of ambition, pop, senseless glory, thirst for fame or desire to ensure that our name would endure at length, that we conceive the idea for such grand edifices: to ensure greater prestige for the Roman Church, and so the Holy See might enjoy greater consideration among all Christian peoples."

These were apparently the words of Nicholas V, on his deathbed, in 1455, spoken as a testament to his cardinals, according to Giannozzo Manetti (1396–1459), who was his apostolic secretary, and who wrote a vita immediately after the humanist pope's death. The words are almost surely not authentic, as the last will of the pope who began the rebuilding of St. Peter's, but they are authentic as a document of what papal Rome thought—and still thinks—of the "grandiosity of the buildings" and their promotional power.

For a contemporary text that is inspired by the same idea, and uses almost the same words as those of Giannozzo Manetti's Nicholas, one can turn to the opening words of *L'appartamento pontificio delle udienze*, by Father Romeo Panciroli, Vatican spokesman during the years spanning the

papacies of Paul VII and John Paul II, and later a papal nuncio: "Christianity, as doctrine, has no need of palaces and domes, but the Gospel was announced by Jesus Christ to men, who have always needed symbols in order to express the grandeur, the vastness and the depth of an idea.

For a Christian adult, and throughout the entire earth, the dome of St. Peter's and the papal palace assume the value of the universality of the believers in Christ, from the humble faithful to sovereigns great and small, who may enter there as into the house of their common Father."

The scale of this piazza makes an impression on everyone, but it must have done so even more in the past. "The entire population of Rome would not fill St. Peter's Square," wrote Giacomo Leopardi in 1822, in a letter to his sis-

ter Paolina. The poet had just arrived in Rome after leaving his native Recanati, then little more than a village, for the first time, and he was exaggerating, but not much. St. Peter's Square, when full, can easily accommodate one hundred twenty thousand people, and the city's population must have been a bit more numerous at the beginning of the nineteenth century, if it was two hundred thousand when Rome was proclaimed the capital, in 1870. But in the mid-seventeenth century, when Gian Lorenzo Bernini designed the colonnade, which was approved by Alexander VII, the population was certainly less than one hundred twenty thousand, and it is likely that one of the ideas that guided both patron and architect was that the entire population of the *Urbe* might be contained in that

94

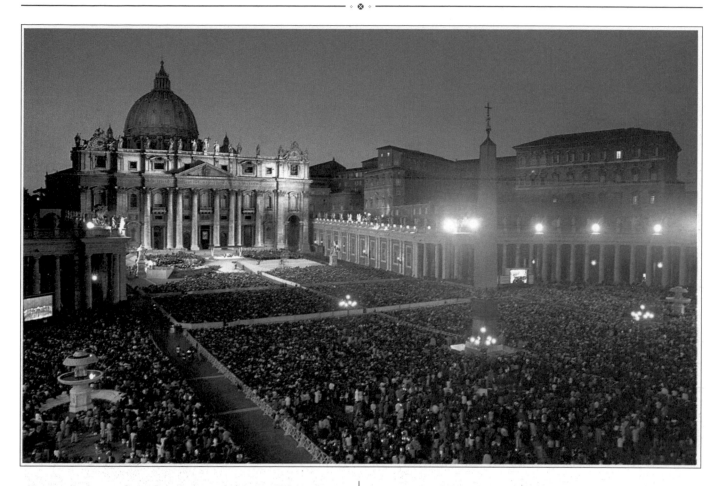

piazza, conceived as the image of the earthly orb.

There is no plaque or marker commemorating the attack on John Paul on May 13, 1981, and this is a discretionary choice that anyone can appreciate. But that bloody incident will long be linked to the pope's piazza. Since then, whenever he walks amid the crowd, everyone thinks about the danger he is risking. And perhaps he, too, thinks about it. "I can assure you, Your Eminence, that no place is more dangerous than St. Peter's Square," he once said to Cardinal Decourtray, who was speaking to the pope of the alarming voices heard in France on the eve of his visit to Lyons, in October 1986.

The attack has changed the level of security, now present whenever the pope celebrates mass outdoors or holds general audiences during the summer. "The entire square, along the colonnade, must be closed off with barriers; one can gain access only through a restricted number of entrances; contents of purses are examined; the Holy Father's jeep proceeds more rapidly than it used to; police are more focused on him than before, but they face the crowd; fortunately these precautions have not reduced the crowds of pilgrims at all." (Jacques Martin)

In 1982, Pope John Paul II began the practice of introducing a Christmas tree and crèche into the square. Wojtyla has popular tastes; the crèche in his apartment and the one in the basilica were not sufficient—he wanted one that everyone could see, one that dominated the stage. And he also wanted a Christmas tree. Without the crèche next to the obelisk, the piazza seemed empty to him,

and without the Christmas tree with its lights, the square seemed cold. Crèche and tree are his Christmas gifts and indicate a simple side to this man who has gone before the United Nations twice to give an address on the state of the world.

The official name of the crèche is "Christmas representation in St. Peter's Square." Everything, every action in the Vatican has an official name, which almost never corresponds to its commonly used name. The General Office of Technical Services for the Government is in charge of installing the crèche. According to an official announcement regarding the 1997 crèche, the principal figures in the representation are the ones that were originally "prepared by Saint Vincenzo Pallotti for the Romans' crèche, created in 1842 in the church of Sant'Andrea della Valle."

The Vatican press release does not refer to a "Christmas tree," but states that "to the left of the crèche a majestic fir tree has been erected; it is over twenty-eight meters tall and comes from the forest of Zakopane, in Poland, and was shipped to Rome by railroad," and that it has been decorated with two thousand lights and a star at the top. There is some discussion about this Christmas tree. Some say it is inappropriate for Christmas, not having Christian origins. Thus a fine distinction is made: it is placed there, as the Pope wants,

but it is not called a Christmas tree. Behind this small anecdote lies a great lesson: you can sometimes do what is disputed, but it is best if you do not call it by the name that provokes the dispute.

Certainly John Paul appreciates the grand square that puts him in touch with the world, in which he has received the "obedience of the cardinals," which he traversed with solemn steps on the day of his inauguration as pontiff, and in which he came close to dying. But its monumentality somewhat intimidates him, just as Pius X was intimidated by the gendarmes and their horses, or as Pope Luciani was frightened, it is said, by the *Annuario pontificio*, the annual papal report.

Placing a crèche at the center of the colonnade and erecting a fir tree next to the obelisk are ingenuous ideas, but they also tell us that there is a man inside every pope.

On Christmas Eve, at half past six in the evening, when it is already dark, the window of the pope's study is opened; the same window where he says the Sunday prayer, the penultimate one on the right of the last floor of the papal palace. John Paul looks out for a moment; he holds a small flame with which he lights a candle, which he then leaves burning on the window sill. With a wave of the hand, he greets the people who have gathered in the square below; at that

moment the tarpaulin covering the crèche falls away. It is a courteous gesture, the candle at the window, and it is one performed by a Polish mother as soon as Christmas Eve begins; she explains to her children that the candle is there to indicate to Joseph and Mary that they can stop at that house if this year they again find no place at the inn. Pope Wojtyla lost his mother when he was nine years old, and it is perhaps in gestures such as this that he remembers her.

Now that we have glanced at the pope's window, we shall take a look at the central loggia of the basilica before entering the church itself. From this loggia, the popes look out to offer bene-

diction after being elected. During the period of "imprisonment," because of the "Roman question," they looked out from the inner loggia and blessed the crowd gathered in the basilica. Pius XI resumed the benediction facing the square on February 6, 1922. On October 16, 1978, John Paul II spoke from this loggia, in addition to offering a blessing. He was the first non-Italian pope in four and one-half centuries, and he almost seemed to apologize to the Italians present for not speaking their language well: "If I make mistakes, correct me."

In that postelection greeting, something no modern pope had done, Wojtyla also said, "I was

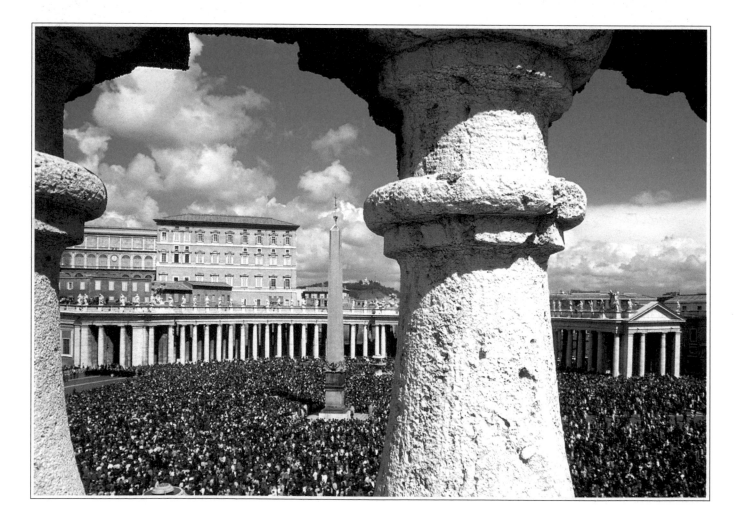

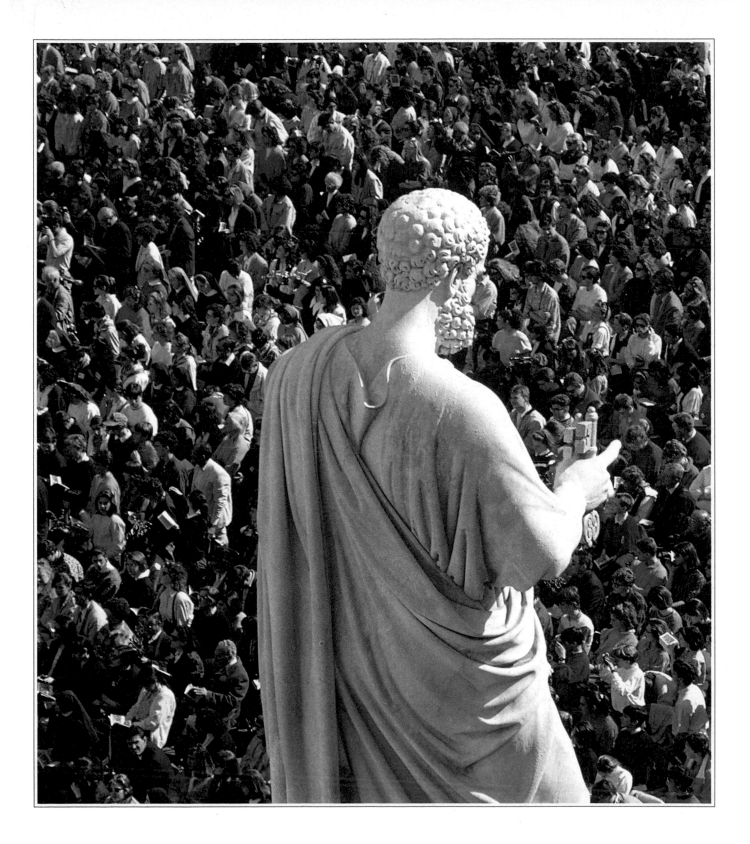

afraid to receive this appointment." Perhaps it was only after the assassination attempt that we understood the meaning of those words. But that attack has not prevented him from continuing to go out among the crowd in the square, following the advice that he himself had given to the world at his inauguration: "Don't be afraid: open, open wide your doors to Christ!" (October 22, 1978).

Other innovations have taken place in the loggia under the papacy of John Paul. On June 29, 1995, he offered a benediction together with Bartolomeo, patriarch of Constantinople; the pope speaking in Latin, the patriarch in Greek, but with a single gesture! Entering the basilica, we can recall another act of reconciliation that took place in this entrance when, on October 26, 1967, Paul VI went out from the churchyard, in full papal dress, to welcome the patriarch; they embraced each other and entered the basilica, arm in arm.

The five bronze doors of the basilica are a world unto themselves, and at least three of them deserve special mention: the central door by Filarete (1439–45) and the two modern doors by Giacomo Manzù and Luciano Minguzzi.

The first door on the left is called the *Door of Death* because it is from here that papal funeral processions enter. It is signed by Giacomo Manzù (1964) and is perhaps the most beautiful; certainly

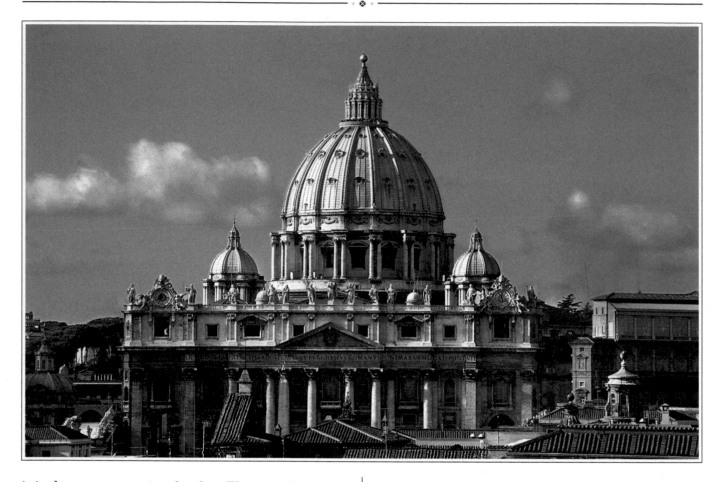

it is the most appreciated today. The second is the *Door of Good and Evil* by Luciano Minguzzi (1977); it is rich with symbolism, as seen in the handle in the shape of a sparrow-hawk capturing a dove. The third is the *Door of Filarete* (1445), ancient and noble, and which can be read like a medieval poem. The fourth (*Door of the Sacraments*, by Venanzo Crocetti, 1966) and the fifth (*Door of Great Forgiveness*, by Vico Consorti, 1949) are modern like the first two but less innovative in their language.

Filarete's door was created for the old St. Peter's, and the humanist sculptor from Florence, caught up in a creative furor, included scenes and decorative motifs that have little to do with the theme assigned him by Pope Eugene IV: the Council of Florence of 1439, which had just sanctioned the union of the eastern and western churches (which immediately split once again). Naturally, the story of that council is depicted, but there are also panels decorated with Arabic letters, male and female nudes interwoven with the swags of the cornices, erotic and mythical scenes taken from Aesop and from Ovid's *Metamorphosis*. This door transmits the spirit of the medieval encyclopedia, from the old St. Peter's to the new. And along with this spirit, there is an appreciation for the profane reality and playful aspect of existence. This appreciation was then lost with the Counter-Reformation, but in Catholic theology and on the doors of St. Peter's, it has been laboriously, although still incompletely, revived in recent times.

On the back of his door, Filarete depicted him-

self and his helpers, who, their work finished, are enjoying a country outing on horseback. Here, in this innocence of a believer who, in his own way, praises life and he who has granted him life, I find the same secular spontaneity depicted by Giacomo Manzù at the edge of the panel commemorating Vatican II (on the back of the *Door of Death*), in the figure of a woman who personifies the church, and who has the same features as Manzù's wife, Inge. Minguzzi was even more audacious, in his portrayal of *The Host of Martyrs* as a massacre of partisans of the resistance against the Nazis (the reference is to a slaughter carried out by the German occupiers in Casalecchio di Reno, Bologna, in 1943).

These profane sentiments can be found a thousand times over throughout the Vatican, if one looks for them. There is a celebration of female beauty, for example, even in the statues embellishing the tombs of the popes; more generally, there is praise for the human body, from the *Belvedere Apollo* to the Raphael Rooms, to the work of Michelangelo in the Sistine Chapel, to Canova's winged figures on the Tomb of the Stuarts. There is also evidence of appreciation for all art of value and significance, even when it doesn't relate to the Christian faith, from Egyptian, Greek, Etruscan, and Roman statues to illuminated books from the Middle Ages, from techniques for building a dome to the study of stars conducted by the Jesuit astronomers of the Vatican observatory.

These riches, passed down from pope to pope through the centuries, men who safeguarded them even when they didn't understand or approve of them, will be discussed in the sections on the Vatican Museums and the Sistine Chapel. But one thing must be said while we linger another moment at the threshold of St. Peter's: in the western world there is no other place that developed with such continuity. That material and conceptual continuity has been like a river, sweeping by, bringing innovations and changes, not always desired by the navigators of the moment. The nudes of Filarete, Michelangelo, and Canova are better understood today than at the time of their creation, and perhaps in the future they will be still better comprehended. One can imagine that

One of the bronze doors of St. Peter's Basilica.

the day will come when the women of the tombs, who personify charity, justice, or truth and who, by definition, must be nude, will be liberated from the draperies of marble or bronze with which they have been covered for centuries, and we will once again be free to praise their beauty.

Here we are in the basilica. Its grandeur fascinates; its complexity disconcerts the visitor. But today less than yesterday, for today's visitor has been prepared by television. This church is extraordinarily telegenic. At the opening of the extraordinary Holy Year of 1983, the direction of the live broadcast was entrusted to Franco Zeffirelli, who demonstrated what television could do in St. Peter's.

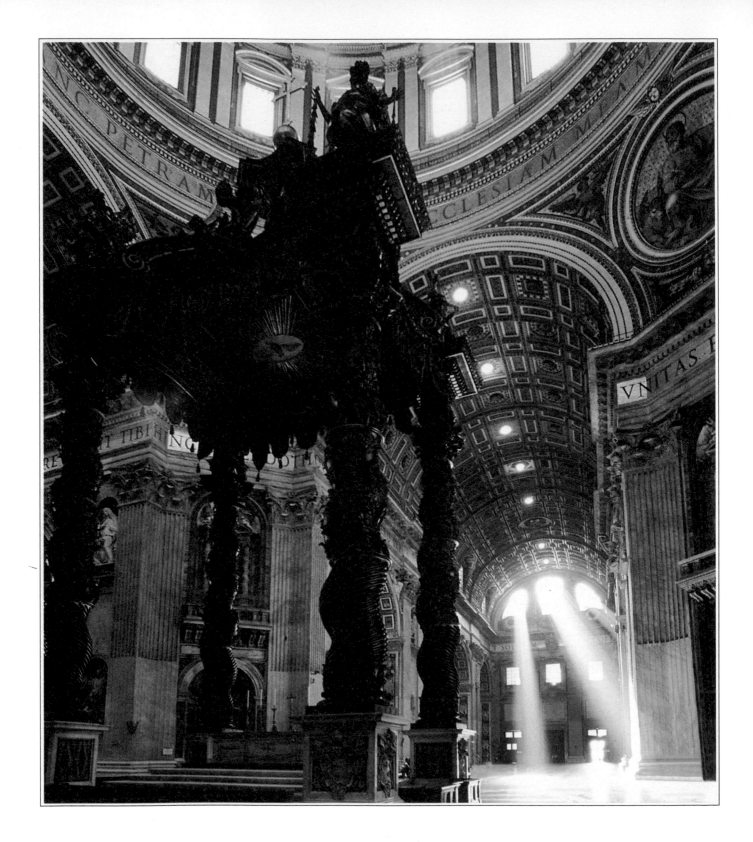

When the pope ascends the steps of the Altar of Confession and passes next to a column of Berni-ni's baldachin, we see in the foreground that even with his miter and cross, the pope barely arrives at the height of the marble cube that is the base of the column. The middle ground indicates how small that base is in the overall scheme of the bal-dachin, which is as tall as the Farnese Palace. A long shot transports us into the vertiginous heights of the vault.

The grandeur of the basilica can also escape a well-prepared visitor. "St. Peter's didn't seem to me much larger than St. Paul's in London," wrote James Joyce after visiting in the summer of 1906. He probably saw the brass star in the pavement, indicating where St. Paul's would measure up, and he wasn't convinced.

The same skeptical impression has been voiced by the people of Milan, upon learning that their cathedral holds only sixth place, tied with the cathedral of Cologne (after St. Paul's of London, the cathedrals of Florence and Rheims, Sacre Coeur in Brussels, and the Sanctuary of the Immaculate in Washington). And not only because it takes a Milanese some time to admit that there can be anything lacking in Milan; in this case, the

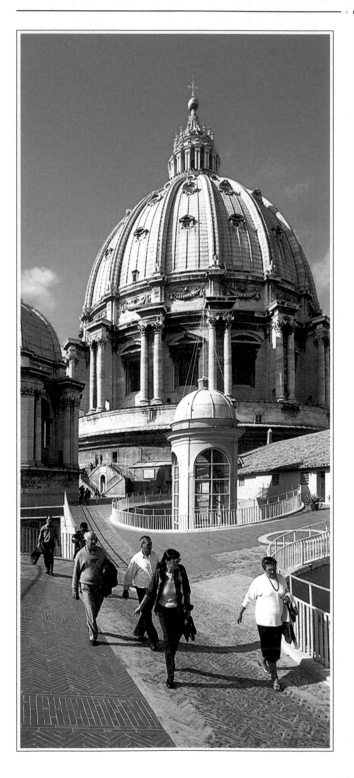

Lombard sensibilities are correct to be offended. The Milan cathedral is mentioned as measuring 139.94 meters, instead of the 158 meters quoted by authorized guides.

All things considered, and having heard all the expert opinions, it is possible to enjoy the grandeur of the basilica without racking one's brains. For, motives aside, true grandeur has been achieved here, and it is only right to enjoy it. As Johann Wolfgang Goethe, who visited St. Peter's on November 22, 1786, said: "We simply enjoyed that grandeur and magnificence, without being too fastidious this time, nor allowing ourselves to be disconcerted by tastes too refined and repressing any judgment too severe."

So wise a visitor might also guide us along the "ascent to the dome." The view of the basilica roof appeared to him as "the image in miniature of a well-constructed city," with "houses and warehouses, all sorts of fountains, churches, and a great temple, all in the air, and beautiful fragmentary passages." The temple in the air is naturally the dome of St. Peter's: "While we stood on the cornice of the column drum, the pope passed by, below, on his way to Vespers." That pope was Pius VI, who twelve years later would be imprisoned by the directory of the French Revolution. Standing in St. Peter's, anyone can be a witness to history.

Left and right: the roof of St. Peter's basilica with a view of the "little domes."

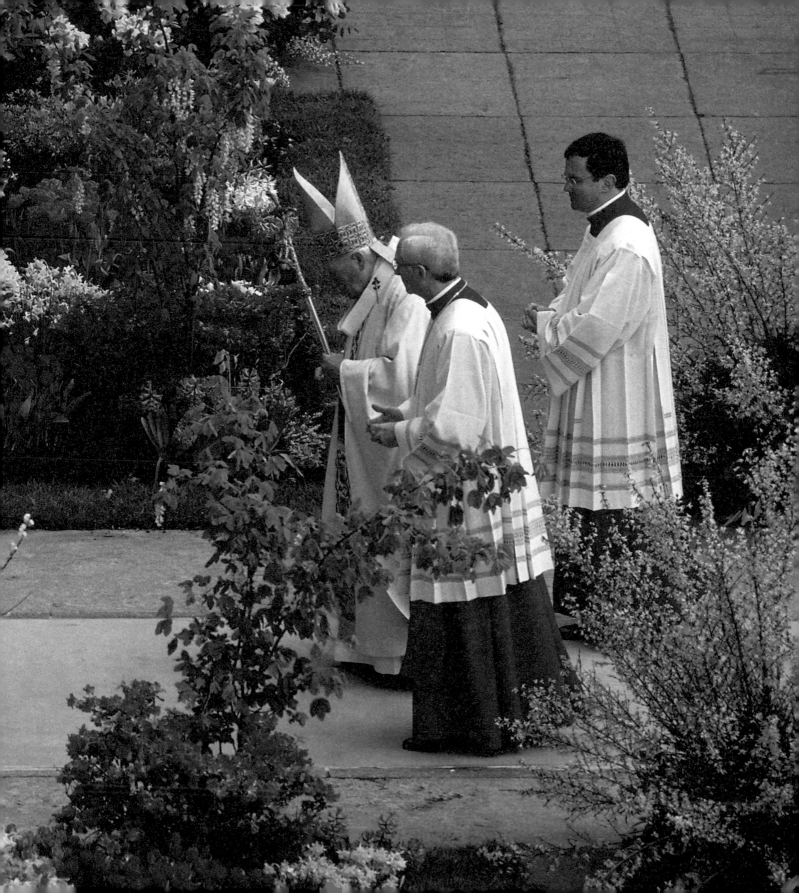

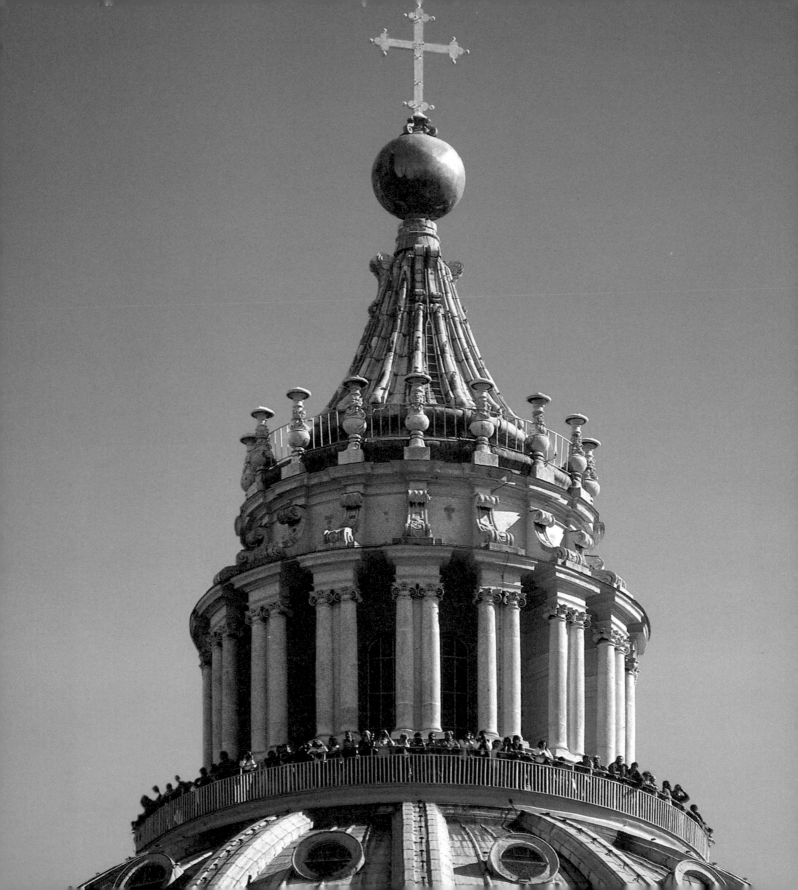

UP TO THE DOME
AND DOWN
TO THE GROTTOES

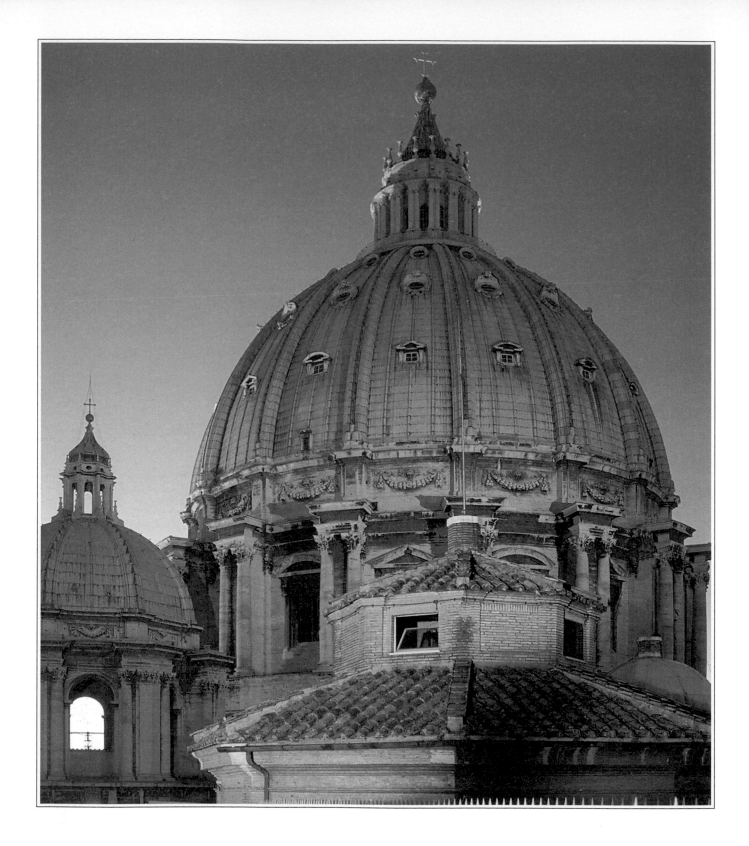

The ascent to the dome is a unique occasion to enjoy unusual views of rooftops and walls, and indeed, all of Rome. Tickets are sold at a window along the right side of the basilica, reached from the atrium, walking past Bernini's statue of Constantine. A line forms behind a barrier—there is always a crowd—and the first sign that the goal is in sight is a notice, ominous in tone, printed in eight languages: "To reach the dome, you must climb 320 steps beyond the elevator. Elderly persons or those who are ill or have heart problems should take this into consideration." The elevator goes to the roof of the basilica, or one can climb what will be a total of 520 steps. For those who are walking, a ticket costs five thousand lire, the elevator route is six thousand. We choose the elevator, and the brick red card we are given reads: "Reverend Edifice of St. Peter's in the Vatican. Dome via elevator."

Vatican language is often quaint. The elevator is placed within the central space of the "Snail leading to the Benedict XIV Lambertini Storeroom." ("Snail" means "spiral," as in spiral staircase.) When we exit onto the roof, a plaque informs us that this electric elevator ("Scansoria cella vi electrica acta," or rising cell moved by electrical energy) was recently installed, under John Paul II. We will read many such plaques during our climb to the dome, and throughout the Vatican, where naming things requires the same commitment as doing them.

At the exit to the basilica roof, the view is so marvelous we don't know where to look first. We are drawn to the lively landscape of rooftops, continually interrupted by skylights, small domes, and out-of-the-way places tucked between the

massive walls. The Sistine Chapel, which floats in midair next to us, also seduces us.

We enter the drum of the dome, where a sign indicates that traffic moves in a one-way direction. Arrows direct us inside, and we find ourselves stunned by the emptiness. The guard informs us that the black letters against a gold field, reading "Tu es Petrus," inscribed all around beneath our feet, are two meters tall.

A very steep spiral staircase, with magnificent views of the city and Monte Mario, leads to the base of the spherical vault, or rather vaults, for the dome is made up of two spherical vaults, one inside the other, and flights of stairs that lead to the lantern are carved out between the two. We run up, slanting to one side as if bracing ourselves against a strong wind. Suddenly we are there, in the "middle eyes," the large oval windows halfway up the ascent. The final stretch is cambered and brings us to the "turn in the lantern," which we navigate, protected by the outer handrail.

We move around the lantern from right to left, beginning from the point where we have at our backs the words "Large Nave"; in fact, before us is the roof of the basilica, looking toward St. Peter's Square. Now we can understand some-

Below: the Sistine Chapel seen from the dome.

thing we once read, that seen from above, the piazza delineates the shape of a key: the obelisk is the central pinhole; the colonnade, the top, outer rounded edge; the two arms connecting to the basilica, the profile of the serrations. The allegory, which refers to the keys of St. Peter, may convey little to those of us who live in modern times, but it helps to know what the creators of this great spectacle had in mind.

Immediately to the left of the colonnade is the papal palace, and we can glimpse the roof garden where the pope takes his afternoon strolls. It is from here that he has sometimes been photographed, with the help of a telephoto lens, during his evening walk, looking pensive amid the potted plants. But without binoculars, we can only see the small arches that overhang the space and some leafy areas between the arches.

Closer, almost beneath us, is the familiar tile roof of the Sistine Chapel, which intersects the roof of the Royal Hall that serves as its antechamber. A little farther off, and more to the left, are the immense walls that surround the Belvedere, the library, and the Cortile della Pigna (the pinecone courtyard, named for the great classical bronze pinecone that was moved there from the arcaded court of the old St. Peter's). The Belvedere Courtyard was once called the Atrium of Pleasure because of the performances and tournaments that were held there. It has been said

The Belvedere courtyard.

that those walls have seen it all, since the Belvedere Courtyard, which once contained knights' banners, is now used for parking. But it sounds worse than it looks, at least from up here. In the Cortile della Pigna, a sphere by the sculptor Arnaldo Pomodoro gleams in the sun like a UFO and acts as a technological pendant to the copper and bronze "pinecone."

From here one can appreciate the best view of the Vatican gardens, picking out the little house of Pius IV, the Fountain of the North Wind, the Gardener's House, the Vatican Radio tower, and the Tower of St. John. Looking past meadows and flower beds, your glance rests upon various struc-

The Government Office Building.

tures that can be seen, one after the other, like knickknacks on a piece of living-room furniture. Above, to the right, is a wooded area, behind the Fountain of the North Wind; to the left, behind a wall, is a kitchen garden, the last still cultivated in the Vatican gardens. It is satisfying to see it, because many insist, even in writing, that there are no longer gardens of this type here. But there it is, with lettuce and artichokes, and two areas with small greenhouses that shine in the sun, in the shape of a scalene triangle, with the equipment shed at the most acute angle, to the left, and access to the steps at the corner of the Mater Ecclesia Monastery.

We are halfway there; now the word "Cattedra," or Chair, behind us, indicates that if we

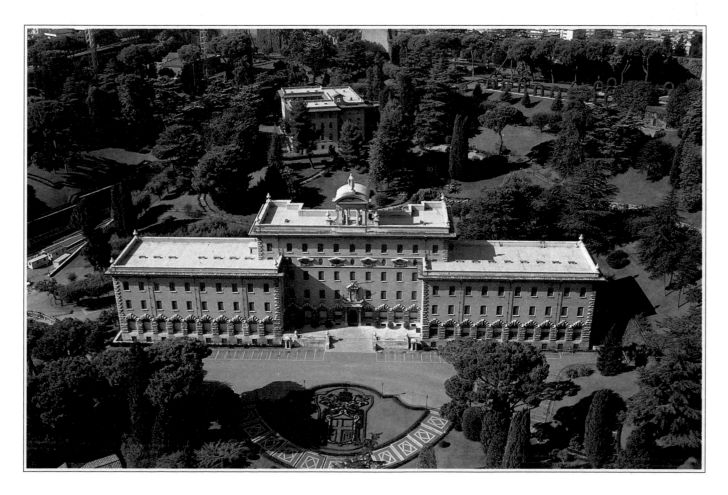

could look through the roof of the basilica, we would see below us the Chair of St. Peter. Here we realize the extent of the Vatican hill excavations that were necessary in the time of Constantine in order to construct the basilica on this spot. They cut down the hill that rose at the back of the tomb, where the apse is now located, and shifted forty thousand cubic meters of earth to fill the hollow that descended toward the Tiber, where the present-day piazza is located. We see the hill, held back by a wall, along the ancient cut that rises steeply behind the apse and seems embedded in it. Before us is the massive bulk of the Government Office Building, and it seems proper to look at it from here, if it is true that Pius XI stood upon this spot when he chose the site for the building.

To the left of the Government Office Building is the railroad station, but there are no trains. I know they arrive every now and then, to unload merchandise, but I have never seen them. Between the station and the little church of St. Stephen of the Abyssinians, an underground parking lot for 250 cars is being excavated, which

Above and right: the new palace of Santa Marta.

Following pages: the cottage of Pius IV, designed by Piero Ligorio, in the Vatican Gardens.

should "restore architectural dignity to the surrounding area," as engineer Massimo Stoppa, Vatican Director of Technical Services, told us. In other words, the Belvedere Courtyard will one day cease functioning as a parking lot.

When we stand with the words "S. Andrea" behind us, we can see the gleaming roof of the Hall of Audiences, with the new Santa Marta to the right and the Palace of the Holy Office to the left. Outside the Vatican, farther ahead and up, above the Propaganda Fide and the Vatican public affairs office, rises a gigantic crane that is excavating the Janiculum parking area. Subsidized by the Italian government, but outside the Vatican territory, it should be able to crowd in a hundred or so buses, as many as are necessary to transport those attending papal audiences, whose numbers will surely increase at the turn of the millennium.

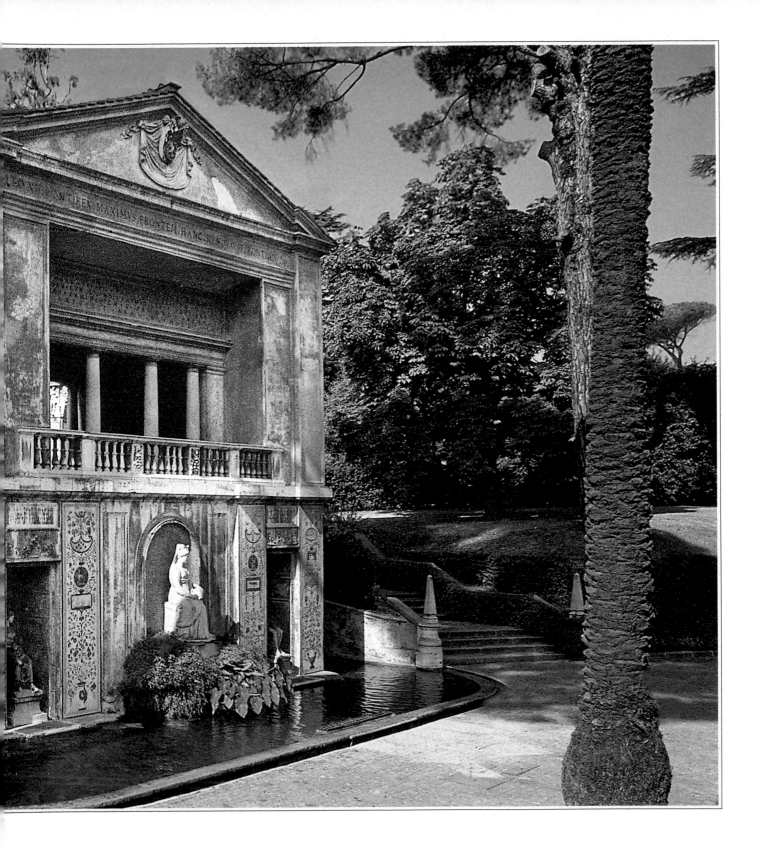

In the background is the Tiber, which has already witnessed this entire millennium and many others.

Redescending from the dome, we stop on the roof of the basilica, where there is a souvenir shop and a mailbox; letters sent from there receive the Vatican postmark. There is also a telephone, which works with tokens and phone cards (but only the "Vatican telephone card"). To call Rome, or any other place outside the Vatican, you must precede the number you are calling with the prefix 2.

The basilica has no paintings; its language is one of stone. Canvases and frescoes were replaced with mosaics in the late eighteenth century, in the belief that mosaic, compared to paintings, "would suffer less the injuries of time." A famous mosaic factory, one that has existed since the late sixteenth century, maintains the old mosaics and creates new ones, makes copies of famous mosaics that the pope gives to guests of state, and executes restorations and copies for outside clients. It is said they use thirty thousand varieties of colored enamels, stored in over ten thousand cases with three compartments each. You can visit the factory, which is located on the ground floor of the hospice of Santa Marta.

With Pope Wojtyla, who has brought the Roman papacy to the center of many global disputes, the work of the St. Peter mosaicists has

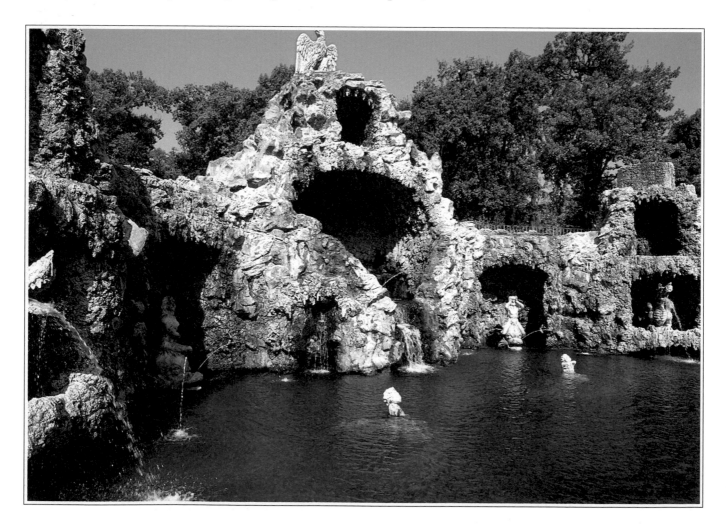

traveled as far afield as Fidel Castro's Cuba. When the pope visited Castro in the Palacio de la Revolucion in Havana on January 22, 1998, John Paul brought the Cuban leader a copy, made in this factory, of *Cristo pantocrator* (Lord of All Things), a charming ninth-century mosaic located in the confessional of St. Peter's, above the tomb of the apostle. Castro liked the gift and told the pope, "It is so beautiful that everyone should see it!" and, with the assistance of Cardinal Sodano, he turned it toward the television cameras.

Women are in a minority in the Vatican, but there is one place, fundamental but little known, where the lead player is a woman. These are the excavations beneath the basilica of St. Peter's. Margherita Guarducci has made an essential contribution to the identification of the primitive tomb of Peter, identifying the bones, deciphering the writings, and familiarizing the world with this mysterious place. This is progress, if you consider that women were once prohibited from entering the "Sacred Vatican Grottoes," under threat of excommunication!

As soon as he was elected in 1939, Pope Pius XII decided to proceed with the excavations beneath St. Peter's, which continued until 1949. In his Christmas radio message in 1950, Pope Pacelli made the grand announcement: "The tomb of the prince of the apostles has been found."

Sixteen years later, Margherita Guarducci has been able to identify some Greek writing (graffiti on the so-called red wall, the first memento of Peter's tomb), which reads "Peter is here within," locating the bones that had been found there, which the excavators had, incredibly, put aside and which were safeguarded in the grottoes. Laboratory examinations attributed the remains of those bones to a male individual, rather tall and robust, between the ages of sixty and seventy. On June 26, 1968, Paul VI made a second announcement: "The remains of St. Peter have also been identified in a manner that we consider convincing."

Left: the Anguillara fountain.

Right: detail of the Galera fountain.

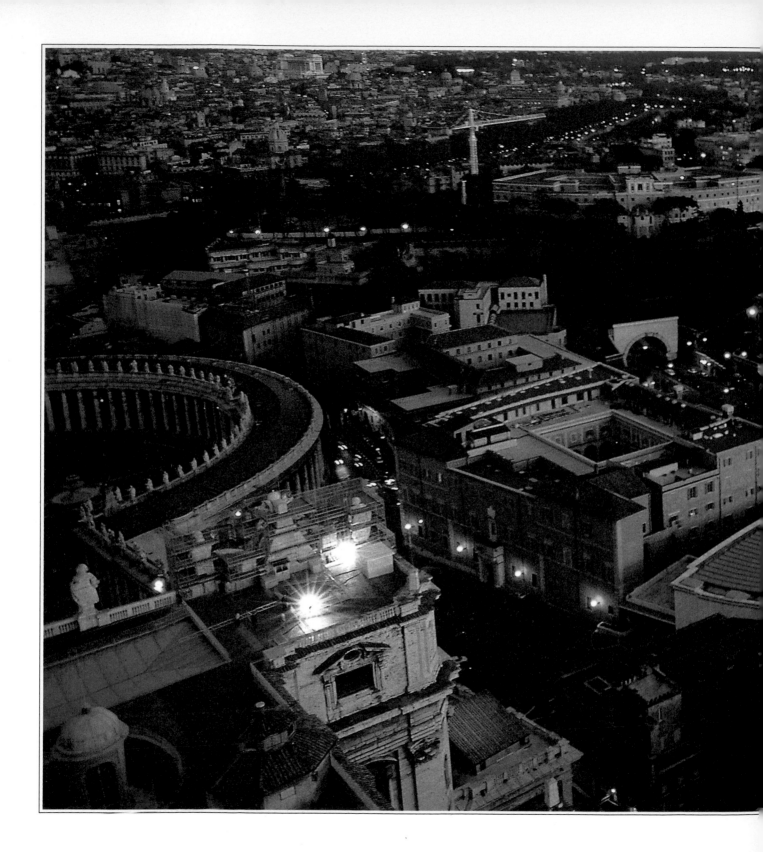

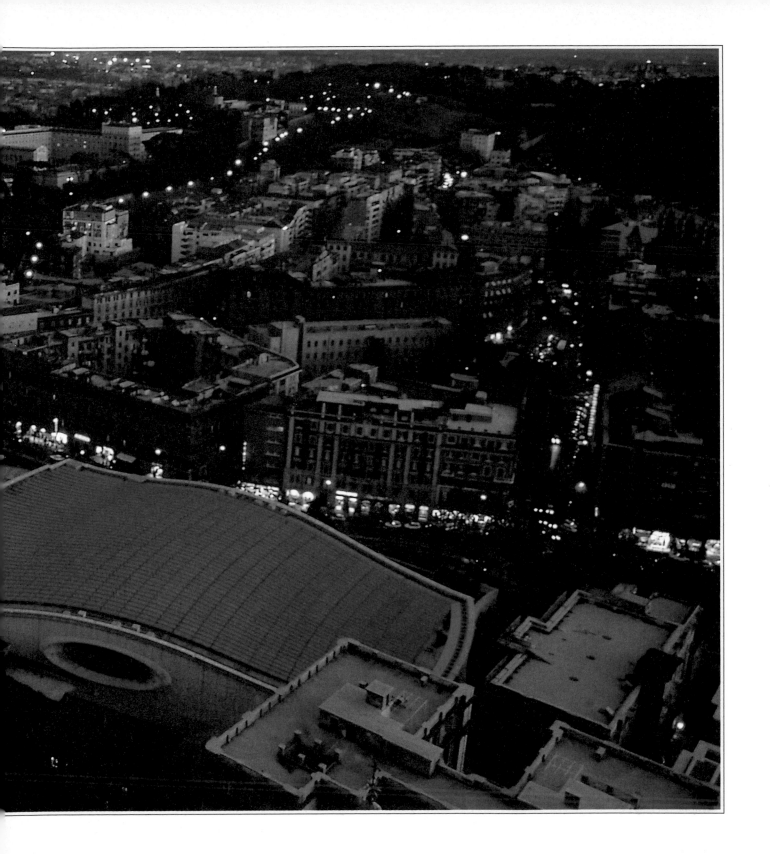

The entrance to the Vatican grottoes.

The emotion felt at finding oneself on the site of Peter's tomb can be sensed, even just descending into the grottoes and pausing outside the niche with the writing "Sepulcrum Sancti Petri Apostoli" (Tomb of St. Peter the Apostle), located six meters beneath the current Altar of Confession. Attention should be given to the meaning of this word: "confession" signifies "witness" given by one who "confesses," that is, affirms his faith with the martyr.

Originally, the site of confession was that of the martyrdom and, by extension, the tomb. Peter was killed, crucified upside down, in the nearby Circus of Nero and was buried here, on the slopes of the Vatican hill, where there was a necropolis.

To visit the excavations, reservations must be made at least a week in advance. A ticket has to be purchased (ten thousand lire per person) at the excavations office, located to the left of the basilica, a bit past the Arco delle Campane (Arch of the Bells).

The excavations have brought to light a small uphill street that runs for about seventy meters beneath the floor of the basilica, intersecting with it at the height of the confessional. The little street is lined with tombs, most of them from the second

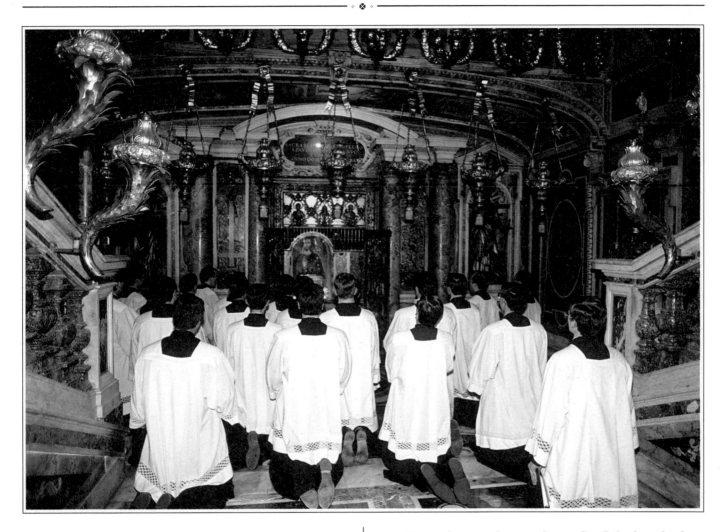

Prayer in front of St. Peter's tomb.

century. It was on this street that the *trofeo* (glorious tomb) of Peter was located. In the late second century, it was described by Gaio: "And I can show you the tombs of the apostles, for if you go to the Vatican or along the Via Ostiense, you will find the tombs of the founders of this church" (that is, the tombs of Peter and Paul).

The tomb of the apostle Peter was decisive for the development of Christian Rome. The Emperor Constantine, after his conversion, established the "bishop's chair" in St. John Lateran, at the opposite end of the city.

But a thousand years later, St. John's, which was always and still is the cathedral, sits in a sparsely populated area of the city, yet lies within the Aurelian Walls. Meanwhile, St. Peter's, which lies outside the walls, in an area that was originally deserted, is now at the center of a populous quarter.

Upon their return from Avignon in 1377, the popes came to live in the Vatican. This choice of a new location was dictated by the development that the city had undergone in the intervening years, completely withdrawing within the imperial walls except for one point, toward the northwest, the area around St. Peter's.

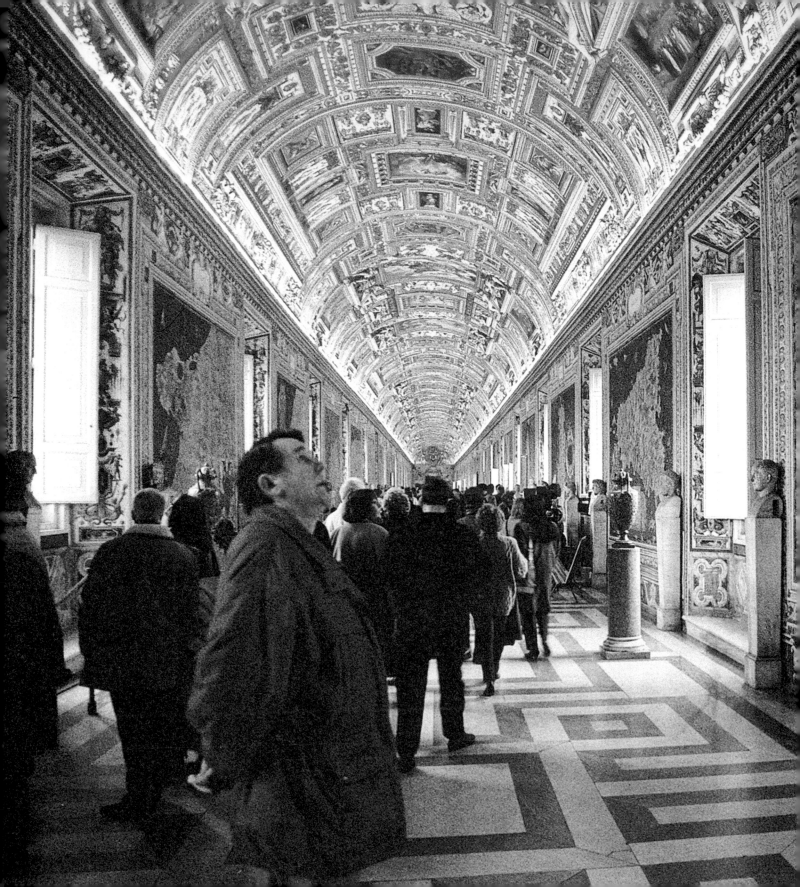

THROUGH THE MUSEUMS, GALLERIES, LOGGIAS, AND CHAPELS

The entire Vatican, like most of Rome, is a palimpsest of epochs, and the Vatican Museums are perhaps the most magical of these compositions. Here, guided by a museum architecture that is unique in its antiquity and continuity of renovations, from the sixteenth century to the present, a single morning can take you from the Etruscans to contemporary art, that is, if your legs and eyes can hold up.

The entrance to the museums is on the Viale Vaticano. If you walk around the walls and enter from St. Peter's Square, it is located two hundred meters beyond the Piazza del Risorgimento. At the entrance, the visitor is greeted by statues of Michelangelo and Raphael, the two major figures to be found on the museum itinerary. And "itinerary" is the appropriate word, for this is not one museum but a score of them, linked by an equal number of museum spaces, with an overall area of forty-two thousand square meters that is open to the public and linear exhibition space of approximately seven kilometers! These museum spaces have complicated names that combine the identities of the patron popes with descriptions of the collections on exhibit, and this can be distracting to those who are less well informed.

For example, the Museo Pio Clementino, the most important for ancient statuary, takes its name from the pope who established the collection (Clement XIV, 1769–74) and the pope who completed it (Pius VI, 1775–99). There are three other museums of ancient sculpture, the Chiaramonti, the Gregoriano Profano, and the Pio Cristiano. The Museo Pio Cristiano takes its name from Pius IX, who established the museum in 1854, and from the fact that it contains sarcophagi, statues, and inscriptions from the early Roman Christian era. The Museo Gregoriano Profano refers to Gregory XVI, who established it in 1844, and to the Roman pagan content of its collection. The Museo Chiaramonti takes its name from Pius VII Chiaramonti (1800–23), who commissioned Antonio Canova for the design. A complete list of the museums reads as follows: Museo Pio Clementino, Museo Chiaramonti, Museo Gregoriano Profano, Museo Pio Cristiano, Museo Gregoriano Egizio, Museo Gregoriano Etrusco, Vaticana Pinacoteca, Collezione d'arte

religiosa moderna, Museo Missionario Etnologico, Museo delle Carrozze.

The first four are museums of sculpture. The Pio Clementino, along with the Egyptian and Etruscan museums, occupies the rooms of the Small Belvedere Palace, located to the left of the entrance to the museums. The Chiaramonti is located on two sides of the Cortile della Pigna and leads into the Pio Clementino. The Gregoriano Profano and the Pio Cristiano are to the right of the entrance to the museums, in a modern building created during the 1960s, at the behest of John XXIII, who wanted the two most important collections in the Lateran palace to be transferred here. With them, in the same building, is the Museo Missionario Etnologico, the contents of which also came from the Lateran. This latter collection is anomalous with regard to all the others, in that it documents cultures and religions of the peoples of Africa and Asia with whom Catholic missionaries came into contact over the centuries.

The Museo delle Carrozze is also different from the others and requires a special permit for entry. Located in a large basement level hall beneath the "square garden" in front of the Vatican Pinacoteca, it was established by Paul VI. The museum contains old papal and cardinals' limousines, landaus, and city and touring cars, from the first cars used by the popes to the model of the airplane that Paul VI flew the first time he crossed the Atlantic, October 4, 1965, when he went to speak at the United Nations.

The ten museums listed above take us barely halfway through the Vatican "museum itinerary."

the face of a sarcophagus, by moving his hand across it. There were some twenty such heads, and perhaps a hundred or so sarcophagi in the corridor, and still others in other museums and throughout Rome and elsewhere. Yet this woman insisted on guiding her blind child's finger around *that* head, saying to him, "You see, here you can feel the smile, here the hair." We should let ourselves be guided by this woman's instinct: we should move through the museums, skipping some things and stopping at others, perhaps singling out a head on a sarcophagus, where we too can look for the smile and the hair.

A charming helical staircase brings the visitor to street level, where the "atrium of the four gates" is located, the old entrance to the museums before the current entrance was opened in the 1930s. You should climb the stairs, even if an elevator is there. The two staircases (one to go up, another to come down) that twist in a helix have comfortable steps and slow you down to an appropriate pace to approach the wonders you are about to see. If you take the elevator, you will see a gendarme, an elevator operator, and a welcome message, written in five languages: "Tipping is not permitted." The ticket office is on the second floor. A full-price ticket costs fifteen thousand lire; a student ticket, ten thousand.

The Vatican favors stone over any other material or language, and its sculpture museums come first and foremost. The Pinacoteca constitutes the most recent portion of the historical museums, and the idea for its establishment came to Pope Pius VII after the plundering of Italy's heritage by Napoléon, who returned to Paris with five hundred wagon loads of stolen artwork, which he installed in the Louvre. After the Congress of Vienna arranged for the return of many masterpieces, the pope wanted them to be kept together in one special museum, as they had been in Paris, rather than dispersed among the various churches and palaces.

The Vatican Pinacoteca cannot be compared in size with the Louvre in Paris, the Prado in Madrid, the National Gallery in London, or the Uffizi in Florence. But it is second to none in terms of quality of artwork and artists in its collection:

There are other galleries, loggias, rooms, halls, drawing rooms, and chapels that contain and connect the various museums or are museums in their own right, such as the Raphael Rooms and the Sistine Chapel. This itinerary has many stages, and we can follow the route suggested by the signs, indicating the possible options at each stage: Galleria dei Candelabri, Galleria degli Arazzi, Camere e Cappella di San Pio V, Stanze di Raffaello, Logge di Raffaello, Cappella di Niccolò V, Appartamento Borgia, Cappella Sistina, Biblioteca Vaticana.

Those who find the mere list of these collections frightening might be interested to hear that one day, in the Museo Chiaramonti, I found a mother helping her blind son to "see" a sculpted head on

Fra Angelico, Giovanni Bellini (*Pietà*), Caravaggio (*Deposition*), Lucas Cranach the Elder, Gentile da Fabriano, Giotto (*Stefaneschi Triptych*), Leonardo (*St. Jerome*), Simone Martini, Melozzo da Forlì, Perugino, Pinturicchio, Nicolas Poussin, Raphael (the entire Room VIII), Pieter Paul Rubens, Van Dyck, Titian, and Paolo Veronese. After visiting the Pinacoteca along with the Raphael Rooms and Loggias, the Borgia Apartment and the Sistine Chapel, the Chapel of Nicholas V and the Collection of Modern Religious Art (predominantly paintings), we can conclude that it is part of the most vast and homogeneous and perhaps highest quality pictorial treasure-house in the world. I would personally suggest stopping at Giotto's *Triptych*, which was in the old St. Peter's. A nostalgia for that basilica of Constantine, which we have often noticed in our travels here, follows us throughout the Vatican. As a museum installation, Room IV is extraordinary, with Melozzo da Forlì's *Apostles and Angels Playing Instruments*, frescoes removed from the Roman basilica of the Holy Apostles: they float against a white wall, at eye level, and you have the feeling you have ascended to heaven.

The Collection of Modern Religious Art is the offspring of the Vatican Museums, established at the request of Paul VI. The title is meant to have an emphasis on religious art, but the point of view is broader than that. The collection includes about eight hundred paintings and sculptures by two hundred and fifty contemporary artists. I will mention a few names, by way of a challenge to those who might still think that Vatican art stopped with Canova: Francis Bacon, Umberto Boccioni, Georges Braque, Carlo Carrà (*Pietà*), Marc Chagall (*Crucifixion, Christ and the Painter, Red Pietà*), Salvador Dalì (*Annunciation*), Giorgio de Chirico (*Nativity, Conversion of Paul*), El Greco, Pericle Fazzini, Lucio Fontana, Paul Gauguin, Renato Guttuso, Oskar Kokoschka, Giacomo Manzù (the twenty-five pieces of the enchanting Chapel of Peace), Marino Marini (*Rider*), Henri Matisse (the furnishings for the Vence Chapel), Francesco Messina, Amedeo Modigliani, Henry Moore (*Idea for Crucifixion Sculpture*), Giorgio Morandi, Emil Nolde, Pablo Picasso, Auguste Rodin, Georges Rouault (perhaps the most significant Christian painter of the century; an entire room is dedicated to his work, with his twenty Miserere engravings), Mario Sironi. As for my personal favorite, every time I go there I remain transfixed before a small bronze by Ernest Barlach, *Die Lesenden Moenche* (*Monks Reading*, 1935); the two little monks share a single book and the same air of sadness—perhaps they are reading about the Passion of Christ, or perhaps they are feeling the onset of war.

The walk that leads from the Belvedere to the papal palace is a beautiful one, through galleries of candelabra, tapestries, and geographical maps, with a view out to the Belvedere and Pigna Courtyards on one side, and the Vatican gardens and apse of St. Peter's on the other.

The Gallery of Geographical Maps, as its name

suggests, contains maps of all the regions of Italy. We move from there into the Loggia of Cosmography, also known as the Third Loggia, or the Loggia of the Secretary of State, located on the fourth floor of the papal palace. It overlooks the courtyard of St. Damasus and ends at the Gallery of Urban VIII, in the Vatican Library. The Loggia of Cosmography contains frescoes on the walls, illuminated by daylight from the large windows; these works depict the nations of Europe, Asia, and Africa and were executed between 1560 and 1564 by Antonio Vanosino from Varese, based on cartoons by Ètienne Dupérac. They were a novelty for their time, and indeed an interest in the world at large was unusual then and predates Enlightenment cosmopolitanism and the modern international world view. The collection of the secretary of state is also fascinating, with objects collected from all over the world. The Vatican Library contains planispheres, terrestrial and celestial globes, planetary and geocentric spheres, planetary and world maps, and even a "planetary clock." It makes one wonder how the dispute with Galileo could have happened, with such passion for the features of the heavens and the earth cultivated amid these walls!

Then we enter the Sistine realm, where the papal palace assumes the form of a medieval castle, and where passage over balconies and circuitous walkways is more suggestive perhaps of those very walls frescoed by the great painters. We arrive at the Sistine Chapel, the site where the popes are elected but also a place of unfathomable history: Michelangelo's figures already populated the vault when German mercenary troops turned the space into a stable for horses.

Two sayings of Pope Wojtyla are connected to the Sistine Chapel. One defines the space as a "sanctuary of the theology of the body," and this is an expression that tells us a great deal about how Christians will look upon human love in the coming millennium. The other was pronounced at the moment of his election, in response to the question if he accepted the call to become pope: "Despite the great difficulties, I accept."

The pope performs a baptism in the Sistine Chapel.

Celebrating mass in the Sistine Chapel on April 8, 1994, for the first time since the restoration of the *Last Judgment*, John Paul described the emotion he felt when he was elected: "In this place, the supreme cardinal of Poland said to me, 'If they elect you, I beg you to not refuse.'"

In this same homily—given while he held his papers in his left hand because his right one was bothering him, following a fall the previous day during an excursion in the Abruzzi—Wojtyla recalled the "audacity" of Michelangelo in depicting "the glory of Christ's humanity," and he cited the Second Nicene Council, the "last of the undivided Church," which that audacity had authorized, since it "rejected the position of the iconoclasts." A "Christian innovation," the pope calls it; and in fact, Judaism "excludes any depiction of the invisible Creator" and "Islam adheres to a similar tradition." Seeing the pope on television in the Sistine Chapel, one makes this bold link between centuries and millennia: Judaism prohibited images; Christianity favored them; Islam returned to fearing them; the uncertain populations of some centuries were caught between one commandment or another; and finally, "Christian innovation" triumphed, with Michelangelo's "audacity" up to the age of television, which may perhaps give a decisive advantage to the faith that has supported the idea of visibility.

Finally, the theology of the body: "This chapel is the sanctuary of the theology of the body," the pope said that day. And again, "It seems that Michelangelo allowed himself to be guided by the suggestive words of the book of Genesis, which, regarding the creation of man, male and female, emphasizes: they were naked, but they felt no shame." Important words. If they seem difficult to us, we can limit ourselves to observing the scene with the apple on the vault, where the nudity of the man—still innocent—is juxtaposed to the face of the woman. And we can sit on the benches at the back on the left and look up at the last sibyl on the opposite side, the Delphic Sibyl. The beauty of her female glance tells us that turmoil was not the only force at play in Michelangelo's life.

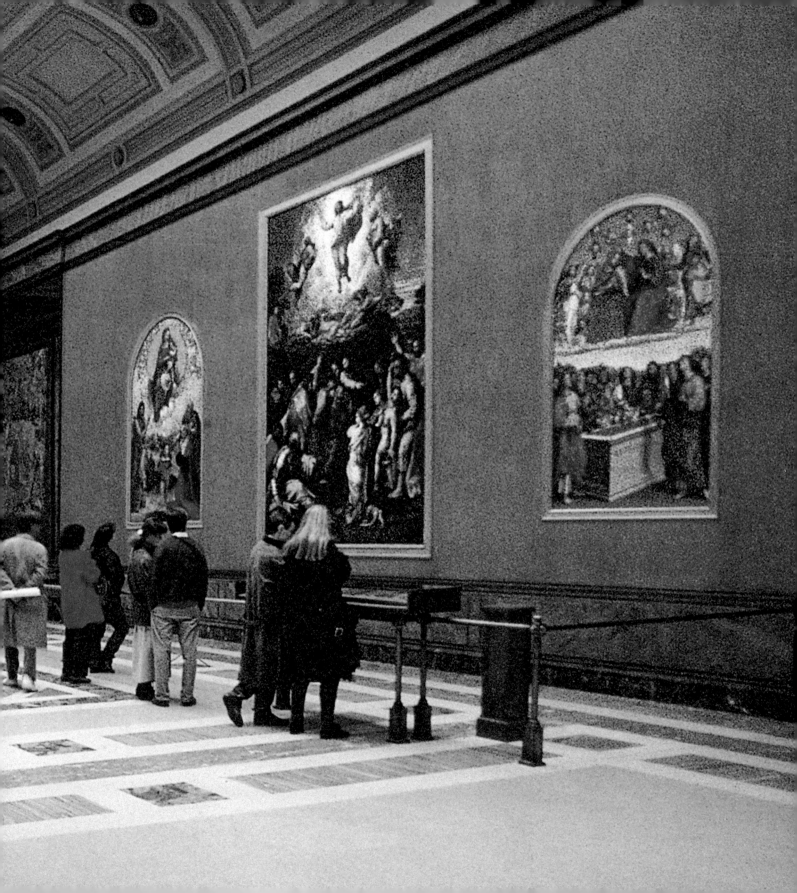

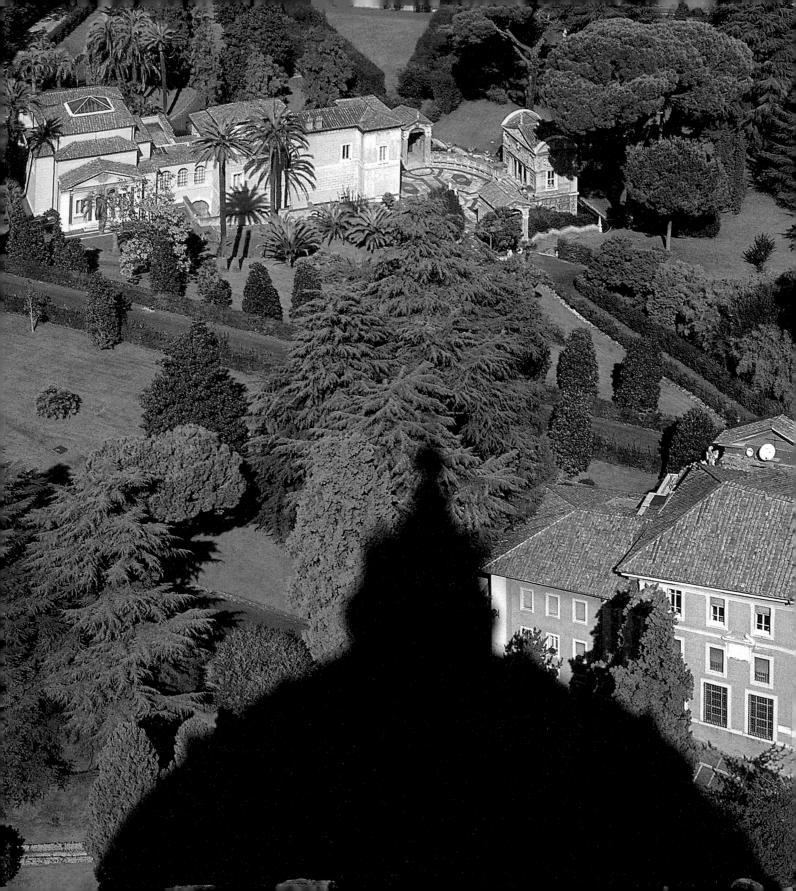

A TOUR
OF THE GARDENS
AND THE WALLS

A visit to the Vatican gardens is a pleasure, even if they are not as extraordinarily beautiful as they were once said to be. For the guided tour with a bilingual guide, a ticket must be reserved in advance and purchased (eighteen thousand lire) at the Information Office for Pilgrims and Tourists in St. Peter's Square, along the Charlemagne Wing that links the facade of the basilica to the colonnade on the left. The bus takes you as far as the high portion of the gardens, where you get out and finally walk around, among the pines and oak, olive and magnolia trees, stretches of Italianate gardens and wooded areas, vegetable gardens and fountains, remains of the ancient Leonine Walls with two towers, a seminary and a convent.

The seminary is the Ethiopian College, which used to be called the Hospice of St. Stephen of the Abyssinians. Part of the building is inhabited by the *Pie discepole del Divin Maestro*, who operate the Vatican telephone exchange. The Mater Ecclesiae (Mother of the Church) convent was instituted by John Paul so the Vatican might have a community dedicated to contemplative prayer in support of the papal ministry; the sisters alternate, eight at a time, coming from various orders, with the first group coming from the Order of Poor Clare.

The Ethiopian College and Monastery are located halfway up the garden hill, one on the left, the other on the right. The tour bus climbs rapidly to the Tower of St. John, which stands at the highest point of the gardens. John XXIII loved this tower and had it restored and lived there for brief periods. In 1979, John Paul II stayed there for a few weeks during the renovation of his private apartment in the papal palace. The tower is often used to house guests of honor, such as the patriarchs of Constantinople—Atenagora (1967), Demetrius (1987), and, most recently, Bartholomew (1995). In 1971, the Hungarian cardinal Josef Mindszenty stayed there, after Paul VI called upon him to leave Hungary (where he had lived for fifteen years, a refugee in the Untied States Embassy in Budapest) and before he moved to Austria.

After visiting the tower, visitors are directed to the heliport, located at the most distant point of the Vatican gardens, within the last rampart. It is

identical to one at the papal villa in Castel Gandolfo. The pope uses it to leave the Vatican when he must go to the Fiumicino airport in Rome for visits abroad or to Ciampino for flights within Italy. He also uses the helicopter to go to and from Castel Gandolfo, without getting stuck in Rome traffic. Heads of state also use this heliport when they visit the pope. When it is not being used, its reinforced concrete platform, which measures 32 x 26 meters, is sometimes used for maneuvers of the Swiss Guard for their formal drills in preparation for their swearing in. The heliport was constructed by Paul VI in 1976, and a Latin marker identifies it as "Helicopterorum portus."

It seems that Paul VI used the heliport only four times, but John Paul has taken off and landed from there countless times, perhaps five hundred, given that in the first twenty years of his papacy, he has left there more than two hundred times for his usual "pastoral" visits, and for each of those, there has obviously been a return trip. And since everything the pope does must be rationalized, this is what we are told about the heliport, in Pope Wojtyla's words: "Many say that the pope travels too much and too frequently. I think, speaking from a human viewpoint, that they are right. But it is Providence that guides us and sometimes suggests to us that we do something *per excessum*" (said during his flight from Abidjan to Rome, returning from his first Africa trip, on May 12, 1980).

As long as they were able to leave the Vatican, the popes took little notice of the Vatican gardens. Devotion to the gardens began with Pope Pecci and ceased with Paul VI, the first pope who truly traveled the world, after many years of confinement within the Vatican.

"It was Leo XIII who made the avenues, in order to go up the little hill in his carriage. He went every day, around sunset, when a picturesque procession came to fetch him in his throne room. Two Swiss guards with halberds, two noble guards with drawn sabers, then the sedan chair carried by four chair bearers in red uniforms, then the commander of the noble guards and the privy chamberlain, then two more noble guards and two Swiss guards" (Silvio Negro). Leo

XIII also had a vineyard planted in the gardens: "There was nothing stranger, according to those who witnessed it, than seeing Pope Leo walk along the rows of vines, leaning on his cane, his feet on the grass, accompanied by the vine-dresser ahead of him, the prelate behind, and the commander of the noble guards, his hand on his baton."

Pope Leo's vineyard was in an area well exposed to the sun, near where a water cistern was later built. The area set up for hunting, with nets to catch migratory birds (sparrows, green- and goldfinches), was high up the hill, to the right, looking up from the dome of St. Peter's, a bit beyond the shrine to the Madonna of the Guard. The pope would go there at dawn during the month of October, when the birds were migrating, and his hunter, a certain Anzini, would already be there:

"The pope simply stood there watching, but taking keen interest in what his employee was doing. For every hundred birds he captured, he received a special price of thirty soldi." (Silvio Negro)

The tour of the gardens over, the guide accompanies us back to the Arco delle Campane and shows us a marker on the ground, in the Piazza of the Protomartyrs, which reads "Site of the Vatican obelisk until the year 1586" and offers evidence of the noble prose of the Vatican epigraphists, heirs to Baronius and Tacitus.

On the way to the exit, we pass the Hall of Audiences on the right, built by architect Pierluigi Nervi and inaugurated by Paul VI on June 30, 1971. Over the century, papal audiences have grown, thanks to easier means of transportation and to the increased popularity of the popes. Pius XI gave speeches at every official encounter, but there wasn't a fixed place or day; he used the various rooms of the papal palace, depending on the size of the group, and his talks were impromptu. Under Pius XII, who began to present written speeches, those rooms no longer sufficed, and the pope had to use the Hall of Benedictions. John

The pope's helicopter lands in the garden of Castel Gandolfo.

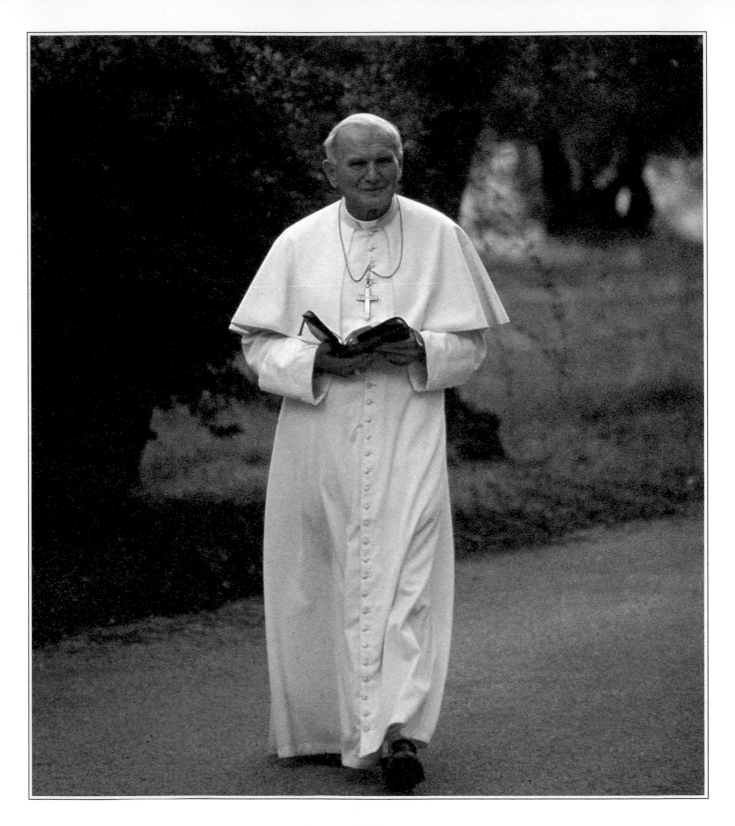

XXIII established the practice of holding a general audience on Wednesday, in St. Peter's. Paul VI wanted to have this hall built "to free the basilica of St. Peter's from the heterogeneous and lively multitudes that usually fill our general audiences," as he said the day the hall was opened. Wednesday was chosen for the general audience so that there would be two weekly appointments, with space between, set aside for the growing crowds of pilgrims: Sunday at noon, for the greeting from the window, and midweek, for the audiences.

Exiting the Vatican, we can tour the Vatican walls, a walk that takes three-quarters of an hour. We start out from St. Peter's Square, walking clockwise around the walls. We pass beneath the colonnade, in front of the entrance of the Charlemagne Wing, which is almost always closed, except when exhibitions are held there, and we immediately find a gate, called the Cancello Petriano, or Peter's Gate, since, after all, everything in the Vatican must have a name.

The Cancello Petriano is the most recent entrance to the Vatican and is the one through which most people pass. It was built in 1971 and

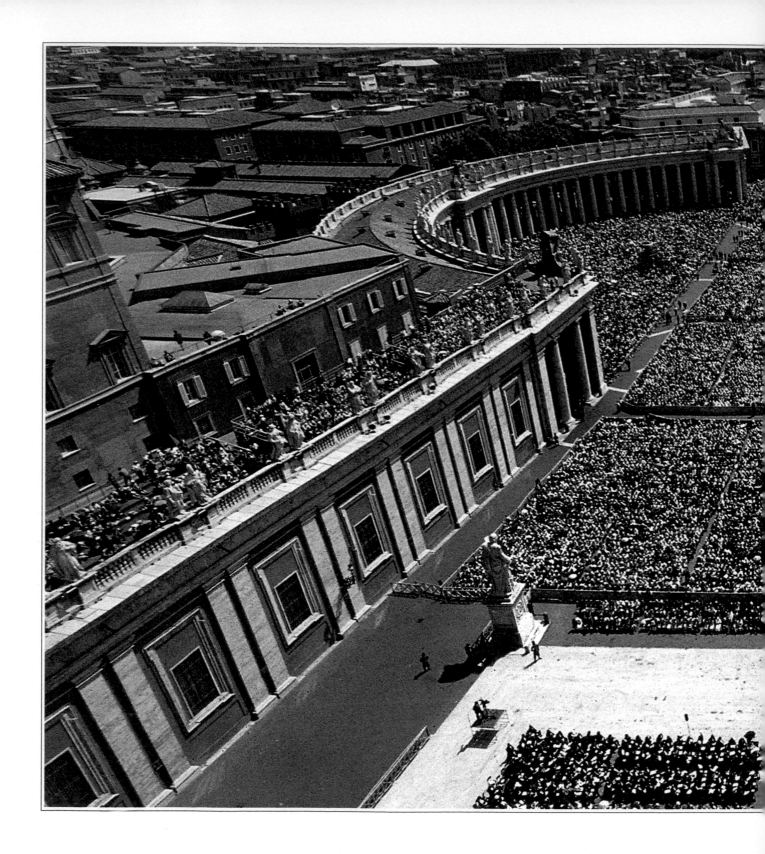

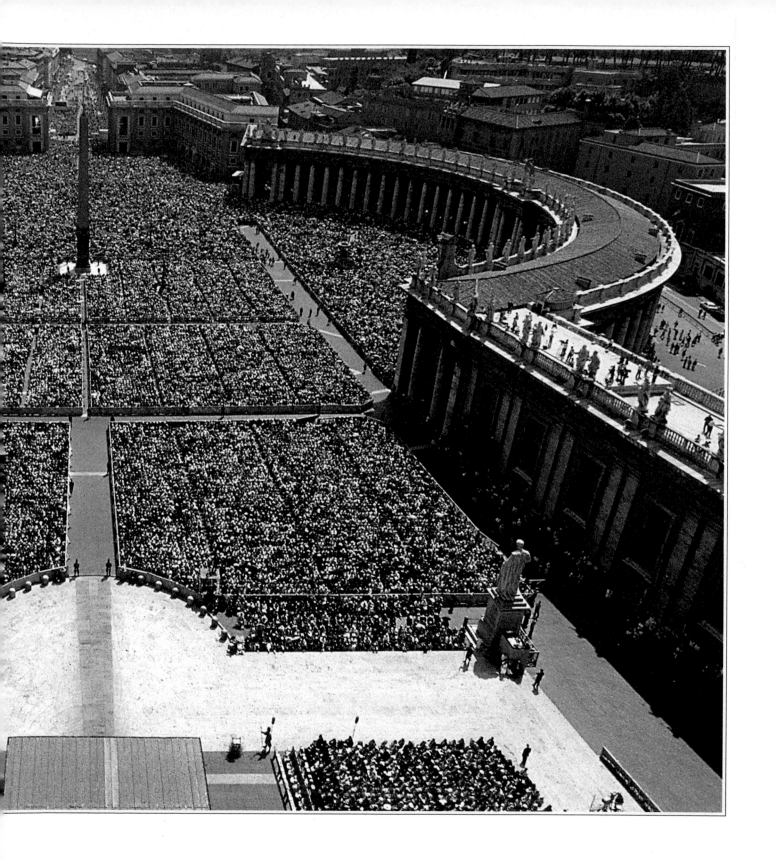

closes off the large square leading to the Hall of Audiences, linking the Palace of the Holy Office to the Charlemagne Wing. It is called Petriano because this was the area of the Museo Petriano, a sort of St. Peter's museum. We pass by a Swiss guard; it's now midday, and he is dressed in his uniform of amaranth and deep blue stripes, but at six in the morning, when one of the five openings in the gate is open, the guard wears his blue barracks uniform, which he will put on again an hour before closing time, scheduled for eight in the evening.

The Palace of the Holy Office doesn't look like much from the outside. This is where those accused of heresy, schism, apostasy, magic, sorcery, divination, or abuse of the sacraments were judged. There was a "prison courtyard," but the prisons themselves were eliminated during the

Below: a fragment of the Berlin wall, now in the Vatican Gardens.

Right: the Vatican Gardens still house the kitchen gardens that provide all the fruits and vegetables.

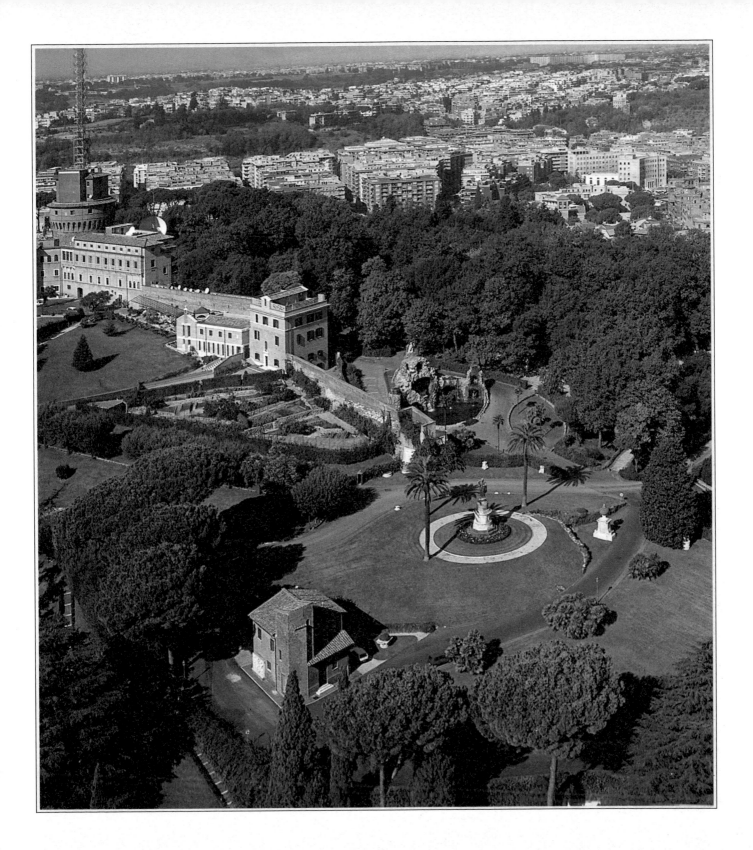

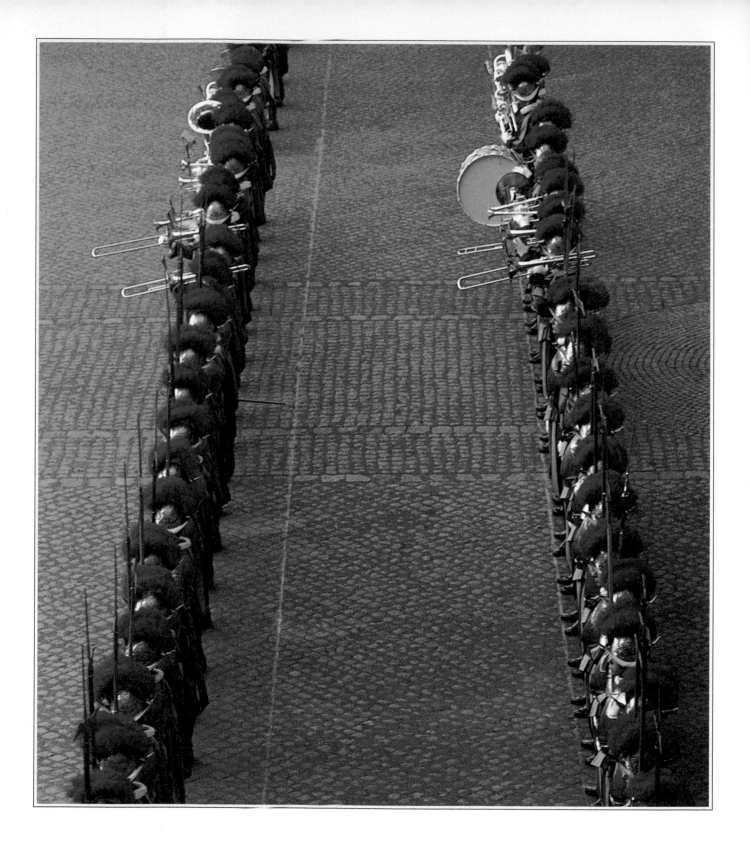

1921 renovations. It was in this palace, in the Hall of the Congregations, that Galileo was summoned to tell the truth "under pain of torture," on June 21, 1633.

Beyond the facade of the Holy Office, at number 9A Piazza del Sant'Uffizio, is a sign that reads "This house is a gift of Mary. Missionaries of Charity": it is the most recent Vatican institution, if one might call it that. Next to the intercom it says: "House of welcome for the poorest." It was opened in 1988, under Pope Wojtyla, at the suggestion of Mother Teresa (who headed the Missionaries of Charity). It was meant as a response "to the serious problem of the homeless in Rome." Thanks to that "small, great woman," as John Paul once called her, the Vatican now has a doorbell that the homeless can ring. Once inside, they find dormitories that can hold seventy people, an infirmary, and a refectory with one hundred seats.

The Vatican, the walls of which repudiate nothing, is an incredible historical palimpsest: traversing a mere fifty meters, we have gone from Galileo to Mother Teresa!

We turn into Via di Porta Cavalleggeri (Street of the Cavalry Gate), which got its name from the fact that, prior to their transfer to the Quirinal in the seventeenth century, the "light cavalry soldiers," a special division that guarded the pope, were housed here.

The low and scarcely visible wall next to which we are walking should not be underestimated; it is one of the few surviving stretches of the true Leonine Walls. It then turns into a more recent section, tall and ribbed with stones. But this low, ancient part is a reminder of the harsh era of Pope Leo IV and his predecessor Sergio II, when, in the year 846 A.D., a Saracen horde disembarked at Ostia and spread through Rome but found the enclosing wall and proceeded to plunder only those areas that stood outside, namely the basilicas of St. Paul and St. Peter.

The later walls, constructed during Renaissance times (between 1431 and 1562) and continually restored over the centuries, are the mature result of Italian military engineering at the transition from the era of bayonets to the era of firearms. And the great architects of the time, who

Above and left: the Swiss Guards in a parade on the day of the swearing in ceremony.

fought interminably among themselves, had a hand in this ongoing project: Bernardo Rossellino, Antonio da Sangallo the Younger, Michelangelo Buonarroti. In fact, these walls are a grand spectacle as they move up and down the hill, a spectacle that is unjustly ignored by the visitor, who already finds so much to see in the Vatican that it doesn't occur to him or her to pay attention to what surrounds the city. Thus tourists are content

with that bit of wall they see in order to reach the entrance to the museums, walking from St. Peter's Square. Unfortunately, that low portion is less interesting, lacking the drama of the walls at the crest of the hill.

We have now arrived at Via della Stazione Vaticana, which leads to the viaduct on which trains pass as they go from St. Peter's Station, in Italian territory, to the Vatican Station, passing over the Vatican wall. This is the vehicular entrance: midway down the street is the Via del Perugino passageway (where trucks and vans enter) and at the end, the entrance for trains. Very few trains pass by, and they consist solely of freight cars. They whistle before passing through the gate with the coat of arms of Pius XI, scaring the cats sleeping in the area.

The Valle del Gelsomino, the Valley of Jasmine, lies between the St. Peter's Station and the Vatican Station. The train traverses the valley over a masonry viaduct. Two twin flights of steps, always deserted, bring us down from the Vatican wall to the Via Aurelia and back up again, after we have passed beneath the railway viaduct. The flight we take down is called the Aurelian Steps, while the one we take up is called the Viale Vaticano Steps.

We follow Viale Vaticano for most of our remaining walk, which is hilly and more spectacular in terms of the architecture of the walls and ramparts, until we redescend into the city, to the Prati quarter. The roadway is quiet now, with a beautiful view of the retaining wall with pine trees above. Among the pines, you can spot a Vatican Radio antenna, looking like a high-tech kite. We are now at the highest point, and looking around, we can see the dome beyond the wall, which appears to be at our same altitude.

As we pass the Tower of St. John, young olive trees project outward from the wall. A bit farther ahead, we arrive at the highest rampart, the one most distant from St. Peter's Square, where the heliport is located. Small red lights on metal poles run along the wall, signaling to pilots who need to land under misty conditions or at dusk.

We turn around the buttress and begin the descent toward the entrance to the museums. The wall protrudes and recedes in such a way that it

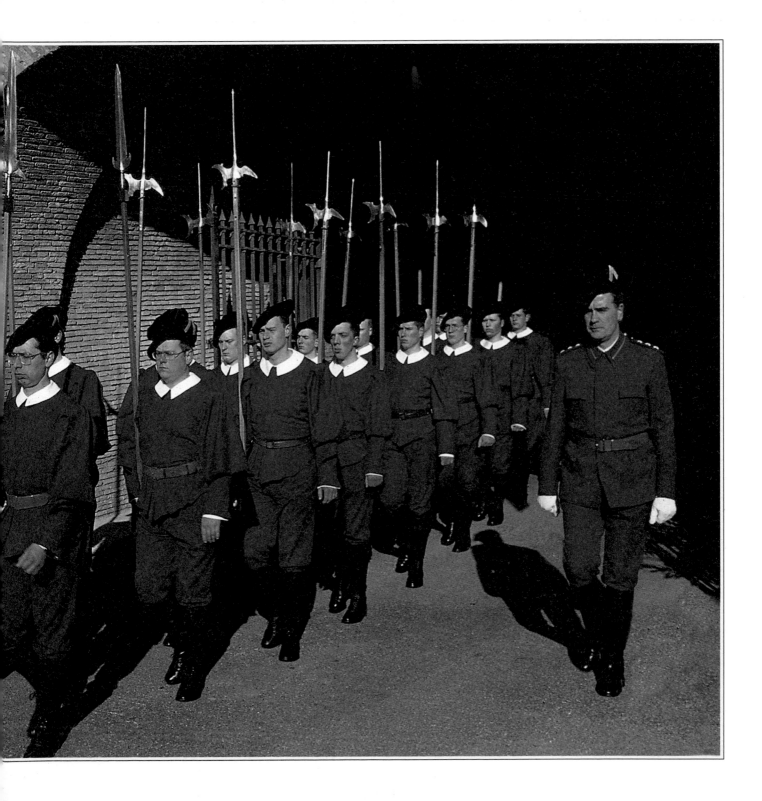

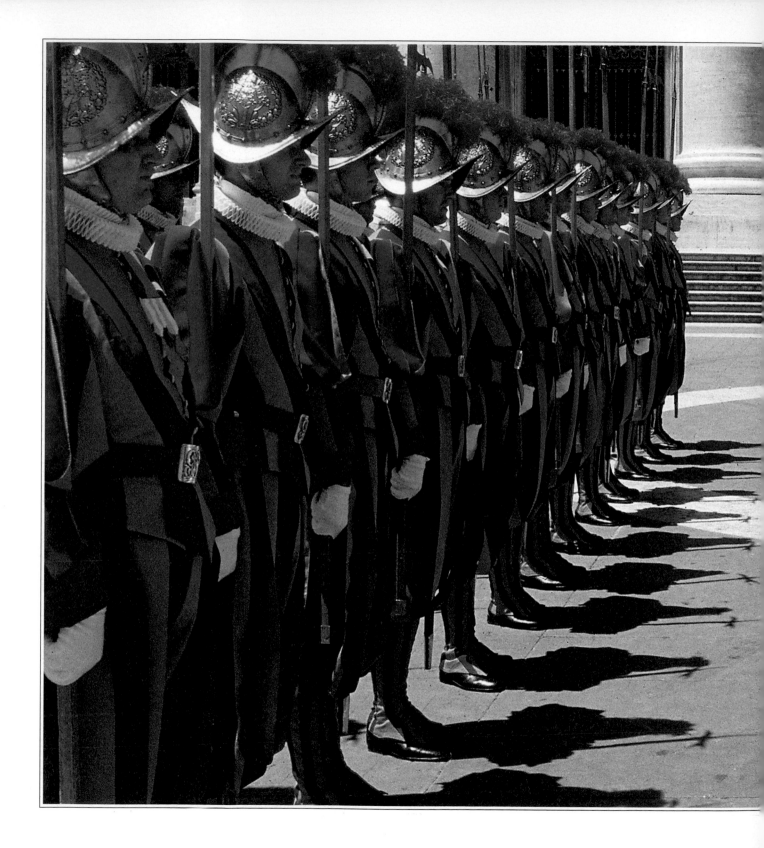

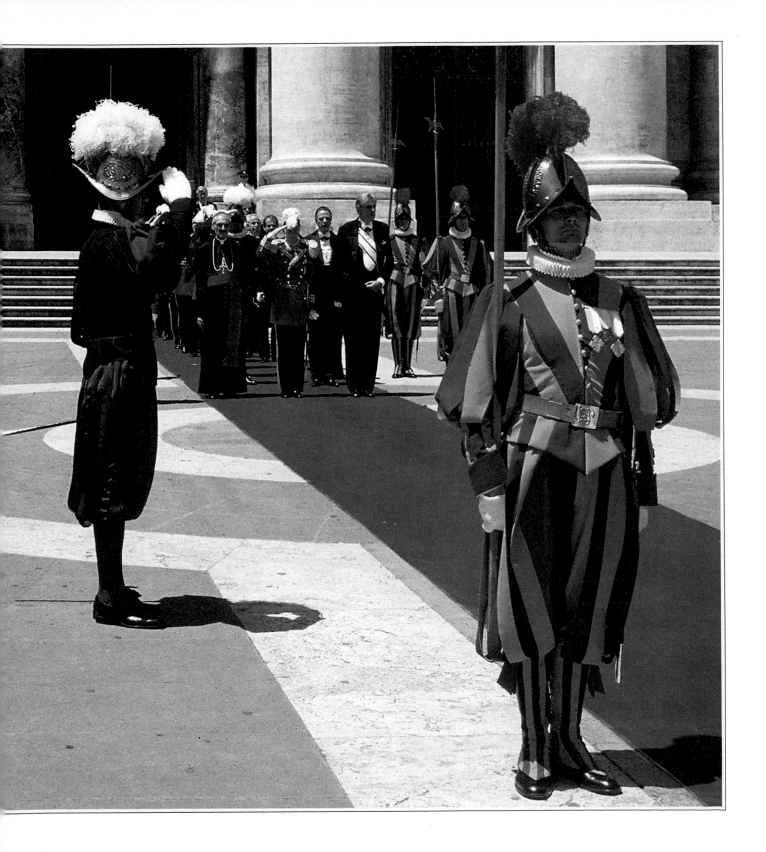

offered ever changing views for the cannons that once lined the ramparts. Now it offers beautiful views to the wayfarer. Halfway down, we see rising above the wall the curve of a small hill, covered with pine woods, and then a group of palm trees beneath the rampart, like girls locked arm in arm for a group photo.

Where the Viale Vaticano leads into the Via Leone IV (named after the pope of the Leonine Wall), at the end of our descent, the wall terminates in a beautiful bulwark, one of the best appointed in the entire city, the Belvedere Rampart. It was built by Antonio da Sangallo and Michelangelo, to whom it is commonly attributed, and indeed the Via Leone IV soon becomes the Viale dei Bastioni di Michelangelo.

Turning down the Via di Porta Angelica, after barely thirty meters, the noble wall completely comes to an end, leaving only a small red wall surmounted by some wire fencing, indicating the Vatican's boundary line. Beyond the fence, we can glimpse the power plant and the gendarmes' barracks. One hundred meters beyond, the wall resumes and accompanies us to the entrance of the Porta Sant'Anna.

Here we are, at the Passetto di Borgo, which emerges from the Vatican wall. This passageway extending for about eight hundred meters and joining the Vatican to Castel Sant'Angelo, already existed in the first fortifications of Pope Leo's city, but what we see today is quite different, as it has been altered and partially rebuilt numerous times. It had, and still has, a corridor in its upper portion that allowed the popes, during times of attack, to seek refuge within the fortress of Castel Sant'Angelo, without going out in the open. The last pope saved by this passageway was Clement VII. On May 6, 1527, at dawn, German mercenary troops spread through Rome and the Vatican, and 147 Swiss guards died defending the basilica. The pope fled through the corridor, along with the court historian, Paolo Giovio, who relieved the pontiff of his priestly robes and threw over his shoulders the historian's own purple cloak so that, as they crossed over the wooden bridge that, at the end, joined the wall to the castle, the "barbarians" would not recognize the

pope's white garment. This is the same Paolo Giovio who wrote in Latin that, in the excitement of the escape, it seemed that there were three thousand people following Clement into his refuge, including cardinals, scribes, women, and children.

Now that our walk is over, we can name the different approaches to the Vatican we encountered: the Arco delle Campane, the Cancello Petriano, the truck passageway off the Via del Perugino, the

The tracks of the train that runs within the Vatican.

entrance to the Vatican Museums, the Porta di Sant'Anna, the Great Bronze Door. Naming them off, we learn another concept: that each of these entrances has a different name: arch, gate, door, great door, passageway, entrance. This, too, is a rule of the city of the pope: within, one man alone rules over all, but each holds onto his own name.

Following pages: the pope with Mother Teresa of Calcutta.

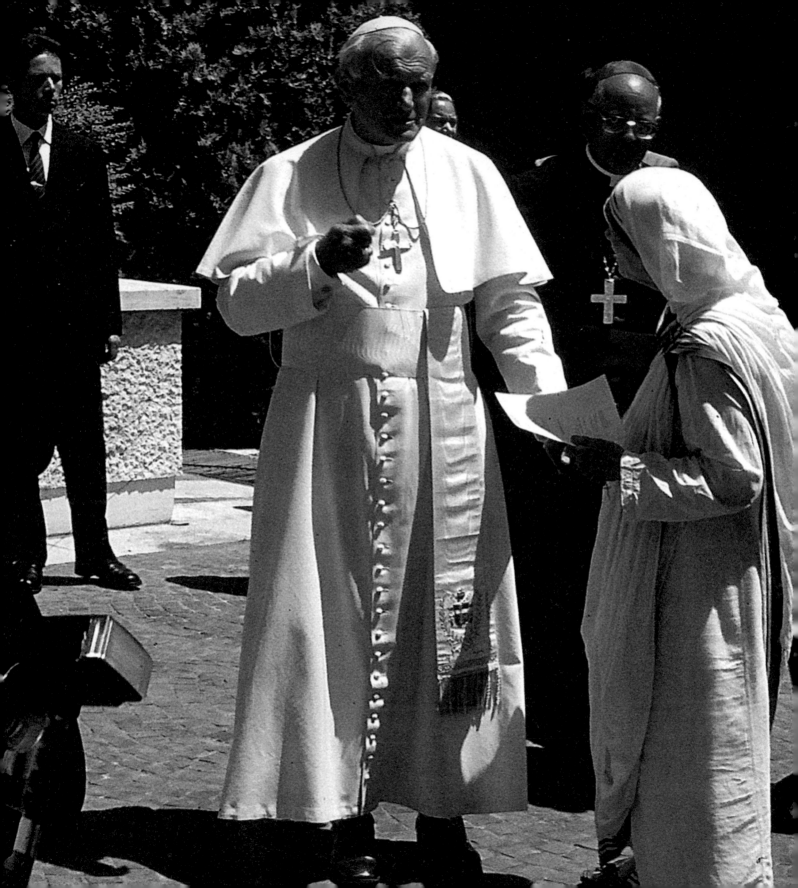

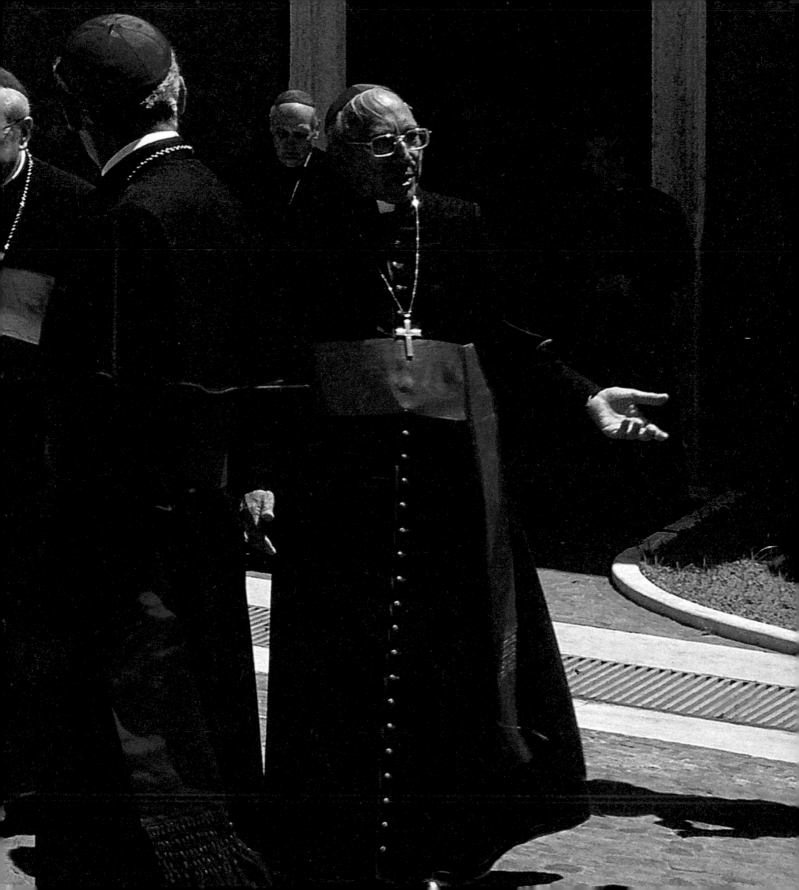

HIS EMINENCE'S TRAIN

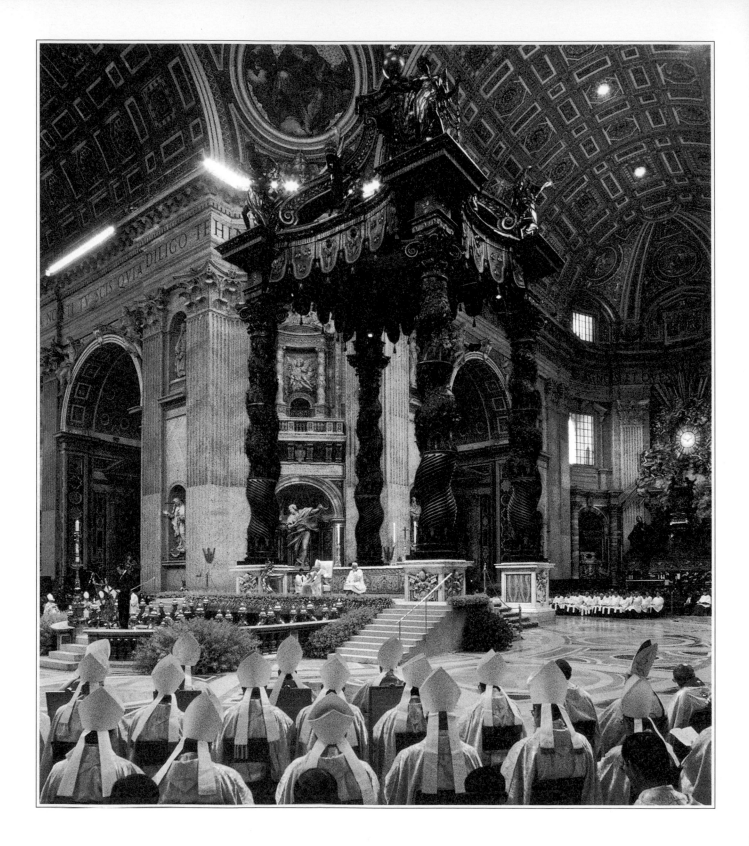

In the Vatican, the cardinals are next in rank after the pope. No one cardinal is considered higher than the others, not even the secretary of state. Not even the most highly honored, the cardinal dean of the sacred college, commands the others. Nor does the Camerlengo, although yes, he does rule, but only during a "vacant see," that is, between the death of one pope and the election of his successor. But the cardinals joined together as a group do, indeed, rule. And there are infinite ways to describe their various meetings: meetings, committees, commissions, councils, concistories, congregations. Congregations above all! An understanding of the word "congregation" provides a key for understanding the Vatican.

In the Vatican, even modern things are attached to ancient names, such as the supermarket, which is called an annona, or provision office. Often either the name or the thing itself relates to the past. This is the case with "congregation," which is an ancient word, coming from the Latin *congregatio*, which means meeting. "Congregation of cardinals," then, means meeting of cardinals. And general congregation means meeting of all. But by extension, in the Vatican, congregation also signifies ministry or department; for example, Congregation for the Doctrine of the Faith (the former Holy Office).

This expansion of meaning is explained by the fact that almost all pontifical departments originated

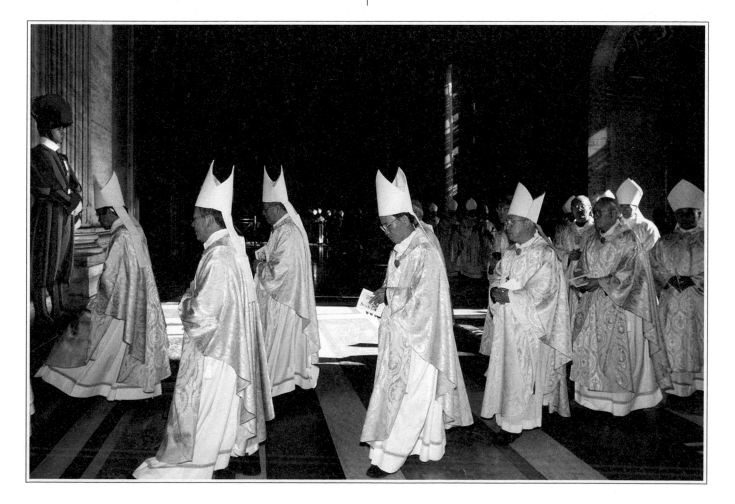

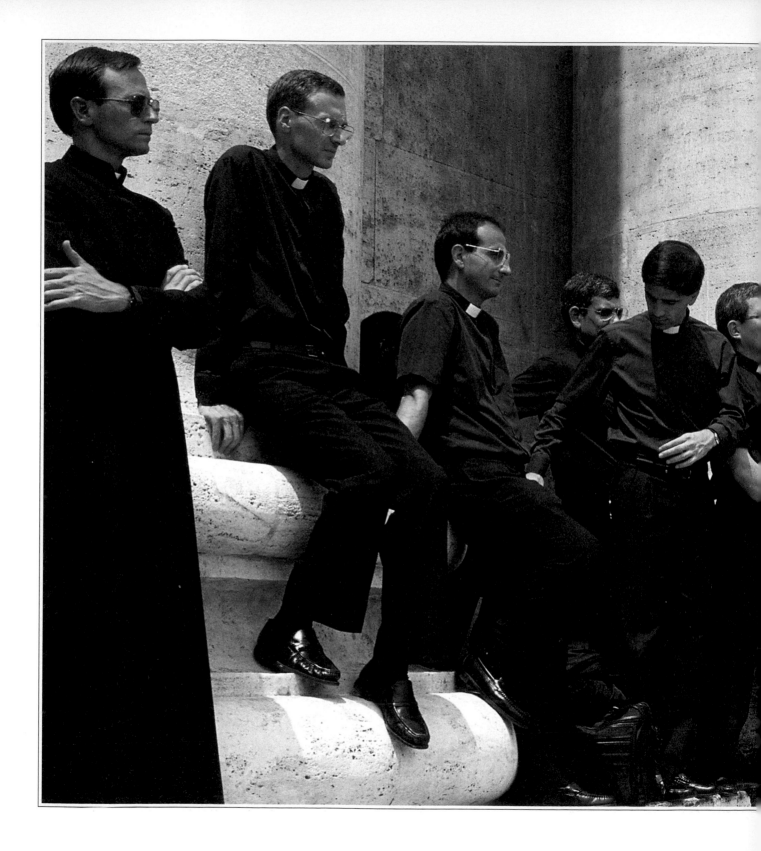

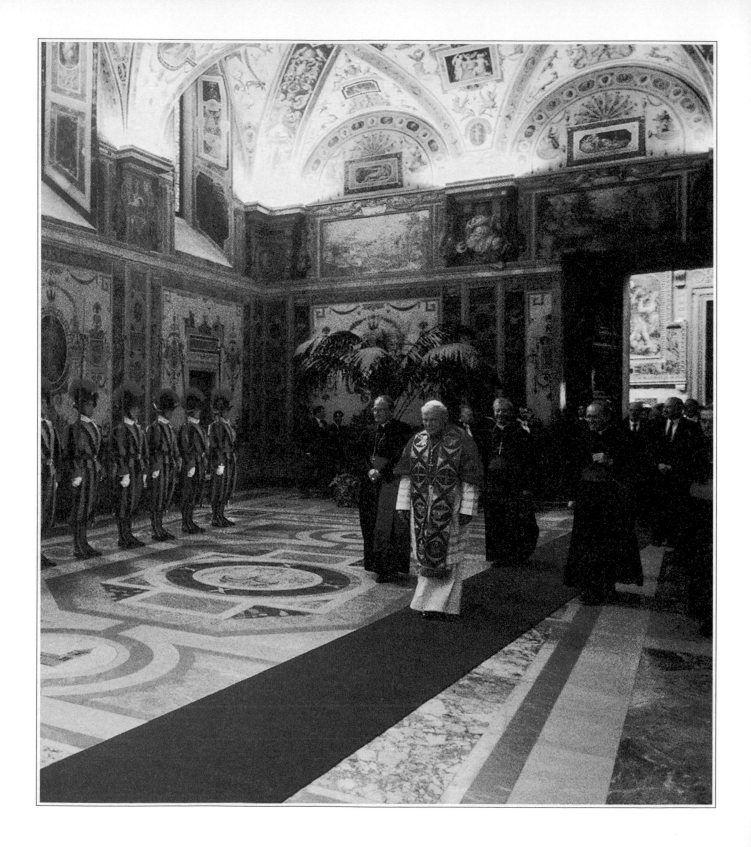

from a commission of cardinals, that is a "congregation," which might have started out being "provisional" and then became "permanent." The first "permanent congregation" was that of the "Holy Roman and Universal Inquisition, or Holy Office," established by Paul II in 1542.

Congregation also means religious family (the Salesians, for example), an association of numerous monasteries (the Camaldolensian Congregation), a chapter of monks or brothers, a session of the council, the college of cardinals or the synod of bishops, laic associations, assemblies of the faithful.

So while the name remains, the thing may change. Or the thing will remain, or return, but the name may change. Thus, meetings of cardinals became permanent, but continued to be called congregations. And provisional or periodic convocations returned to favor but were no longer called congregations, but rather meetings. But we should now turn to the governmental activities of the cardinals.

"Yesterday afternoon the Holy Father presided over the meeting of the Most Eminent Cardinals, Department Heads of the Roman Curia, in the Hall of Congregations of the Papal Palace." This was how the announcement read, from the Bulletin of the Vatican Press Office, describing the periodic meeting of the department heads, who are the formal equivalent of the cabinet of a modern state. It is the secretary of state who presides over these meetings, even if the pope is present. The secretary outlines the situation, mentioning the most significant events that the Curia will be interested in the coming months, and then he gives the floor to the individual department heads, who report on their activities. The goal is coordination and advice. But the participants say there is no true discussion and no decision made in common. In terms of government, the Vatican is still an absolute monarchy.

Who participates in the meetings of department heads? Some thirty people, for there are precisely twenty-eight departments, and their representatives belong to the Curia, which includes, at least formally, the secretary of state, nine congregations (Doctrine of the Faith, Eastern Churches, Ritual and Sacraments, Proceedings for Sainthood, Bishops,

Cardinal Joseph Ratzinger.

175

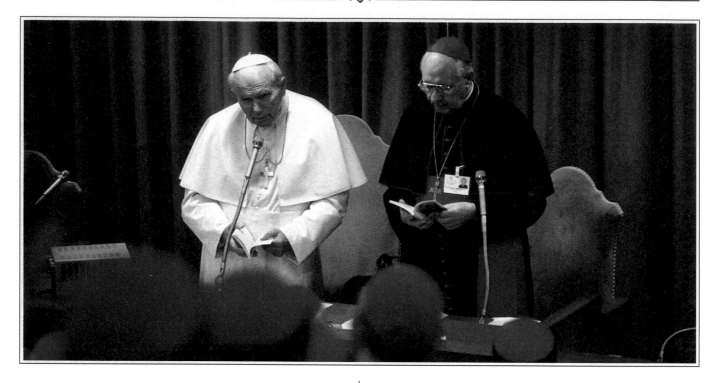

The pope in the Hall of the Synod with Cardinal Pieter Schotte.

Evangelization of Peoples, Clergy, Consecrated Life, Catholic Education); twelve councils (Lay, Christian Unity, Family, Justice and Peace, Cor Unum, Migrants and Itinerants, Health Workers, Interpretation of Legislative Texts, Interreligious Dialogue, Dialogue with Nonbelievers, Culture, Communications); and three offices (Apostolic Chamber, Apsa, Prefecture of Economic Affairs).

John Paul once joked about the figure-shadow relationship that exists between the pope and the cardinal who is secretary of state. While visiting Castel San Giovanni (Piacenza) on June 15, 1988, the pontiff turned to Cardinal Casaroli's fellow townspeople and said: "It only looks like the pope is working. Really it's the secretary of state who does the work!"

The secretary of state's apartment is on the second floor of the apostolic palace and has been there ever since he had to leave the fourth floor to make room for the pope's private apartment, at the beginning of the century. A review of history and a map of the Vatican palaces show that over the centuries, the popes' apartments have moved ever higher and more to the right, if one looks up from St. Peter's Square; it is almost as if they were trying to isolate themselves above all others.

Alexander VI, a Borgia pope, set up his apartment on the second floor of the palace, called the palace of Nicholas V, after its founder; this suite of rooms was located to the left of the St. Damasus Courtyard. His successor, Julius II, left that apartment and climbed up one floor, to the level of the Raphael Loggias and Rooms, "quia non volebat videre ogni hora, ut mihi dixit, figuram Alexandri praedecessoris sui" (Because he didn't wish to see at every hour, as he told me, the image of his predecessor, Alexander), according to Paride de Grassi, Julius's papal master of ceremonies. Julius was referring to the painting of Alexander by Pinturicchio, in the Hall of Mysteries, a lifelike and vital image, unforgettable for us but clearly invasive for one who had known him as a victorious adversary in conclave.

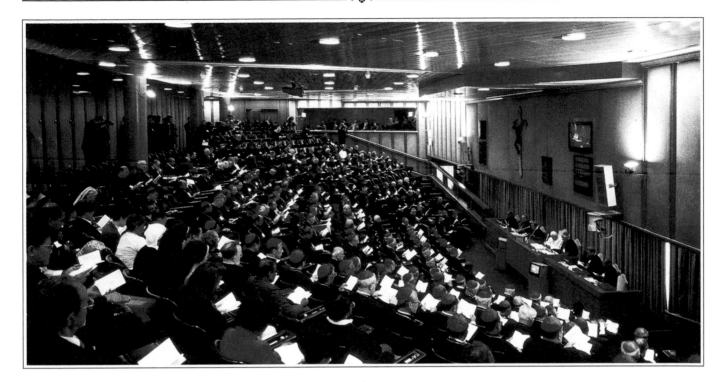

Other popes then moved toward the center and to the right of the St. Damasus Courtyard, still remaining on the third floor. Leo XIII, the first who no longer had the benefits of an alternative residence at the Quirinal, moved beyond the St. Damasus Courtyard, toward the fourth and fifth windows of the farthermost palace facade, where the antechamber of the Apartment for Audiences was located. Then, at the beginning of our century, Pius X decided to move to the fourth floor, into the rooms that correspond to the end windows on the right of the facade overlooking St. Peter's Square, and to the windows of the facade looking out toward Castel Sant'Angelo. It is said that it was the need to defend their private lives that backed the modern popes into this corner and to seek refuge in the rooftops!

Cardinals are addressed as "eminence." Perhaps the day will come when that title is abolished, as will "excellency" for bishops and "monsignor," which is denied to no one. John Paul, in the book *Crossing the Threshold of Hope*, once spoke of the discomfort these titles can cause. His own "Your Holiness" and "Vicar of Christ," he commented, "even seem to go against the Gospel," where it is said, for example: "And call no one your father on earth" (Matthew 23:9). It was in the seventeenth century that cardinals began to be called "eminence," while prior to that time, they were called "most illustrious." Manzoni has one of his characters charmingly mention that new title in *I Promessi Sposi*, when Don Abbondio, in the final chapter, says the cardinal archbishop was called eminence "since the pope hath prescribed, beginning last June, that this title be given to all cardinals." The year was 1630, and the title is still required, as we approach the year 2000. They have given up the train on the cardinal's robe, which was a vanity, but they cannot seem to part with the title, which might seem even more a vanity.

Once, cardinals throughout the world met only for a conclave. John Paul held "extraordinary concistories," intended as "plenary meetings of the college of cardinals," every four years, to provide the pope with guidance on particular issues. The concistory held in June of 1994 dealt with prepara-

tions for the grand jubilee. At the conclusion of that meeting, June 14, 1994, John Paul led a toast after lunch, in the Santa Marta Hospice, during which he jokingly reflected on the novelty of having the cardinals meet before a living pope: "It's wonderful to have so many cardinals in the Vatican without there being a conclave!"

For new cardinals, "courtesy visits" (until the time of Paul VI they were called "visits of fervor") are an almost unique opportunity to visit areas of the Vatican palaces that are not part of the museum itinerary and that are outside the Apartment for Audiences. For example, on the afternoon of February 21, 1988 (that morning there had been a concistory, in St. Peter's Square, with the handing out of seven "red caps"), at least seven cardinals walked along the following route: the Royal Hall (where friends and relatives of Dario Castrillon Hoyos and Jorge Arturo Medina Estevez were received), the Hall of Benedictions (Fernandes de Araujo, Policarp Pengo, Rivera Carrera, and Shan Kuo Hsi), the Ducal Hall (Giovanni Cheli), the First Hall of Vestments (Salvatore de Giorgi), the Second Hall of Vestments (Lorenzo Antonetti), the Borgia Apartment (Dionigi Tettamanzi, Aloysius Ambrozic, Christoph Schoenborn, and Jean Balland), and the Second Loggia of the Papal Palace (Dino Monduzzi, Francesco Colasuonno, James Stafford, Francis Eugene George, Adam Kozloviecki, and Antonio Maria Rouco Varela).

The largest of these spaces is the Hall of Benedictions, located above the atrium of the basilica and as long as its facade. Halfway along the room's left side (looking toward the papal platform), it

opens onto the central loggia of the basilica, from which one can see the pope offering his blessing—hence the name. The right side of the room opens onto the inner loggia, from which the "silver trumpets" once sounded when the pope entered St. Peter's. There were four horns, and they weren't silver, but the name derived from their "silver" sound. Paul VI did away with them.

It was in this hall that the pope fell, stumbling on the carpet, in early November of 1993. He dislocated his right shoulder and, for a while, was forced to offer his blessing with his left hand. This was one more indication of how actively involved the papacy has become since the days of the popes imprisoned by Napoléon. John Paul gave the fol-

lowing description of the accident, speaking from his window the following Sunday, just before offering his blessing with his left hand: "Last Thursday, as you know, I was forced to spend a brief time in the hospital, having fallen while descending the steps of the podium, to move toward those in attendance, at the end of an audience" (November 14, 1993). As for the left-handed blessing, perhaps it is meant to show us that the Roman papacy has once again clearly become a place of adventure at the turn of the millennium.

Left: Cardinal Edmund Casimir Szoka.

Below: the pope with Cardinal Andrei Deskuv.

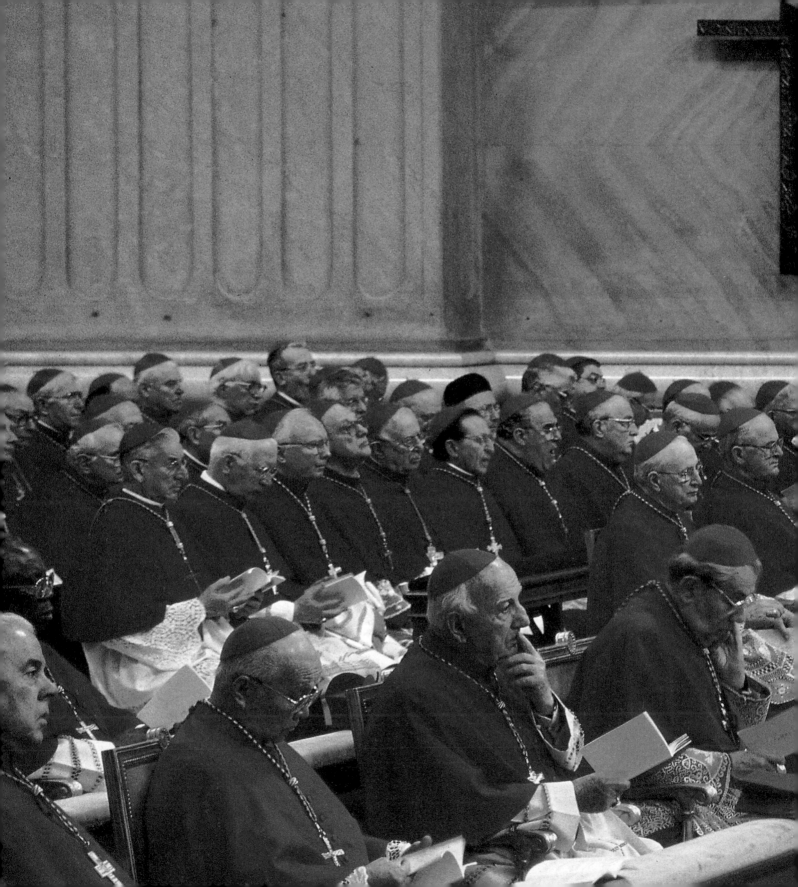

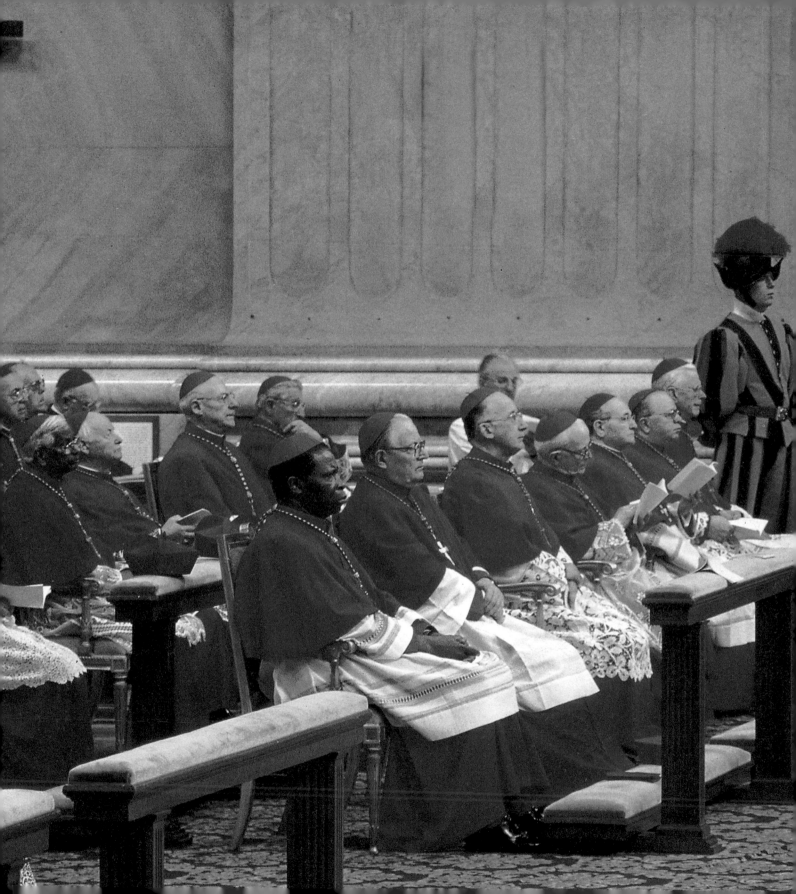

TO THE POST OFFICE
AND PHARMACY

For the people of Rome, the idea of working in the Vatican assumes mythical status. It was particularly so in the past, when misery ruled, and during the Second World War. But even today the myth endures and, like all myths, risks being suddenly overthrown.

During the contentious years of the 1960s and 1970s, throughout Rome (for example along the Via Nazionale, on the wall of the Villa Aldobrandini), one could see guarded but peremptory graffiti: "Don't go work in the Vatican."

But the attraction has obviously always been greater than the aversion. This explains the continuing fantasy, which has endured into our own century. Tano Citeroni, an amiable photographer ("a true Roman"), devoted a book of his work to St. Peter's Square, which he calls "the most unusual, suggestive, human" theater in the world. "I first experienced the scene in St. Peter's Square in 1950. My mother took my brother (who was five) and me (I was ten) to see the Holy Year pilgrims. I wanted to meet the pope. An altar boy in my parish had sworn to me that if I succeeded in touching the pope and taking Communion immediately afterward, when I grew up I would find work as a gardener in the Vatican."

The Swiss Guard is the smallest and most photographed division in the world. Its one hundred men participate in all papal ceremonies and keep guard at the Vatican doorways, where they are seen by television and tourist crowds alike. As with any closed place, people move around the Vatican walls, and girls from every country ask to have their photographs taken alongside these young men with their helmets and halberds. Regulations prohibit such photographs, but the girls don't know that. The uniform of the Swiss Guard is also eye-catching. Contrary to the old guide books, it wasn't designed by Michelangelo Buonarroti, but it is beautiful all the same, with yellow, red, and blue stripes, white collar, red plume, polished two-pointed helmet, halberd (each guard has four), and shiny armor (with a point on the breastplate similar to those on the helmet) resting on a leather holster belt.

A sense of history fascinates even more than

the uniforms. The guard is perhaps the oldest armed force in the world, and it is the only one that can claim uninterrupted service for nearly half a millennium, in the same location and serving the same purpose for which it was established in 1506.

It was precisely the antiquity of its origins that saved the guard in the nineteenth century, "the extremely ancient Swiss Guards." Having survived the reforms of this century, it seems likely that the guards will remain as long as the Holy See maintains temporal sovereignty, or as long as young Swiss men are willing to swear allegiance to the pope.

The guard is a denominational order. The first article in its regulations states that it is "a

Left: the Swiss Guards at rest.

Above: the parking lot with the pope's famous car in the foreground.

when the Swiss Confederation abolished mercenary service abroad, and again in 1970, when Paul VI, seeking to move the image of the Vatican closer to the modern view of the church, did away with the other armed papal forces (the Noble Guards and the Palatine Guards) but kept

military force made up of Swiss citizens, whose principal task is to constantly stand vigil over the safety of the sacred person of the Holy Father and his residence."

The pope is the guard's commander in chief, and all guardsmen must be Catholic as well as Swiss, between nineteen and thirty years of age, single, of good reputation, in good physical health, and "at least 174 centimeters tall."

Silvio Negro felt that in order to truly see the extremely beautiful, martial, and serene nature of the Swiss Guard, one had to witness, at least

once, the "swearing in of new troops," which he described as follows: "After formation, the chaplain read out the oath, in German and in French. Then the young soldiers emerged, one by one, from the lines, each accompanied by a drum roll. Each soldier, in turn, moved forward as far as the flag, which the sergeant held from a horizontal staff. Standing with legs open wide, perhaps to remain more steady, he raised his right hand above the cloth of the della Rovere Pope, the two smallest fingers folded down, signifying that he was swearing in the name of the Trinity, and shouted out: 'I swear to observe, loyally and in good faith, everything that has now been read. May God and His Saints assist me'.

The guard was established by Julius II, a warrior pope who guided the troops and personally led their assault atop the walls. The pontiffs had enlisted Swiss troops on numerous occasions, to defend one alliance or another. But Julian della Rovere was the first to establish an entire company, made up solely of Swiss. Untrustworthy as a pope, Julius II was nonetheless one of the most influential pontiffs in terms of the image of the papacy. Under his rule, Bramante began building the new St. Peter's, Michelangelo frescoed the vault of the Sistine Chapel, and Raphael created his Rooms. The Swiss Guard can be added to this list as one more element linked to Julius II in the collective memory.

Below: the pope's private physician, Dr. Renato Buzzonetti.

Right: the pharmacy.

In those times, as Machiavelli denounced in *The Prince*, Italy was "overrun by Charles, plundered by Louis, occupied by Ferrando, and reviled by the Swiss." The Swiss shamed Italy with their military valor. The papal guard showed an example of this extraordinary bravery during the sack of Rome in May 1527. Pope Clement VII had supported the League of Cognac with France and Venice, against the emperor, and the imperial troops plundered the city and held siege to the pope, in Castel Sant'Angelo, for six months. Despite their superior numbers, the German mercenary troops fighting for the emperor failed to enter St. Peter's until they had killed the 147 Swiss guards defending the doors. And the swearing-in ceremony on May 6 of every year is an act of remembrance of this heroism.

The Swiss guards risked being disbanded by Pius X, at the beginning of the century. They protested because the new pope had turned down the "bonus" traditionally granted with each election. Pope Sarto, already embarrassed by the pomp of his office, decided to dissolve the company, and the Catholic cantons that had always provided the soldiers had to intervene to save the guards.

More than half the current guards come from the cantons of Valais, Lucerne, and Saint Gall; a few come from French-speaking Switzerland, and there are occasional Ticinese (who were once excluded).

The official language of the guards is Italian, and they have a "language master" who teaches them. Beards, mustaches, and long hair are forbidden. Their terms last a minimum of two years. Most return to their former lives; others

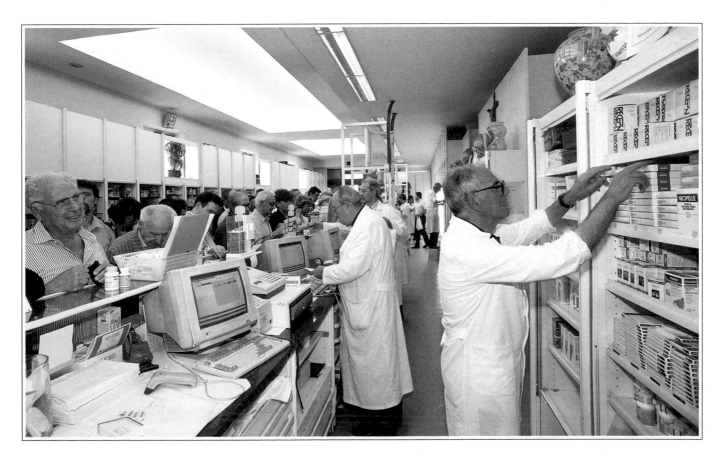

Left: the "statue cleaner" at work in St. Peter's Basilica.

take advantage of their military experience to enter the police or armed forces or to work for security companies.

Guards must be single when they enter service, but they are granted a "permit for matrimony" if they have reached the rank of corporal, are twenty-five years old, have served for three years, and if there is "a vacant apartment in the guards' quarters."

New recruits stay in ten-bed dormitories, the guards have double rooms, noncommissioned officers and officers have single rooms, and families are given apartments. The guards' lodgings are located within the Vatican, between the right colonnade of St. Peter's Square and the Gate of Sant'Anna.

Life is strictly regulated, and guards must return each evening to their quarters.

In addition to obligatory service at audiences and at mass, and honor guard duty at diplomatic receptions, they also stand guard at the entrances to the Vatican (the Arco delle Campane, the Great Bronze Door, The Gate of Sant'Anna, and the Cancello Petriano, leading into the audience hall), at the entrances to the papal palace, at all the floors (and loggias) of the palace, in the Royal Hall, and in front of the apartments of both the pope and the secretary of state.

The guards also have "shooting" duties; once a year they must go shooting, in response to a requirement of all Swiss citizens. They practice with the weapons and munitions of the Swiss forces, on a range belonging to the Italian forces. When the guards have leave, Swissair gives them a 50 percent reduction on Rome-to-Switzerland tickets. After ten years' service, a guard is eligible for a pension.

In addition to the "most ancient Swiss Guard," the Vatican has a modern police force. "God is my security," Pope Wojtyla once said (in Ibadn, Nigeria, on February 15, 1982), responding to a question from journalists about the risk of attacks. But his security also lies with the Vatican City Security Force.

There are about one hundred twenty officers, under the command of an inspector general and a vice inspector, who, in 1970, replaced the Papal Gendarme force.

In recent years, the pope has had numerous occasions to be grateful to his "gendarmes," as they are still unofficially called. John Paul is not only grateful to them for the important service they perform, but for having protected him so many times from the crowds that always press in on him, as they did even the day following his election, when he first left the Vatican to visit the Gemelli Polyclinic on October 17, 1978. "I want to thank those who have guided me here and who have also saved me, for the crowd's great enthusiasm might have necessitated an immediate stay here by the pope, in order to recover."

The Vatican has always been a place of juxtaposition of great and small. The first pope to have a house built on the Vatican hill seems to have been Innocent III, around the year 1200. He immediately added a "panetteriam, butilleriam, coquinam et marescalciam," namely, a bakery, a wine cellar, a kitchen, and a stable for horses. Indeed, a tour of the lower Vatican, the Vatican of those who live and work there, reveals a wine cellar and a bakery.

The Vatican also has a supermarket, but it goes by the ancient name "annona," or provision office. The name comes from the Latin, of course. An annona was one year's gathering of crops, and by extension means "provisions."

The Vatican once had a prefecture of provi-

Above and right: two people at work: the gardener and the vegetable gardener.

sions, but where does one go today for provisions? Where does one shop? At the supermarket, the annona!

The supermarket is located on Via San Giovanni di Dio, behind the pharmacy and next to the printer's. It has everything, like a normal supermarket, and is open from 7 A.M. until 6 P.M. and until noon on Saturday. The prices are lower than in Italy, and admittance requires an identity card issued by DIRSECO (Office of Economic Services) to employees and retirees, as well as to heads of certain religious institutes in Rome that

fall under papal authority. "Customers" arrive at the checkout counters with overflowing carts, and they often shop for entire communities. There are twelve registers, as well as an express

Above and right: the butcher and the "sanpietrino".

line that has a sign that warns, "Maximum Nine Items."

The supermarket is perhaps the only building in the Vatican that does not have an inscription or marker. The door reads Entrance, nothing more. But the coat of arms of pope Montini (three small mountains) tells us that he was responsible for its construction. If you pay by credit card, the receipt reads "spaccio annona," or provision store, while cash receipts read "self-service."

There is no form of commercial advertising on the walls or hanging from the ceiling, as in supermarkets in Rome and throughout the world. But there might be a seasonal sign announcing: "Clothing warehouses. Tuesday, February 24, spring and summer collections go on sale." This refers to another commercial venue in the Vatican.

The clothing warehouses are inside the supply warehouse, on the basement level and at the back of the Government Office Building. In addition to clothing and shoes, there are furs, luggage, knickknacks, watches, pens and tobacco. The same identity card needed for the supermarket is required here. The salesclerks are Vatican employees and wear staid uniforms that make them resemble railroad workers.

All Vatican businesses are "state monopolies"; private companies may not present or sell merchandise. But these are still shops, exposed to risk of theft, and there are the usual signs, warning shoplifters: "Customers should be advised that articles on display are electronically protected." The warning is followed by the trademark of the firm that provides security: Sensormatic.

Gasoline is also subject to the same rules, but customers need, in addition to an identity card, a coupon, issued by the Vatican fuel office. Monthly allotments vary, depending on the employee's job.

Holders of identity cards may also buy cigarettes, cigars, and high-quality tobacco, at duty-free-shop prices, that is, without custom duties added. But how long will this last? The problem was posed by a parish priest from Rome, during a meeting with the pope at the beginning of Lent. It was March 2, 1995, and the priest was Ugo Mesini, a Jesuit. Wojtyla responded thus:

"One of you has spoken of tobacco. In this regard, my conscience is clear, but I must speak about it with Cardinal Castillo!" Cardinal Castillo was then in charge of the Government Office, and perhaps what the pope meant was

that he, Wojtyla, does not smoke and it wasn't he who introduced tobacco sales to the Vatican.

The Vatican pharmacy has a history that borders on legend and deserves retelling. After the king of Italy took over Rome, there was no pharmacy within the precinct of the Vatican palaces. During the day, nearby pharmacies could supply what was needed, but at night? For one thing, it was best to exit the Vatican as little as possible after curfew. "In case of medical emergencies, every evening a Carmelite monk arrived, from the pharmacy of the Monastery of Santa Maria della Scala, in Trastevere. He settled in among the Swiss Guards at the Gate of Sant'Anna, where, if need arose, he could be found, with his supply of remedies. In the morning, when the neighborhood pharmacy opened for business, the monk returned to his cloister."

This description comes from the official *Mondo Vaticano* dictionary, published by the Vatican publishing house in 1995. After four years, that particular monk's duties were inherited by another from the Order of the Brothers of St. John of God, who became a permanent fixture and was granted "a chamber set aside for a pharmacy." The pharmacy is still managed by the same order and is the only "commercial enterprise" in the Vatican that is open to all, not just Vatican employees, for the purchase, for example, of medicines that are not sold in Italy. People need only tell the guard that they want to enter the pharmacy, and once inside they must present a medical prescription, just as in any other pharmacy in Rome, and prices are the same.

The pharmacy is on Via della Posta. Three papal coats of arms, on glass panels, along with three inscriptions, tell the story of this institution.

The first panel, to the left of the sales counter, bears the arms of Pope Mastai and the inscription reads:

"Vatican Pharmacy. Established by Pius IX, 1874 AD." "AD," or "Anno Domini," year of Our Lord, appears on all Vatican dates, even when, as in this case, the rest of the inscription is in Italian. The second panel, at the center, has the arms of Pope Montini and specifies: "Vatican

Pharmacy. Rebuilt by Paul VI, 1963 AD." The third, on the right, has Pope Wojtyla's arms and concludes: "Vatican Pharmacy. Expanded by John Paul II, 1989 AD."

In 1997–98, the twenty-seventh soccer championship was held in the Vatican. Sixteen teams competed: ACV (Vatican Catholic Association), Argonauti (television station, museums, and security), Archivio segreto, Centro industriale (maintenance departments: bricklayers, plumbers, gardeners, and technicians), DIRSECO (Economic Services Office, the Government Office), Gladia-

tors (IOR), Hermes (museums), Meridiana (secret archives), Poste, Radio Vaticana, Santi Pietro e Paolo (Palatine Guards), Santos (museums), Team X (IOR), Telefoni (telephone workers), Vigilanza (security), Vigili del fuoco (firemen).

There is also a national team, as it were, that participates in the Italian amateur championship games, which would be equivalent to something like a Series 4 team; it goes by the name Società Sportiva Sistina, or Sistine Sporting Group.

The Sampietrini have a name that already functions as a description, for in Italian, "sampietrino" has come to mean "St. Peter's maintenance man."

They are the cleaning and maintenance personnel, who take care of the inside and outside of the Vatican basilica and its outbuildings. There

are twenty-four high-ranking workers and a fluctuating number of lower ranking ones, who are promoted after at least four years of service when vacancies appear. There are twelve members of the Papal Fire Department, plus two squad heads and one officer; they wear brown uniforms, wool or cotton, depending on the season. They have barracks in the Belvedere Courtyard and have three fire trucks and one hook and ladder. The barracks contain a terminal connected to every fire alarm in the Vatican City (museums and galleries, library, archives, printer's, Philatelic Museum, Hall of Audiences).

The firemen's tasks involve some special duties; for example, every evening, two of them help the maintenance workers inspect St. Peter's Basilica after closing hours. Provided with extension ladders, they check all the niches and pulpits, to ensure that no one has climbed up there to spend the night or that no items remain that might turn out to be bombs.

Looking at the cars parked in front of the supermarket and those that go up to the St. Damasus Courtyard, you will note two different types of Vatican license plates: official state plates, with the letters *SCV* (Stato della Città del Vaticano), and those for citizens with the letters *CV* (Città del Vaticano), introduced in 1987.

Cars reserved for the pope have license plates with red letters against a white background; other plates have black letters against a white ground.

Vatican citizens are not born; citizenship is official and is acquired or lost when one assumes or leaves office.

As of October 1, 1997, there were 466 Vatican citizens: 48 cardinals, 253 Holy See diplomats (most of whom, obviously, are scattered throughout the world), 78 Swiss guards, 43 clergy and members of religious orders, 44 laypersons. The pope is not included in this number. As of the same date, the Vatican had 455 residents, including 164 citizens and 291 noncitizen residents, such as the nuns who live at Santa Marta, residents of religious orders who work there, and the Salesians who direct the printing plant.

Official statistics don't tell us the number of women, but there are very few among the citizens or residents. During our tour of this part of the Vatican, we saw many women in the supermarket, in the pharmacy, and at the radio station, but fewer in the Curia offices and even fewer, almost none, in charge of other offices.

Women never serve at the altar, and there are no women at conclave, concistory or plenary sessions. Women are sometimes invited to synods, and there occasionally might be one who dares to ascend the papal audience platform, where there are usually only bishops, Swiss guards, and cameramen around the pope. Even the cameramen in the Vatican are only men. A woman might be called upon to read during celebrations of mass in the basilica or out in the piazza.

Once a woman was sent to represent the Holy See at a United Nations conference (September 1995, Beijing), but it was a conference on women, and a similar choice has not followed for other conferences. On that occasion, John Paul, in his *Message to the Vatican Delegation*, published on August 29, 1995, invited "all men of the Church" to make a "change of heart" and to have a "positive view of women."

Perhaps the "change" invoked by Wojtyla will bear fruit with his successors.

Collecting the mail.

197

THE VATICAN WEBSITE

The memory of St. Peter, the home of the pope, a place of credentials, museums, excavations—the Vatican is no place for journalists, at least those who lack credentials, obviously. Using ordinary information networks, one quickly discovers that ordinary credentials don't suffice, and information must be gleaned from other channels.

Looking for news about the Vatican is worse than trying to go there at night! They tell you to call back tomorrow, or to submit questions in writing, or to go to the press office. And yet there are scores upon scores of professionals who do this work. After months and years of patient investigations, they have chosen their contacts and have perfected their modes of access. "Access" is the magic word: tell me who sent you, that is, from whom you've gained access, and I will tell you what you want to know. But all it takes is a change in office manager, and the most experienced correspondent, who has spent decades reporting on conclaves and synods, will find himself listening to some newly arrived clerk telling him he must report to the press office. In short, hunting down Vatican news is quite an adventure.

And so, as the rules require, let's start out from the Press Office, at Via della Conciliazione 54. The reception room of the press office has two hundred seats and a booth for simultaneous translations and film projections. There are about three hundred accredited on-site journalists, but their number doubles or even triples during concistory sessions, synods and conclaves. The increase in requests for information about the activities of the pope and the Holy See led the Press Office to create, in 1990, the first Vatican telecommunications system, called the Vatican Information Service. The VIS, as it was immediately called, reaches all corners of the globe: bishops in every nation, papal representatives, international institutions, and even newspapers, as well as individuals interested in following the everyday activities of the Vatican. Subscribers may choose to receive documentation in one of three languages (English, Spanish, and French), and by the means most convenient to them: fax, e-mail or via the Internet.

Left; the Vatican Publishing House.

Above: the printing house of the Osservatore Romano, the Vatican's daily newspaper.

Pope Wojtyla has visited the press office only once, but he gives group interviews to journalists, which are actual press conferences, on all his international travels. He always sets the right tone, even using his cane as an excuse, as he did during his Rome–Manila flight on January 11, 1995: "As you see, I carry a cane, and this cane is used to beat those who are out of order, perhaps even journalists!"

But everyone knows that the media present a challenge for everyone, and the pope is no exception. For example, as the pope's suffering

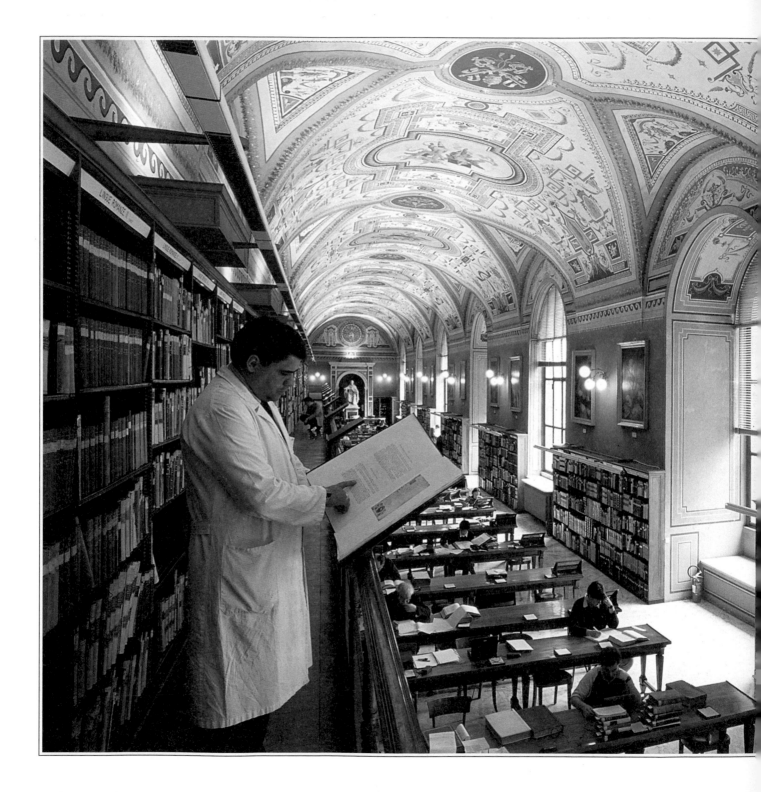

persisted after his right femur was replaced, the newspapers emphasized an obvious moment of pain he experienced, ascending the altar steps. The next day, August 22, 1994, in Introd (Aosta), Wojtyla said to his spokesman, Joaquín Navarro-Valls: "Ask the journalists if they haven't ever had a twinge of pain!" But overall, John Paul—always considered a "great communicator" by the media—has a good relationship with the press. Navarro-Valls maintains that there has been "an objective alliance between the media and the pope," which has modified the papal image. "We don't know what percentage is due to the pope and what to the media, but they are both responsible for this profound change."

The Vatican Television Office is still a recent development and has a small staff (some ten technicians and four journalists with three studios and a registration hall on Via del Pellegrino, next to the *Osservatore Romano* offices). But it perhaps wins out over all other Vatican media, thanks to the powerful images it conveys and the dynamism of its current director, Don Moretto. The station films all the pope's public activities and finances its own activities, selling footage to television networks the world over. The public can also purchase tapes, and many people buy tapes of general audiences, as a souvenir of a pilgrimage to Rome.

We all hear how television has taken over the world. At this point, Olympic games and parliamentary sessions are programmed to accommodate live television broadcast schedules. The same holds true for the pope's activities, as was clear on October 8, 1994, a Saturday evening, when John Paul spoke before the television cameras in St. Peter's Square: "I have to speak for twenty-five minutes, and I don't know if these twenty-five minutes are up yet!"

The Vatican publishing house puts out the *Annuario pontificio* (a yearly report), the *Annuario statistico della Chiesa* (edited by the Central Statistics Office of the Church), *L'attività della Santa Sede* (another annual report), the *Acta Apostolicae Sedis* (the official bulletin of the Holy

The Vatican Apostolic Library.

See) and various periodical reports on congregations and Vatican foundations. *The Catechism of the Catholic Church* (1993) has been the most widely disseminated publication in the world. In 1983, the Vatican opened a bookstore in St. Peter's Square, in the so-called Charlemagne Wing (to the left, facing the basilica facade, in the section perpendicular to the facade, close to the Information Office for Pilgrims and Tourists).

The *Osservatore Romano* is the official Vatican newspaper, published daily in Italian, six times a week in French (since 1949), English (1968), Spanish (1969), Portuguese (1970), German (1971), and Polish (1980). Pilgrims are well acquainted with the newspaper's photography office on the ground floor on the Via del Pellegrino, for it is here that they can purchase photos of ceremonies in which they have participated. Photographer Arturo Mari takes pictures of all those who approach the pope, and most of them, nearly all, stop by the photography office to retrieve the photos, which are sold at a reasonable price.

The pope is always accompanied by his personal photographer. His personal physician or private secretary or guards might not be there at a particular time or place, but the photographer is always at his side. Wojtyla is gracious about this demand for images and often jokes about it, although he, the most photographed man in the world, is utterly disenchanted with the process. "So many people offer me their hand, but while they do so, they're looking at the photographer," he commented on March 5, 1995, while visiting the parish of Santa Maria del Soccorso in Rome.

John Paul II's relationship with the media has a sort of innocence, but no ingenuity. "This conflict has been engaged not only with arms of war, but also, to a certain extent, through the media," he said after the Gulf War, in the spring of 1991. Has there been anyone who understood those events better?

Vatican Radio began broadcasting on February 12, 1931, from a "broadcasting center" created in the Vatican gardens and furnished with a single eighteen kilowatt "Marconi" shortwave transmitter. It was created and set up by

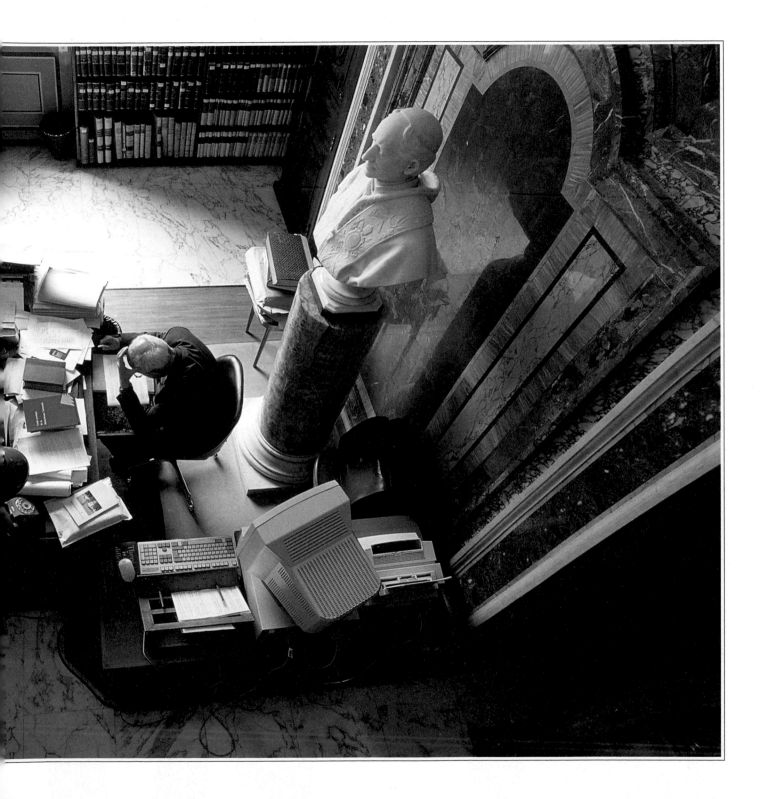

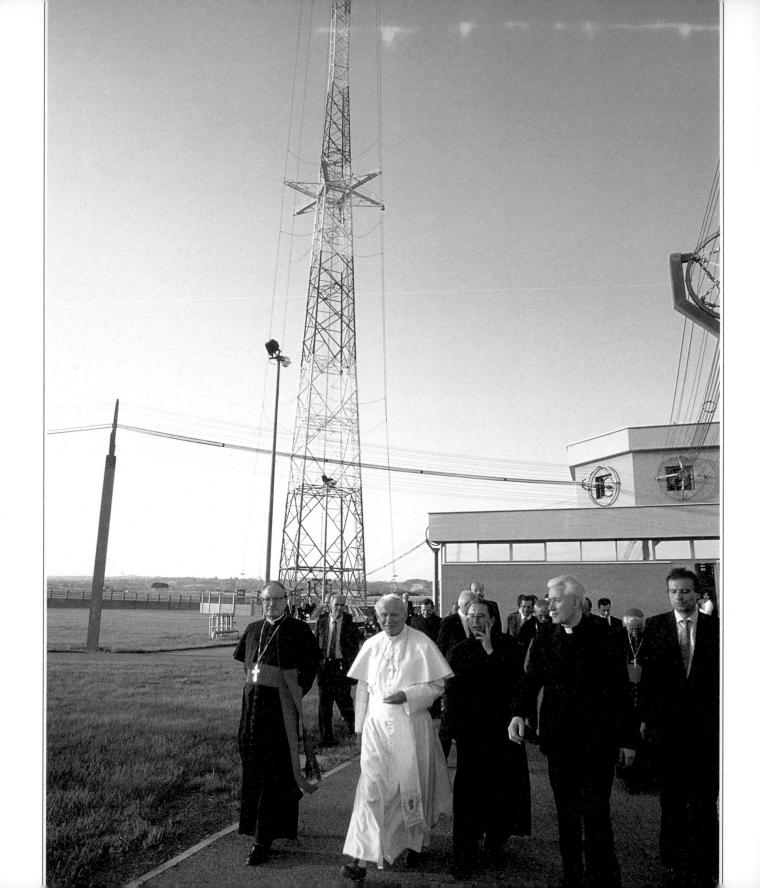

Left: the pope on a visit to the Vatican Radio headquarters.

Guglielmo Marconi himself, in the presence of Pius XI. At the time, it was a state-of-the-art installation (its antenna was able to transmit the signal as far as South America and Oceania) and marked the debut of the Vatican into the modern world of telecommunications. It has remained a part of that world, although over time it has fallen back to a less advanced position.

Pius XI, Marconi, and the others involved in the radio station's inception (and these included the electrical engineer and writer Carlo Emilio Gadda) were fully aware of the significance of this debut. The pope solemnized the occasion with a message of cosmic celebration: "Hear, you heavens, listen, earth!"

In an essay titled *The Grand Technical Facilities of the Vatican* (1933), Carlo Emilio Gadda described it as follows: "A telegraphic and telephonic radio station of great power . . . was erected on the hill, and two tall steel framework towers support its antenna. The station is linked to offices, through telephones and teletype machines, so that if a letter is typed, for example, in the Apostolic Secretary's office, the same letter is simultaneously typed beneath the eyes of the radio telegraph official. . . . Thus the City is provided with the most modern means of communication that science and technology of our wonderful century have prepared, to facilitate, to intensify the life of the spirit!"

Today Vatican Radio, which has its editorial offices at the beginning of Via della Conciliazione, in the first building on the right, facing Castel Sant'Angelo, broadcasts in thirty-two languages and has transmitters of over one thousand kilowatts, which allow its signal to be sent to every corner of the world.

"Innovation does not dwell in Rome," wrote Nikolaj Vasil'evic Gogol, in 1838. This was true under the rule of Pope Gregory XVI, the pontiff at that time, who did not want a railroad in the papal state because, he maintained, it might artificially alter the "natural" distribution of wealth among peoples and countries. Who knows what John Paul would have to say about this fear of railroads, he who so loves to travel by plane and who would like to alter, in every way possible, the distribution of wealth? For centuries, innovation did not dwell in the Vatican, and *novitas* was synonymous with danger, if not heresy. But it is dwelling there now, or at least making its way there. For proof, one need only log on-line to the Vatican website: http://www.vatican.va.

The suggestion to open a Vatican website was made by the director of the Press Office, Joaquín Navarro-Valls, to the pope during the summer of

1995. According to Navarro-Valls, "the debut came with the message *Urbi et Orbi* at Christmas of that year, and two weeks later, 2,376,000 people from seventy countries had already logged onto the site to read the pope's messages; 4,678 messages, in ten different languages, arrived at our address in a single week!"

Joaquín Navarro-Valls is convinced that, after radio and television, the Internet could represent an unexpected and "interactive" opportunity for the papacy to communicate with the world. At the Vatican site, the scholar can find a data bank, the journalist the news of the day, and the interested web surfer a window where he or she

can ask questions and leave messages.

The Internet site is the most recent Vatican media tool. The oldest is *Osservatore Romano*, which began publishing in 1861, followed by Vatican Radio, which began transmitting in 1931, the Vatican Press Office, which opened after the Council of 1966, and the Vatican Television Center, which issued its first videotape in August of 1983, on the occasion of the pope's visit to Lourdes.

But official and authorized sources may not be enough for the poor journalist. He or she may have to venture into the Leonine City in search of news.

To enter the Vatican, one needs a "pass": a light blue, numbered slip of paper with the heading "Stato della Città del Vaticano—Governatorato" (Vatican City—Government Office), which lists the name of the visitor, the

reason for the visit, and the entrance at which the pass must be presented. For example: "Permit to enter the Vatican City issued to Mr. Luigi Accattoli, to visit His Excellency Tauran, November 18, 1997, 5 P.M., Bronze Door entrance. To be shown whenever requested and to be returned upon leaving the Vatican City."

But entry to the Leonine City does not provide access to news. The Vatican has a strict policy of confidentiality, known as "papal confidentiality." The most recent regulation is contained in a directive issued by the secretary of state on February 4, 1974, and states that any member of the Roman Curia who violates the rule of confidentiality will be "immediately dismissed from office." Matters protected by the rule are listed under nine items: preparation of papal documents, information from the office of the secretary of state; examinations of doctrine at the Congregation

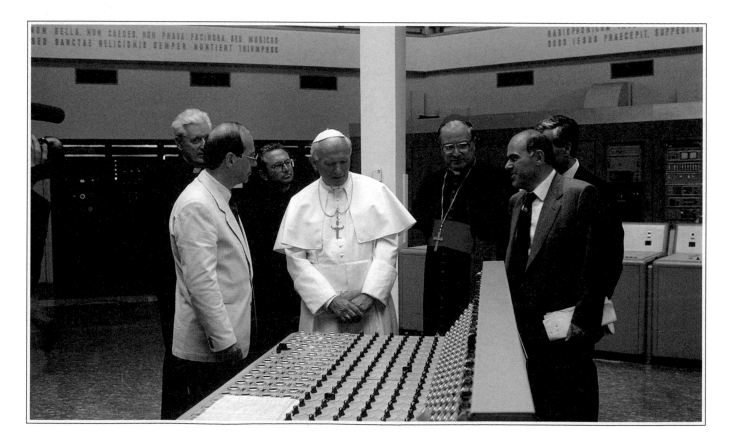

for the Doctrine of the Faith; denunciations and proceedings regarding "crimes against the faith and its customs"; reports of representatives of the Holy See; information regarding "the creation of cardinals" (that is, the nomination of new cardinals), and the nomination of bishops, nuncios, and prelates of the Curia; matters and practices for the attention of the pope or cardinals who are department heads, or nuncios. In practice, all Curial activity of any significance is subject to the rule of confidentiality. This explains why it is so difficult to seek out news in the Vatican!

Left: the pope on a visit to the Vatican Television headquarters.

The new office of the Centro Televisivo Vaticano.

Wojtyla's high-tech introduction into people's lives is facilitated by the way in which his image is presented to the media. He is shown as unique, unblemished, ideologically simple—an image seemingly prepared specially by an ad agency through mass communications means. Their rule is simplification, and the papal image is simple. At the beginning, Wojtyla was helped by his vigorous, physical, sportive image, the intensity of his expression, and the fact that he was well versed in the art of communication through the theatrical experiences of his youth.

It needs to be recognized that the policy of secrecy does not impede the pope's presence in mass communications. Over the years, he may have lost his strength and intensity of communication, but he has gained in his capacity to draw people to him, and that hold over others is more tenacious, more deeply felt than ever.

BIBLIOGRAPHY

Biblioteca apostolica vaticana. Florence: Nardini, 1985.

La Cappella Sistina. La volta restaurata: il trionfo del colore. Novara: Istituto Geografico De Agostini, 1992.

Michelangelo e Raffaello in Vaticano. Vatican City: Edizioni Musei Vaticani, 1994.

Mondo Vaticano. Passato e presente. Edited by Niccolò Del Re. Vatican City: Libreria Editrice Vaticana, 1995.

Il Vaticano e Roma cristiana. Vatican City: Libreria Editrice Vaticana, 1975.

Basson, Michele. *Guida alla necropoli vaticana*. Vatican City: Fabbrica di San Pietro in Vaticano, 1986.

Bonomelli, Emilio. *I Papi in campagna*. Rome: Gherardo Casini, 1953.

Calvesi, Maurizio. *Le arti in Vaticano*. Milan: Fabbri, 1980.

Chélini, Jean. *La vie quotidienne au Vatican sous Jean Paul II*. Paris: Hachette, 1985.

Citeroni, Tano. *Teatro San Pietro*. Milan: Fabbri, 1982.

Fallani, Giovanni; Mariani, Valerio; Mascherpa, Giorgio. *Musei Vaticani. Collezione d'arte religiosa moderna*. Milan: Silvana editoriale d'arte, 1974.

Fallani, Giovanni; Quilici, Folco. *Città del Vaticano*. Esso Italiana, 1984.

Guarducci, Margherita. *Le chiavi sulla pietra. Studi, ricordi e documenti inediti intorno alla tomba di Pietro in Vaticano*. Casale Monferrato (Alessandria): Piemme, 1995.

Jung Inglessis, Eva-Maria. *San Pietro*. Special Edition for Pontifical Museums and Galleries. Vatican City, 1978.

Levillain, Philippe; Uginet, François. *Il Vaticano a le Frontiere della grazia*. Milan: Rizzoli, 1985.

Martin, Jacques. *Vaticano sconosciuto*. Vatican City: Libreria Editrice Vaticana, 1990.

McDowell, Bart; Stanfield, James L. *Viaggio in Vaticano*. Italian translation. Milan: Touring Club, 1991.

Negro, Silvio. *Vaticano minore. Altri scritti vaticani*. Vicenza: Neri Pozza, 1963 (Bagutta Prize, 1936)

Neuvecelle, Jean; Imber, Walter. *Vaticano. Porte aperte*. Milan: Edizioni Paoline, 1980.

Panciroli, Romeo. *L'appartamento pontificio delle udienze*. Rome: Editalia, 1971.

Petrosillo, Orazio. *Città del Vaticano*. Vatican City: Edizioni Musei Vaticani, 1997.

Pietrangeli, Carlo. *I Musei Vaticani. Cinque secoli di storia*. Rome: Quasar, 1985.

Pietrangeli, Carlo; Mancinelli, Fabrizio. *Vaticano, città e giardini*. Vatican City: Edizioni Musei Vaticani, 1985.

Poupard, Paul. *Conoscere il Vaticano*. Casale Monferrato (Alessandria): Piemme, 1983.

Roiter, Fulvio. *Vaticano*, with text by Andrea Riccardi. Milan: Vita e Pensiero, 1997.

Sansolini, Massimo. *Io sediario pontificio. La mia vita accanto ai Papi*. Vatican City: Libreria Editrice Vaticana, 1998.

Zeppegno, Luciano; Bellegrandi, Franco. *Guida ai misteri e piaceri del Vaticano*. Milan: Sugar Co., 1974.